the digital photographer's guide to

PHOTOSHOP
ELEMENTS

Improve your photos and create fantastic special effects

revised & updated

the digital photographer's guide to

PHOTOSHOP ELEMENTS

Improve your photos and create fantastic special effects

Barry Beckham

revised & updated

LARK BOOKS
A Division of Sterling Publishing Co., Inc.
New York

The Digital Photographer's Guide to Photoshop Elements:
Improve Your Photographs and Create Fantastic Special Effects

Beckham, Barry, 1950-
 The digital photographer's guide to Photoshop Elements : improve your
 photographs & create fantastic special effects. Barry Beckham-- 1st ed.
 p. cm.
 ISBN 1-57990-528-5 (pbk.)
 1. Photography--Digital techniques. 2. Photography--Special effects
 3. Adobe Photoshop elements. II. Title.

TR267.C66 2004

778.3--dc21
 2004007919

10 9 8 7 6 5 4 3 2 1

Published by Lark Books, a division of
Sterling Publishing Co., Inc.
387 Park Avenue South, New York, N.Y. 10016

Revised and updated edition
Text and Images © The Ilex Press Limited 2005

This book was conceived by ILEX,
3 St. Andrews Place, Lewes,
England, BN7 1UP.

Distributed in Canada by Sterling Publishing,
c/o Canadian Manda Group, 165 Dufferin Street,
Toronto, Ontario, Canada M6K 3H6

If you have questions or comments about this book, please contact:
Lark Books
67 Broadway
Asheville, NC 28801
(828) 253-0467
www.larkbooks.com

For more information on
this title, please visit:
www.web-linked.com/elemus

contents

Introduction

Photoshop Elements gives you complete control over color. Take a shot in color, then turn it into black and white. Then use the tools at your command to adjust every tonal level, and every aspect of brightness and contrast. You can give a new photo a vintage look, or take an old photo and make it look like it was shot five minutes ago. With a little technique, almost anything is possible.

The Digital Way

Digital photography has become a fascinating hobby for many people since the digital revolution first began. Since then, the rollercoaster of technological advancements has never slowed down.

The constant upgrade of cameras and equipment with ever-higher pixel counts and the improvements in film and flatbed scanner resolution have all been great news for photographers and for the quality of our pictures. On the other hand, the never-ending improvements and updates make people justifiably nervous of spending their hard-earned money on the latest equipment because of the worry that it may go out of date very quickly.

I would suggest, however, that you do not concern yourself too much with the endless chase of pixels and resolution. There really isn't a need to replace your equipment constantly as the technology moves on—as long as it still works.

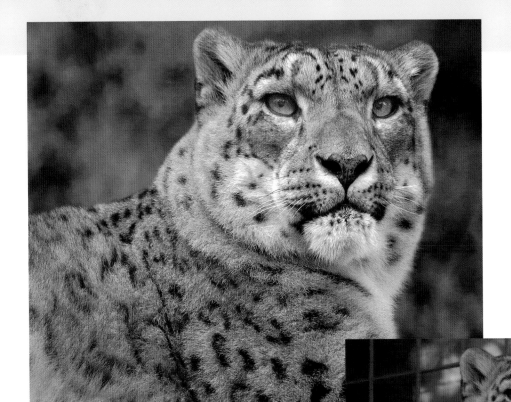

The prints I make at 20 by 16 inches are considered good-quality images by some very discerning professional and amateur photographers. Most of these prints are taken from images shot with a mid-range 3-megapixel camera; so, while it might be nice to own a top-of-the-range 8-megapixel camera, it is certainly not essential. You can use and enjoy your equipment no matter what the pixel count or resolution.

This book is concerned with making pictures better. This could involve small changes in color; the removal of objects that spoil your images; or the correction of some of the common faults that are difficult to avoid. I will also show you how to take your photographs further, whether they are shot using a digital camera or scanned with a flatbed or negative scanner.

Photoshop Elements, produced by the Adobe Corporation, is now in its third version. Adobe produces Photoshop CS, a powerful, complex, and expensive program that is recognized as the world-standard software for image editors and professionals. Realizing that Photoshop CS was out of reach for many people, Adobe designed Elements specifically for amateur photographers and hobbyists— although businesses use it too.

Removing this big cat from its cage is a cinch in Photoshop Elements. You can select any part of an image and move or remove it, change a background, transform the focus of a shot, and blur and sharpen at will. Here, the background has been changed and blurred, getting rid of the cage mesh. Also, the colors and tones of the shot have been adjusted and the image has been cropped to enhance the composition.

Introduction continued

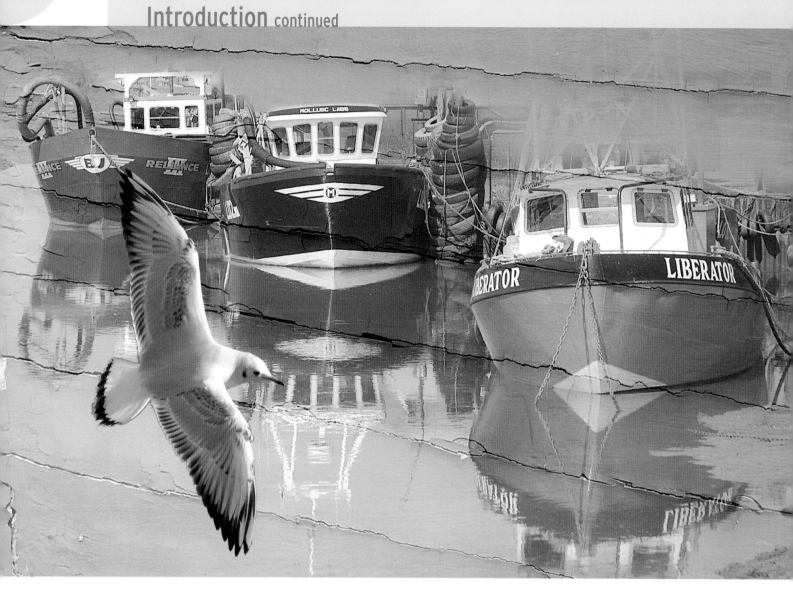

Photoshop Elements can create complex montages, where images or parts of images are layered and blended together to create stunning new composite shots. You have complete control over how the different elements interact with each other. See how three simple photos—fishing boats in a harbor, a seagull, and distressed wooden slats—build into one dynamic whole. This is only a basic example of what Photoshop Elements can do.

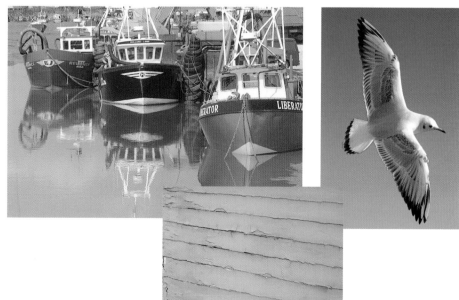

Adobe removed many of the complex parts of Photoshop CS that amateurs would never use and replaced them with more convenient tools to allow us to learn quickly and carry out the tasks we want more easily. Because it is a fraction of the cost of Photoshop CS, it would be easy to assume that Elements is lacking somewhere. Flick through the pages of this book, however, and you will soon see that the program provides you with all the tools you need to improve your images.

Elements is a powerful image-editing tool. Apart from using it to make corrections to pictures to improve them, for example, you can create new images from scratch by combining two or more images in a montage. You can also use the tools of Photoshop Elements to bring out your creative side by adding filter and artistic effects to your pictures.

One word of warning: both digital photography and Photoshop Elements can be highly addictive pastimes, and it may be three weeks before you leave your computer after starting to read this book. It is a fascinating hobby, and you need just a little learning to get the best from it. So, stock your fridge and join us on this digital journey of discovery.

Photoshop Elements has inherited Photoshop's vast range of effects filters. Using these, you can recreate the effects of natural artistic media, such as oil paint, watercolors or charcoal, add artificial lighting to a scene, add strange new colors or textures, and much, much more. Filters can be combined and faded on demand, and thanks to Elements' instant Undo, you are free to experiment to your heart's content.

getting started

This book is not intended as a technical manual. Instead, it introduces you to the tools and processes of Photoshop Elements through practical examples and tutorials. By following these, you can learn tricks and techniques that you can apply to your own images to get great results. Photoshop Elements prides itself on its ease of use, but there are still some things you should know before you delve any deeper into its tools and features. This section outlines the basics: the core concepts of digital images; how to get them from your camera and into Elements; and how to use the program's interface. Read on and you will learn everything you need to start creating great pictures of your own.

Importing Images from a Digital Camera

There are many digital cameras on the market, and many ways in which they store images. Generally, they connect to your computer using a standard USB connection, using the cable supplied by the manufacturer. You should have no trouble downloading your images in this way, but you should always check and follow the instructions given with your equipment; in some cases, you may need to install some software from the camera manufacturer to enable the download process to work.

Downloading images directly from your camera is fine, but it may mean using up battery power. To avoid that, you will need to hook up your camera via the mains supply. Another popular way to achieve the same end is via a card reader: an inexpensive device that attaches to your computer via a USB connection. Card readers can be purchased that read any type of storage card, or even several types.

Once connected, you simply remove your storage card from the camera and place it in the slot on the card reader. Your images can then be downloaded easily—Windows or Mac OS will treat the storage card as it would a CD-ROM or any other storage device. Battery power is not required. Windows XP users will find that the operating system recognizes the storage card as it is placed into the card reader, notices that the card is packed with digital images, then asks what it should do with the files.

Resolution—pixels, megapixels, and ppi

Throughout this book we will be referring to pixels and resolution. These are important for one reason: when you are working on an image in Elements, it makes little difference whether you are working on an image from a 2-megapixel camera or a 6-megapixel camera. When it comes to printing it out, however, size really does matter.

The smallest unit of a digital image is the pixel: one square dot with its own color and brightness values. Any image has a physical size measured in pixels—e.g. 1,600 x 1,200, or 1,600 pixels wide by 1,200 pixels high. In digital photography, we need to qualify that by saying how many of those pixels are visible in an inch of paper or screen surface. Computer monitors are designed to display images at a resolution of either 72 or 96 pixels per inch (ppi), but a printed image is less forgiving. When we print out a photo, we want the image to print out at a resolution of 300ppi for true photo quality, or at least 150ppi for a convincing effect.

TIP

Check that the software supplied with your camera is suitable for your operating system, i.e. Windows 98, Windows ME, Windows XP. If not, you may find that an up-to-date version of the software needed will be available on the camera manufacturer's website.

The average 2-megapixel digital camera can create an image of 1,600 x 1,200 pixels in high-quality mode. If we printed this out at 300ppi the print would be 5.33 inches wide by 4 inches high, and while we could print it larger there would be some drop in quality. The average 5-megapixel camera gives you more options: it can create an image large enough to print out at 8.54 inches wide by 6.4 inches high at 300ppi. Basically, a higher resolution image can be printed out at larger sizes without losing definition or gaining a jagged appearence. Alternatively, you can crop in on part of an image and blow it up, then still get a good-looking printed result.

◄ *A storage card reader gives you quick and easy access to your digital photographs. As well as saving you from having to plug your camera into your computer, it also doesn't waste your camera's battery. Storage card readers are available for every card format, and some can cope with more than one: this model can read CompactFlash, SmartMedia, MultiMedia Card, and SD Memory Card formats.*

> For this shot, taken with a 3-megapixel camera, the original 8.9MB file would fit a space 30 inches by 20 inches at a resolution of 72ppi. If printed at 300ppi it would cover approximately 7 by 5 inches. Had the same image been taken by a camera with a lower pixel count, the resolution, and therefore the quality of the image, could be retained, but the size on screen would be reduced to 15 by 10 inches. If printed at 7 x 5 inches, the resolution would drop to 150ppi and quality would be reduced.

Why does resolution matter?

If you're confused by resolution, think about the images used in billboard advertisements. We see them everywhere—large, colorful, dynamic and apparently sharp. Walk up close to the billboard, however, and you will see that they are not so sharp—in fact, the images are made up of lots of dots.

Let's assume that the billboard we are looking at is 20 foot by 10 foot and that 6 million dots have been used to create that dynamic poster. What would happen if we removed 3 million of those dots? The poster would lose quality, because fewer dots would be spread across that 20 by 10 foot area. To retain the same quality, we would have to reduce the size of the hoarding so that the remaining 3 million pixels continued to give us the same sharp image.

The same principle works when you print out digital photos. Both a 4-megapixel camera and a 2-megapixel camera can take an image which you could print out at 8 by 10 inches. The difference is that the 4-megapixel shot would contain enough information to print out at a resolution of 240ppi—which would be good photo quality if we consider 300dpi as the ideal. The 2-megapixel shot only contains enough information to print out at 150ppi. It will still look acceptable, but the shot will not have the same level of fine detail or definition.

Importing Images From a Scanner

Just a few years ago, the only practical method for getting images onto the computer was via a flatbed scanner. They were large and expensive, but did an excellent job. These days they can be bought for very reasonable prices, and have evolved to a state where high-quality results are obtainable from a compact desktop model.

A flatbed scanner is a welcome addition to the digital photographer's armory. It will not be long before family and friends discover your digital skills and you are asked to restore an old family photograph or remove some intrusive object from a valued picture.

Many of the scanners now available come with a film scanning hood that allows negatives and slides to be scanned as well as prints. If you have yet to purchase a flatbed scanner and you have negatives to scan, this is something worth considering. Of course, dedicated slide and negative scanners are also available.

When you use your scanner you will see that you have several choices to make about scanning resolution. These can be a bit baffling, especially when you compare the 72ppi resolution images that you see from your digital camera to the choices you have in your scanning software, where 2,700ppi and higher settings are available.

These very high resolutions exist so that you can scan small images such as a postage stamp or a color slide or negative and still get a decent-sized print from the original scan. As you increase the size of the image using Photoshop Elements, the dots that make up the resolution have to stretch over a wider area. However, if the scan resolution is high to start with, you can get away with enlarging the image without any great loss of quality.

If you are scanning a letter-sized photograph and choose a resolution of 2,700ppi, the resulting file size will be enormous. If you are intending to make a bigger print than letter size from a letter-sized scan, that may be the option you choose, but your computer would need the power to handle the file sizes. For a letter-sized finished print from a letter-sized scan, it is unlikely that you would need a scanning resolution of anything more than 300ppi. So, for small objects, push up the resolution and for larger ones reduce it.

◄ *A good standard letter-sized flatbed scanner, such as this Epson Perfection 2400 Photo, is a wise investment for the digital photographer with a backlog of 35mm negatives and prints. With a 2,400dpi optical resolution and a built-in transparency adaptor, it can cope with prints and slides.*

If in doubt, it is far better to scan at a higher resolution than you need and reduce the file size later using the *Image Size* palette in Elements.

This same advice is also valid for film and negative scanners. Due to the small size of a negative or slide, scanning resolutions of 2,700ppi become useful as they enable you to print at letter-size size or larger.

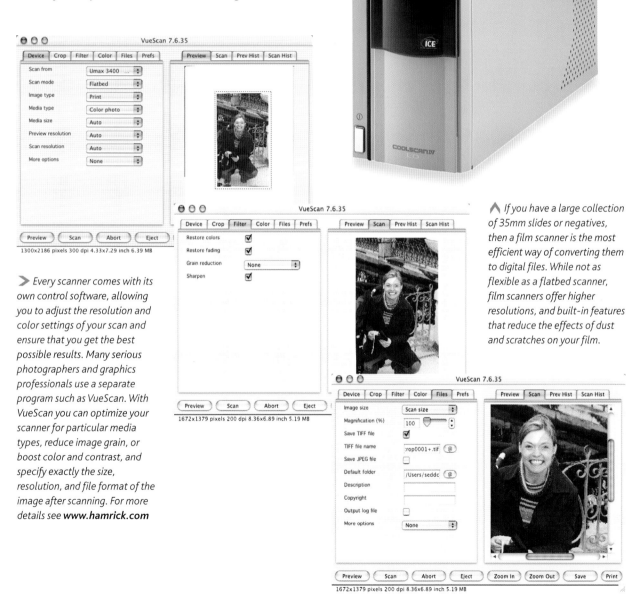

⋀ *If you have a large collection of 35mm slides or negatives, then a film scanner is the most efficient way of converting them to digital files. While not as flexible as a flatbed scanner, film scanners offer higher resolutions, and built-in features that reduce the effects of dust and scratches on your film.*

❯ *Every scanner comes with its own control software, allowing you to adjust the resolution and color settings of your scan and ensure that you get the best possible results. Many serious photographers and graphics professionals use a separate program such as VueScan. With VueScan you can optimize your scanner for particular media types, reduce image grain, or boost color and contrast, and specify exactly the size, resolution, and file format of the image after scanning. For more details see www.hamrick.com*

FLATBED GLASS

LIGHT SPILLAGE

RESOLUTION CHOICE

VIDEO CLIPS

GRAB FRAME

Scanning Real Objects

Flatbed scanners are not only good for scanning flat subjects like a photograph or pages of a book; they can also scan real objects, such as the sea urchin shown below.

When you are scanning real objects, you need to select something that does not have too much depth and lay it carefully onto the flatbed glass. This sea urchin was about one inch in diameter. Be careful not to scratch the glass surface of your flatbed scanner, or this single scan could work out very expensive. You can close the lid of the scanner on the subject, but obviously it will not fully close on a solid object. Close the flatbed lid carefully as far as it will go. There might be some light spillage around the edges

of the scanned subject, which shows up as a colored halo around the image. However, you are likely to be scanning the object for use in another picture for which the background is going to be removed anyway.

Alternatively, rather than closing the flatbed lid onto your object, try to find some black cloth or other material to lay over the subject during the scan.

Use the same resolution choices as described on pages 14–15. If the subject is small, use a higher scanning resolution; if it is big, reduce the scanning resolution. Whatever resolution you use, the file sizes should not be so big that your computer has difficulty handling them.

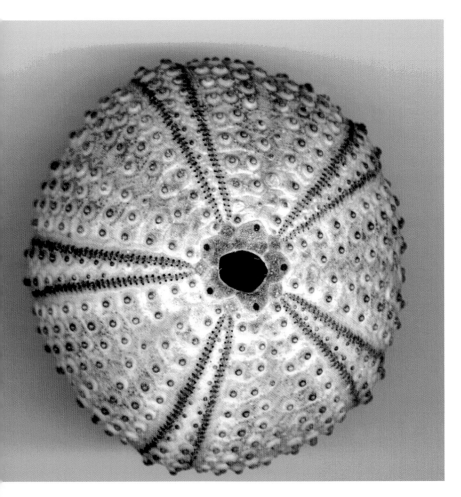

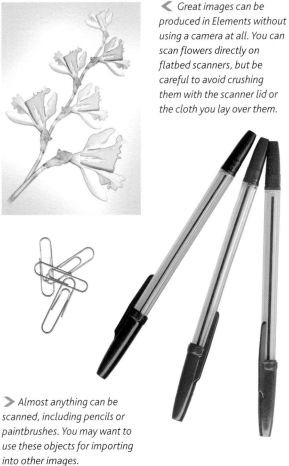

‹ *Great images can be produced in Elements without using a camera at all. You can scan flowers directly on flatbed scanners, but be careful to avoid crushing them with the scanner lid or the cloth you lay over them.*

› *Almost anything can be scanned, including pencils or paintbrushes. You may want to use these objects for importing into other images.*

Importing Frames from Video

If you have a digital video camera, you can also incorporate still frames from your movies into your Photoshop Elements work. While you can't expect the same resolution or detail that you would get from a standard digital camera, it is another source of imagery to use. Elements has its own tool to help you import this material.

1

I You need to import your video onto the PC. To do this, refer to your camera manufacturer's instructions. Once you have a sample of your video footage imported onto your PC, go to the *Menu Bar* and select *File > Import > Frame From Video*.

Click the *Browse* button, locate the video footage on the PC and doubleclick the file name. Your video will appear in the *Frame From Video* palette.

2 You can use the standard video controls to play back the video clip or you can use the slider bar to find the frame you want to grab quickly. Pause the video, hit the *Grab Frame* button, and the grabbed frame will appear in a separate window. You can then save that file to your hard disk.

Be aware that the quality of these images will vary between different video cameras due to the file sizes they record.

It is not necessary to stop the video while grabbing a frame. If you require a series of grabbed frames from a moving video, continue to click the *Grab Frame* button as the video runs. Elements will grab as many frames as you wish.

2

3

3 Click the *Done* button when your video-grabbing session is complete and save the images.

The Elements Work Area

work area

TOOLBAR

SELECTION TOOLS

MENU BAR

SHORTCUT BAR

OPTIONS BAR

Let's look at the Elements work area in a little more detail. Most parts of the Elements interface can be set to "float" anywhere on screen, but by default you should find the *Toolbar* on the left, the *Options Bar*, *Shortcut Bar*, and *Menu Bar* at the top of the screen, and the *Palette Bin* on the right. For the moment, we'll just cover where to find the tools and various options. We'll cover what they do, and how you to use them, as we go further into the book.

The Toolbar

The Toolbar houses the three types of tools that are available. The functional tools are used to manipulate and change images. They include the Crop tool, for cropping pictures to the size and shape you want; Painting tools to add pixels, effects, and other changes; the Type tool; and various Shape tools.

Other tools do not change images in themselves, but are used in conjunction with others to make changes. The selection tools fall into this category; you use them to prepare the way for another, more functional, tool. The selection tools are some of the most important groups of tools on the Toolbar.

Photoshop Elements offers many different tools to make selections, which indicates their importance to digital photography. If you want to edit a particular part of an image without affecting other areas of an image, you make a selection of that part first. The edge of the selection looks like a moving dotted line and is often referred to as "marching ants."

There are also some tools that just affect the environment you are working in. These include tools such as the Move tool, the Hand tool, the Zoom tool, and the Eye Dropper tool.

As you look at the Toolbar, you will see that some tools have a small black triangle icon in the bottom right corner of the main icon. Click and hold on this icon and other options will roll out for you to select from.

Individual tools will be explained as they arise in the tutorials throughout this book, but let's jump to the bottom of the Toolbar to look at the Color Picker. You can select the foreground color by clicking the foreground square and the background by clicking the background square.

The Color Picker palette that opens up when you click either square allows you to select any color or shade of color and transfer that to the Color Picker on the Toolbar.

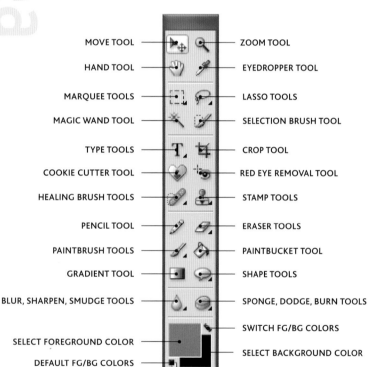

MOVE TOOL · ZOOM TOOL
HAND TOOL · EYEDROPPER TOOL
MARQUEE TOOLS · LASSO TOOLS
MAGIC WAND TOOL · SELECTION BRUSH TOOL
TYPE TOOLS · CROP TOOL
COOKIE CUTTER TOOL · RED EYE REMOVAL TOOL
HEALING BRUSH TOOLS · STAMP TOOLS
PENCIL TOOL · ERASER TOOLS
PAINTBRUSH TOOLS · PAINTBUCKET TOOL
GRADIENT TOOL · SHAPE TOOLS
BLUR, SHARPEN, SMUDGE TOOLS · SPONGE, DODGE, BURN TOOLS
· SWITCH FG/BG COLORS
SELECT FOREGROUND COLOR · SELECT BACKGROUND COLOR
DEFAULT FG/BG COLORS ·

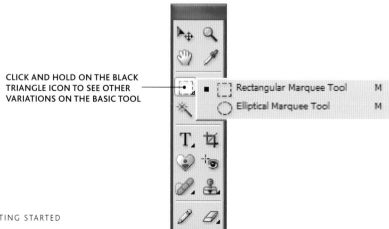

CLICK AND HOLD ON THE BLACK TRIANGLE ICON TO SEE OTHER VARIATIONS ON THE BASIC TOOL

Rectangular Marquee Tool · M
Elliptical Marquee Tool · M

MARCHING ANTS

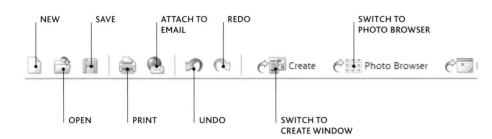

NEW SAVE ATTACH TO REDO SWITCH TO
 EMAIL PHOTO BROWSER

OPEN PRINT UNDO SWITCH TO
 CREATE WINDOW

The Menu Bar

The Menu Bar *at the very top of the screen is now pretty standard and much the same as many other software packages. You will get details of where and how to access these areas and tools as you proceed through the tutorials.*

SWITCH TO SWITCH TO SWITCH TO
DATE VIEW QUICK FIX STANDARD
 MODE EDIT MODE

The Shortcut Bar

The Shortcut Bar *is another standard feature in modern software, appearing in word processors, spreadsheets, and paint packages. If you hold the cursor over any of the Shortcut icons, the name of the tool will be displayed as a* Tool Tip, *which is a reminder of what the shortcut links to.*

The Options Bar

The Toolbar *options will change to reflect any tool you select from the Toolbar. It is worth taking a look at some of the options that appear in the Options Bar as you select a tool.*

That said, in a lot of manipulations, the default settings of many tools work pretty well. So, if in doubt, try the default setting first before making any alterations.

This is the Options Bar *for the Marquee tool. As you might expect, the options on the bar differ wildly from tool to tool, so hover over the button and use* Tool Tips *to work out anything you don't understand.*

The Elements environment will soon become familiar to you as you work through the tutorials and processes covered in the later chapters of this book. Bear in mind that the Photoshop Elements interface is very similar in most respects to the professional version of Photoshop. Should you ever move up to Photoshop CS you won't have to learn from scratch.

RECTANGULAR
MARQUEE

ELLIPTICAL SET FEATHER CHOOSE NORMAL OR
MARQUEE SIZE FIXED MARQUEE

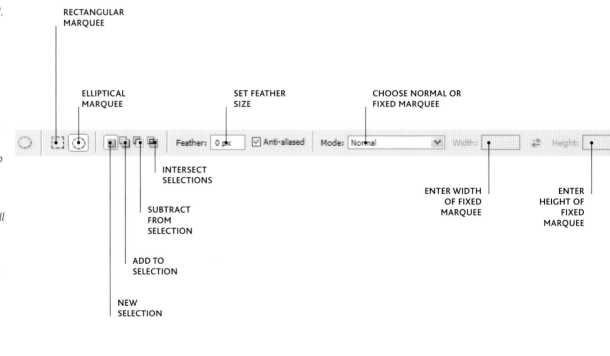

INTERSECT
SELECTIONS

SUBTRACT ENTER WIDTH ENTER
FROM OF FIXED HEIGHT OF
SELECTION MARQUEE FIXED
 MARQUEE

ADD TO
SELECTION

NEW
SELECTION

The Elements Work Area continued

PALETTE BIN

UNDO HISTORY

LAYERS

BLEND MODES

ADJUSTMENT LAYERS

The Palette Bin

The Palette Bin, *found along the right-hand side of the screen, is an essential part of the Elements work area. It contains the* How To, Styles and Effects, Layers, *and* Undo History *palettes, all of which we'll be looking at in more detail later.*

Click and drag the tabs in the Palette Well *and you can drag any of the palettes out onto your desktop, which can be useful if you need to access one often as you work. On PCs click the small red button at the top right of the palette (or the small red button at the top left on Macs) and they snap back into the* Palette Bin.

Elements has always made it easy to browse your images, and with Elements 3 (for PC only) Adobe have taken it a stage further. Now featuring a series of organizing tools, such as Photo Browser *and* Photo Review, *Elements makes it easy to find, review, catalog and make instant collections of your favorite images.*

If you're a Mac user, Elements still features the powerful File Browser, which you can access from the Menu Bar *via* Window > **File Browser**, *or* File > **Browse Folders**.

The file browser will show each of your images as a thumbnail; doubleclicking the thumbnail will open the file into Elements. A single click will highlight the thumbnail, showing you a bigger version in the viewing panel bottom left.

If your images were taken with a digital camera, the technical details will appear in the extreme bottom left panel.

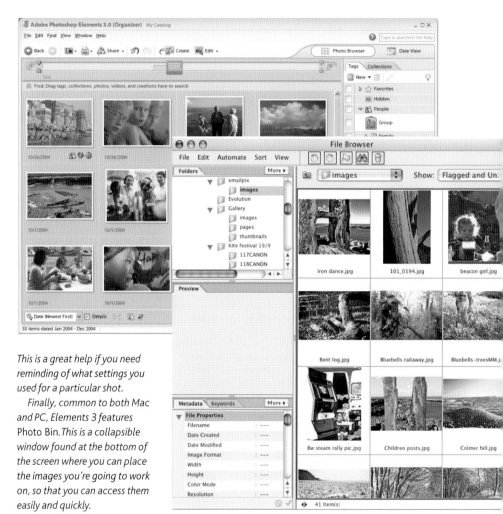

This is a great help if you need reminding of what settings you used for a particular shot.

Finally, common to both Mac and PC, Elements 3 features Photo Bin. *This is a collapsible window found at the bottom of the screen where you can place the images you're going to work on, so that you can access them easily and quickly.*

Undo History

Another palette from the Palette Bin *that we will need from time to time is the* Undo History *palette. If we open an image on screen and click the* Undo History, *we will see that the palette has already recorded the* Open *command.*

As we carry out each task such as cropping and cloning, each stage will be recorded in the Undo History. *It records the last 20 commands by default, but we can adjust that upward or downward in* Preferences. *If we make an error while carrying out our manipulations we can jump back to any of these 20 stages using this palette.*

The Undo History palette can be dragged out or dropped back in the Palette Bin *just like any other palette.*

The Layers Palette

One of the most important tabs in the Palette Bin and one that we will visit often is the Layers palette. Click the Layers triangle and the palette will roll down from its holding position. We can also click the Layers tab and drag the palette out onto our desktop if that is more convenient. To replace it just click and drag the tab back into the Palette Well or tick the Close Palette to Palette Well option via the More button. Hit the red cross (PC) or the red button (Mac) and the palette will return to the Palette Well.

What are layers? Think of them as sheets of clear plastic that you can lay over your photo. You can copy parts of the photo, or another photo, to one of those sheets and move them around. Alternatively, imagine that you could use one of those sheets as a filter, to improve the contrast or adjust the brightness of all or part of your image. Best of all, if you make a change to your image on one of those sheets, and regret

the change later on, you can just get rid of the sheet and go back to the image as it was.

In fact, layers are a little more complicated than that. Layers have options for Opacity, so that you can make any changes made on the layer or any picture elements on it more or less transparent. You can also use the Blend Mode option to change how the layer interacts with those below it. We'll demonstrate some useful tricks using Opacity and blend modes later on in the book.

The Layers palette will show a thumbnail of the image we have on screen. You might also see a small padlock to the right, which indicates whether the layer is locked—the background layer will be by default. While a layer is locked, some options, such as making the layer transparent, are not available. To remove the lock on the background layer, doubleclick the thumbnail and type a new name in the New Layer dialog that appears.

We can have as many layers as we can cope with and each layer can be dragged up or down the stack. This may be important to ensure we have one object behind another to achieve a certain effect in the final image.

To the left of the thumbnail we have a small paintbrush symbol that tells us which layer we have selected for editing, and to the left of that there is a small eye that allows us to turn off the layer so that it temporarily becomes invisible on screen.

At the top left of the palette you will find a drop-down menu with a number of blend modes. These affect how a layer interacts with the layers below it. We will see how this becomes useful in many of the tutorials later on in the book.

All the options we find by clicking the more button, we will also find duplicated in the layers section of the Menu Bar.

The three icons located at the top of the Layers palette include the Trashcan where we can drag and drop unwanted layers, the Create New Layer icon, and the Create Adjustment Layer icon.

This section covers how to put right some of the more common faults in images using simple changes via Elements' *Quick Fix* options. Although you can spend hours creating all sorts of way-out and creative images using Photoshop Elements, you still need to make certain adjustments to the pictures beforehand. Many of those changes are pretty standard, and you will find that you constantly revisit the more common tools. Photoshop Elements groups most of these tools together in one place, under the *Quick Fix* palette. Some of these tools create subtle changes, others bring about more dramatic effects.

making your photographs look good

Quick Fix Tools

Usually in life we can have little faith in those who offer us a quick fix, such as curing baldness with a miracle lotion, or losing weight as you sleep with a wonder cure. However, Elements' *Quick Fix* options might restore your optimism: this is one quick fix that actually works!

No matter how you get your images onto the computer, there are almost always some slight corrections you will need to make to your pictures, usually affecting the color or tonal values, increasing the sharpness, or rotating or flipping the image. This is true of scanned images as well as images from digital cameras. The *Quick Fix* mode in Photoshop Elements allows you to address those faults quickly and easily from just one palette. Some of these options are demonstrated in the next few tutorials.

What makes an image appealing apart from its subject matter is the tonal range of the image, the contrast, and the colour balance. Elements' *Quick Fix* palette allows us to address all of these from one place.

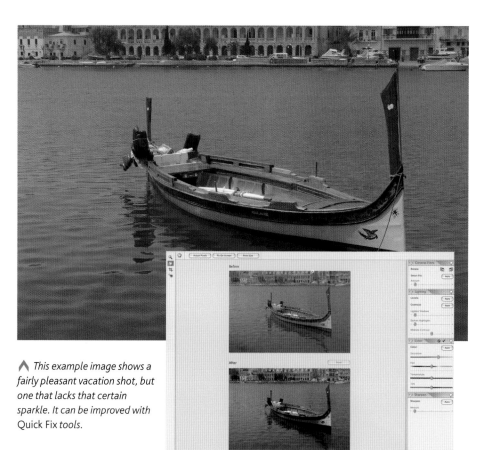

∧ This example image shows a fairly pleasant vacation shot, but one that lacks that certain sparkle. It can be improved with Quick Fix *tools.*

∨ *Elements brings up all your choices for a quick fix in one handy window and shows you a before and after thumbnail before you commit to any changes. From the* Quick Fix *panel select the* Lighting *palette and click the* Auto *button next to* Contrast; *the* After *thumbnail reflects the changes about to be made. The result can be slight or significant, depending on the tonal range of your original image. If the tonal range is already good, Elements has little to fix. However, you often don't appreciate how flat the tonal range of an image is until you have the "before" and "after" images to compare. If you think that the contrast can still be improved, you can manually adjust your image by using the* Lighten Shadows, Darken Highlights, *and* Midtone Contrast *sliders.*

Type a question for help

Quick Fix Standard Edit

◀ *The* Quick Fix *window can be accessed easily by clicking the icon from the Shortcut bar.*

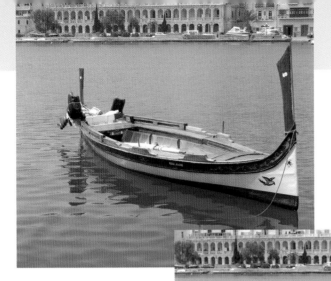

∧ Click the check mark icon if you want to commit the quick fix to the image. If you change your mind afterward, select the Undo *button from the* Shortcut bar, *or click the* Reset *button located between the before and after images.*

≪ *If you click the* Auto Levels *button, the thumbnail will reflect the changes about to be made. You can see from the example image that applying* Levels *has created a much bluer and more cool-looking image, especially when compared with the warm tones of the* Auto Contrast *option.*

∨ *Click the* Auto *button in the* Color *palette and you will see that the color has been subtly changed to create a better, more lifelike result.*

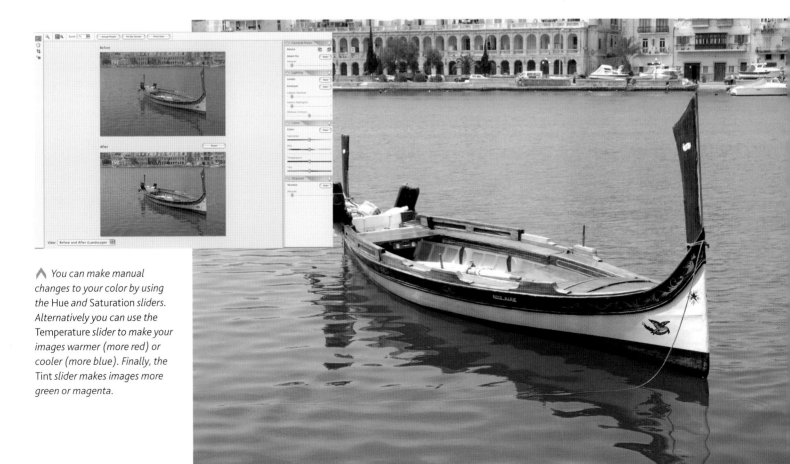

∧ *You can make manual changes to your color by using the* Hue *and* Saturation *sliders. Alternatively you can use the* Temperature *slider to make your images warmer (more red) or cooler (more blue). Finally, the* Tint *slider makes images more green or magenta.*

Quick Fix Tools continued

∧ *In* Quick Fix *mode you can also sharpen an image. To see the effect of this sharpening, you should first enlarge your image using the* Zoom *tool from the top right of the* Quick Fix *window. First click on the Auto button in the* Sharpen *palette. If you still think your image needs sharpening, move the sharpen slider gradually to the right.*

> ∧ *In* Quick Fix *mode adjusting the "temperature" of your photos couldn't be easier. In the* Color *window, the same window you used to alter* Hue *and* Saturation, *you'll find a slider called* Temperature. *Moving the slider to the right makes the image more blue, suggesting cold, and moving the slider to the right increases red and adds warmth to your images, as shown here.*

⋀ Also in the Color window is a Tint slider, which can be used effectively to alter the overall tint of a black and white image.

⋀ When you shoot digital images in portrait mode they often appear on their side when you first see them opened on screen. The Rotate function in Quick Fix will automatically turn them for you.

Cropping

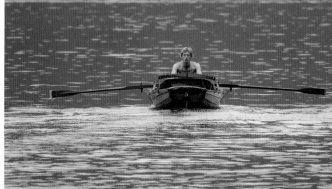

Why do you need to crop your images at all? Usually, you will be cropping either to remove unwanted detail, such as a person half in and half out of the frame, or to create a better composition than was possible to achieve when the photograph was taken.

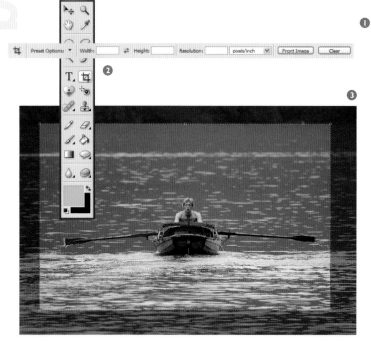

Cropping to improve a composition

1 This is a good example of an image that can be improved with a crop. We do not need all the detail above and below the rower and it can be safely removed.

2 As you select the *Crop* tool from the *Toolbar*, a number of options appear at the top of the screen. If you are just doing a basic crop you can ignore them completely.

3 Drag out the crop shape onto the picture space and don't worry about getting the crop selection right first time. Elements shields the area to be cropped to enable you to evaluate your crop more easily.

4 You can left-click and drag any of the toggles that appear around the edge of the bounding box and drag out the shape and adjust it till you get it just right. Once you have your crop selected, you can complete the task by hitting the *Enter* key, by clicking the tick at the right end of the *Options Bar* or by selecting another tool from the *Toolbar*.

Preset Options: ▼ Width: 8 in ⇄ Height: 6 in Resolution: 72 pixels/inch ▼ Front Image Clear

∧ You can also crop to a target size and resolution. This is useful, for example, when preparing several images of the same size for a website.

In this example, the image size started out at 10 by 8 inches at 200ppi. If you want an 8 by 6-inch image at 72ppi, you can input that size onto the Options Bar after selecting the Crop tool.

> You can drag out a shape that selects almost the entire image or just a small part of it. Whatever portion you select, the resulting image would still be 8 by 6 inches at 72ppi. In the example above, I selected just a small part of the image from the top right corner of the shot and Elements resized it to fit.

∧ It is best to avoid increasing size or resolution from the original image if you can avoid it. While Elements would carry out this task, it can only increase the resolution by interpolating pixels. What you gain in size from the process, you will lose in definition and detail. As a rule of thumb, an image can be reduced in quality for e-mail or Web use, but a low-quality image should not be increased in size to create a much bigger print.

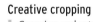

Creative cropping

❶ Cropping and rotating can be used creatively to improve a picture. This example image has some impact already, but the vulture sits too square in the picture space.

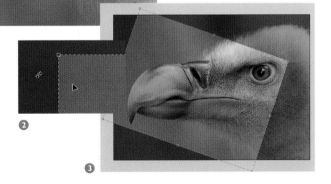

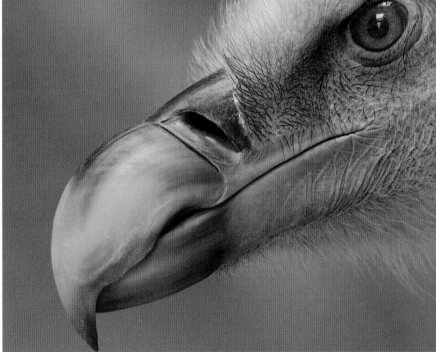

❷ Select the *Crop* tool from the *Toolbar* and drag out a crop shape over the bird's head. If you move the cursor outside of the bounding box it changes to linked arrows.

❸ Elements is telling you that with a click and drag you can now rotate the crop shape. Rotate the crop until the eye is up near the top right corner of the square crop shape and the beak points down to the bottom left corner.

❹ Don't worry if you have to crop slightly outside of your image at the corners—you can always repair those with the *Clone* tool later. With the cursor inside the bounding box, you can also click and drag the whole shape, so this one tool allows you to perform the whole procedure.

Sloping Horizons

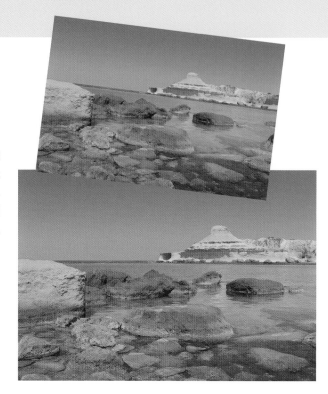

When you use a flatbed scanner to scan an image it can be difficult to get the image completely straight on the flatbed glass. This means that the resulting scan will not be straight. Similarly, it's just as easy to take skewed shots with a digital camera as it is with an traditional 35mm SLR. Elements can fix it, either way.

> *Photoshop Elements has a command that not only straightens the image, but crops away the unwanted white areas around the outside of the scan. From the* Menu Bar, *select* Image > Rotate > **Straighten and Crop Image** *and Elements does the rest for you.*

①

②

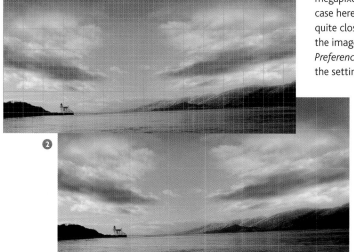

Rotating the horizon

1 A sloping horizon is often the result of not holding the camera level at the shooting stage. To correct a sloping horizon, you can use a grid as a guide to ensure that the horizon ends up straight.

2 From the *Menu Bar*, select *View > **Grid*** and Elements will apply a grid to the image. If you are working on a 3-megapixel image, as was the case here, the gridlines will be quite close together, cluttering the image. You can go to *Edit > Preferences > **Grid*** and change the settings to space them out.

3 Increase the gridline setting so that the spacing is much easier to see and from the drop-down menu select a bright color such as yellow. From the *Menu Bar* select *Image > Rotate > **Custom*** and you can type in an angle, rotating the image by any degree either right or left. I found that about 1.7 degrees was perfect for this image.

This process straightens the horizon, but you then need to crop away the corners that have been exposed during the turning process.

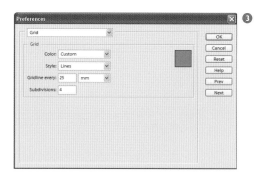
③

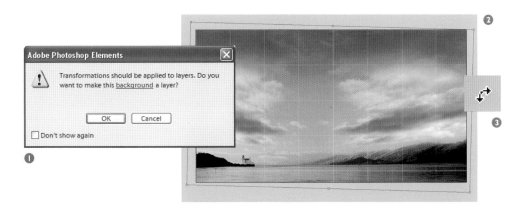

Transforming the horizon

1 Here is an alternative method of straightening the horizon. Select *Image > Transform > **Free Transform.*** If you are working on the background layer, Photoshop Elements realizes that what you are asking is not yet possible. To rotate your image with the *Transform* tools, you must first convert the background image into a layer. You can do that manually, but the software is coming to your aid here, and displays a message for us.

2 Allow Elements to assist you and click *OK* and *OK* again from the *New Layer* box. Elements has now placed a bounding box around the entire image. If you move your pointer outside of this box beyond the edge of the image, it will change to a linked arrow.

3 Click and drag to rotate the image and level up the horizon. This option does exactly the same job as the first, but you can now deal with those corners at the same time and in a slightly different way.

Hold down the Shift key and move your pointer to a corner toggle. Drag out the toggles of each corner so that the image fills the spaces left by the rotation. Hit *Enter* or click the tick box on the *Options Bar* to complete the transformation.

4 Because you have previously changed your image from the default background to a layer, you should select *Flatten* from the *Layer* menu before saving. You also need to go to *View > **Grid*** and the grid will be removed and the job completed. This process is fine for small changes, but any larger transformations that increase your images should be avoided.

Adjusting Contrast

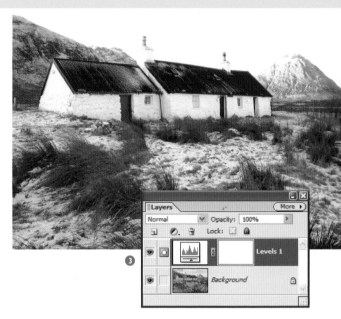

When you make adjustments to an image via the *Levels* command, it may greatly improve the foreground, but be far too much for the sky, which becomes pale and lacking in detail. You may feel caught between a rock and a hard place: if you get one part of the image right, another part will look worse. One solution is to make a selection of each part and manipulate each one separately using different settings. Another way, which allows you more flexibility, is to use the *Adjustment Layer* tools.

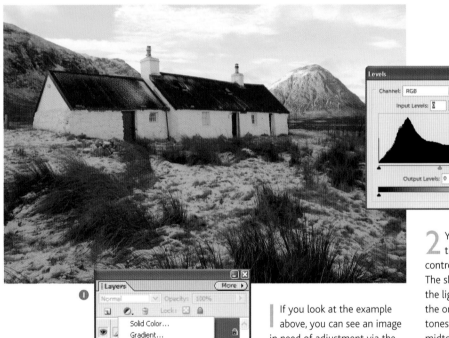

I If you look at the example above, you can see an image in need of adjustment via the *Levels* command. Rather than use the auto settings in *Quick Fix*, you can take a more hands-on approach by selecting the *Layers* palette from the *Palette Bin*. You can then click the *Adjustment Layer* icon at the bottom left of the *Layers* palette and select *Levels* from the options that appear.

2 You can adjust the levels in the image using the slider controls in the *Levels* palette. The slider on the right controls the lighter tones in the image; the one on the left darker tones; and the middle one the midtones. You can adjust the tones manually using the sliders with the RGB channel selected, or you can select the color channels separately from the drop-down menu, then adjust the levels for each one. The last method can be more effective if, for example, you wish to retain the warm tones of a sunset.

3 Another way to adjust the tones in subjects like this, where the snow has caused a blue cast, is to click the *Eye Dropper* tool on the right of the *Levels* palette. Look carefully at the image and click down again within the picture space somewhere on the snow. The place you choose should be the lightest tone you can find that retains detail. You can do the same with the other *Eye Dropper* icons and click in the darkest tone with detail or a midtone, but the lighter tone options seem to work better.

Get this selection right and the image will be transformed; click *OK* if the result looks right. If it doesn't, hold down the Alt key and the *Cancel* button will change to a *Reset* button; you can then choose another place to select from. Click the *Layers* tab from the *Palette Well* to see your adjustment layer.

You will also see that your manipulations have destroyed all the detail in the sky in this example, but all is not lost. This is where the adjustment layer comes into play.

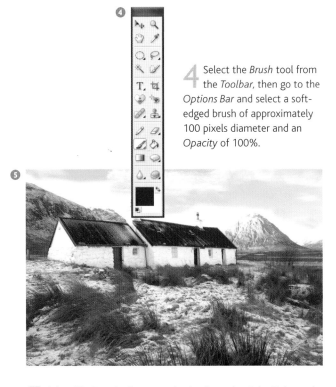

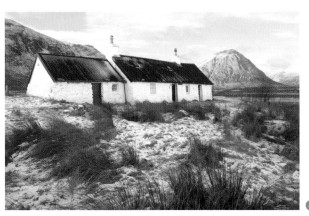

4 Select the *Brush* tool from the *Toolbar,* then go to the *Options Bar* and select a soft-edged brush of approximately 100 pixels diameter and an *Opacity* of 100%.

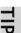

5 Select black as the foreground color from the *Color Picker* and spray along the top edge of the sky. You will see that you are able to bring back the depth of tone from the original sky. This is because the adjustment layer has not permanently changed any of the pixels in the image. The adjustment layer allows you to mask the sky selectively to reveal the original tones.

6 One asset of the adjustment layer is that if you make a mistake you can switch to white as the foreground color and repair the error. You can even save the image as a Photoshop file and return to the adjustment layer days later if you wish.

TIP

Vary the brush size and the opacity as you work, particularly where the sky meets the hills.

7 If you wanted to darken the sky still further, you could apply yet another adjustment layer, darken just the sky tones, and then mask the remainder of the picture. Flatten the image from the *Menu Bar* via *Layers* > **Flatten** to amalgamate the adjustment layer with the image to complete the manipulation.

Adjusting Exposure

If you are using a digital camera with an LCD screen, which gives you a preview of your images as you take them, under- and overexposure should be a rare occurrence. However, it does happen and you need to know how to deal with it as effectively as possible. Of course, the best option is to get the exposure right at the taking stage, but tricky lighting conditions can fool the light meters in our cameras from time to time.

There are several ways of dealing with exposure problems, but Photoshop Elements can guide you if you select the *How To* recipe palette from the *Palette Bin*.

Fixing underexposure

Open an underexposed image and open the *How To* palette. Click on *Fixing Your Photos* and then select *Lightening dark areas of a photo*.

The recipe will tell you exactly how to proceed and will carry out some of the tasks for you if you wish. Click and drag your *Layers* palette from the *Palette Bin* onto your desktop so you can observe what Elements is doing as you go through the process. As the *Layers* palette is now visible on screen, you can ignore step 1 in the recipe—it only opens the *Layers* palette for you.

2 A duplicate layer can be created manually from the *Menu Bar* via *Layer > Duplicate Layer*, or by dragging the thumbnail of your image up the layers stack and dropping it over the left icon of the three on the top bar.

❷

3 From the drop-down blend modes, choose *Screen,* and you will notice a great improvement. You can fine-tune this process by reducing the *Opacity* in the *Layers* palette.

❸

❶

Following the recipe

You can make a duplicate layer of your underexposed image. using the manual method shown above. However, click Do This Step For Me *in step 1 of the recipe and Elements will open up the* Shadows/Highlights *dialog window. From here Elements will automatically make the adjustment, but if you're not happy with it, you can fine-tune manually.*

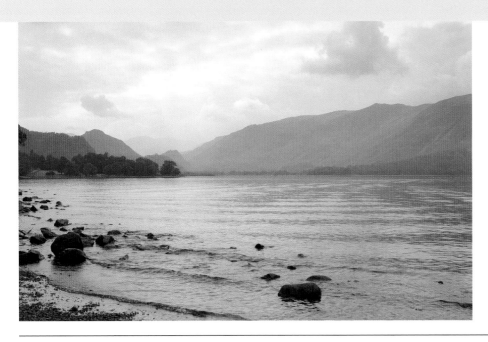

4 The results can be very good, but visit the *Quick Fix* tools for final adjustments and sharpening.

Fixing overexposure

You can use the same recipe to correct overexposure, but remember that no process can bring back detail that is not in the original image.

❶

❷

2 Make your layer copy as you did with the underexposure example, but this time use *Multiply* from the drop-down blend modes and the *Opacity* slider to make any final adjustments.

ADJUSTING EXPOSURE

Adjusting Colors

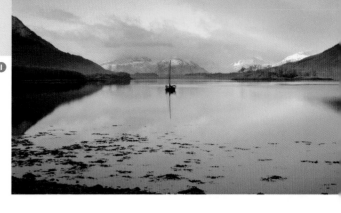

Photoshop Elements has provided us with a simple way to change the color in an image via the *Color Variations* palette, which is a little like the *Quick Fix* option. You can globally change the color or change selected areas if you make a selection first. See page 164 for some more details on how to go about this.

Color Variations is probably best applied to average key images where you are not looking to correct precise color, but where you want to affect the mood of an image. This example image fits into that category, where changes in precise color are not the object of the exercise.

2 The *Color Variations* command is found via *Enhance > Adjust Color > Color Variations*. It's a very visual palette with a before and after thumbnail for you to monitor the effect of any changes you input. It is also rather like the *Quick Fix* options in that you can decide to accept the changes or not via the *OK* or *Undo* buttons before committing them to the image.

3 The amount of blue added is decided by the *Adjust Color Intensity* slider at the bottom left of the *Variations* palette. By default it is set midway along the slider bar.

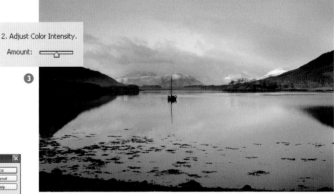

4 With the example image on screen and without any changes to the default options in this palette you can click the button to *Increase Blue*. You will see that the *Color Variations* tool will add blue tone to the image and display the result in the *After* box.

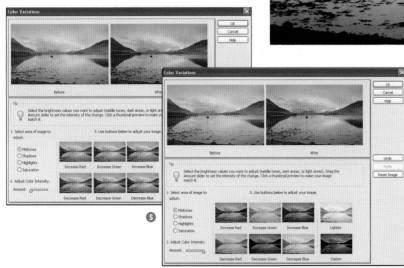

5 Every time you click a thumbnail, Elements will add or subtract that color depending on what you have chosen. If the change is too great and you want a more subtle color, reduce the intensity with the *Color Intensity* slider before applying changes.

The *Color Intensity* slider has six settings from a mild adjustment to a stronger intensity of color. In both these examples, the image has had just one click of red added, but from either end of the *Color Intensity* scale.

6

Tinting with Color Variations

This Color Variations *palette can also be used to add color to a monochrome image. In this monochrome example, I set the options to* Midtone *and with the intensity slider set midway, I increased the red by one click, decreased the blue by one click and added one click of the* Darken *button.*

6 At any stage of your color experiments, you can reset your image back to its starting point by clicking the *Undo* button or by clicking the *Before* thumbnail.

If you reduce the *Color Intensity* slider to about one-third value and hit the *Increase Blue* thumbnail again, you will see that the effect is far more subtle.

You can also affect other color changes by selecting *Midtones*, *Highlights*, or *Shadows* from the other option choices.

It is also possible to click more than one thumbnail to add multiples of color. With just a few clicks of those thumbnails, you can change the mood of your images quite significantly.

Emphasizing Color

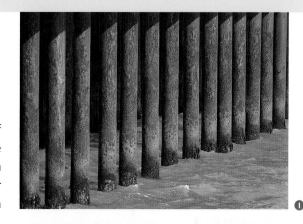

Many of your images can be improved in a variety of ways, and that is the main concern of this book. One of those ways is to enhance the color, but do so only when the image demands it. If you overdo your increases in color saturation or use it on the wrong subject, your images can look unappealing and false.

Color manipulation can be fun, and here we'll explore two ways of emphasizing color that can create a dynamic image. The *Hue/Saturation* palette can be used for most images if they require only subtle changes in color, while there is a technique using the *Color* blend mode that works well where a more forceful effect is required.

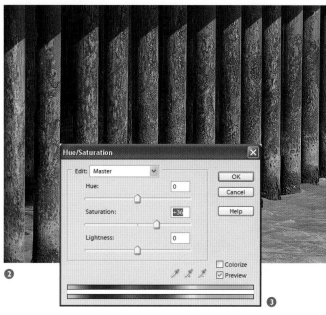

Increasing saturation

1 This example image is crying out for an injection of color to bring out the impact of the rusty legs of the pier.

2 The simplest way to achieve this is by selecting *Enhance > Adjust Color > Adjust Hue/Saturation* from the *Menu Bar* at the top of the screen.

3 Move the *Saturation* slider gently to the right to squeeze as much color into the subject as you can.

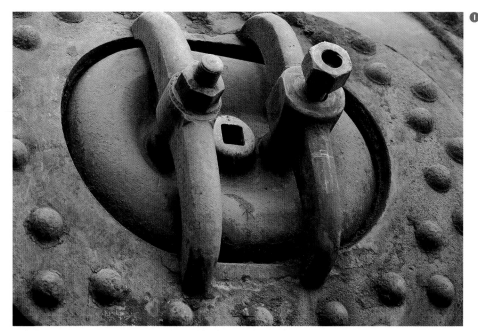

Using the Color blend mode

1 If we really want to push the color saturation high for a particular reason, we can use another technique as we have with this close-up shot of a traction engine.

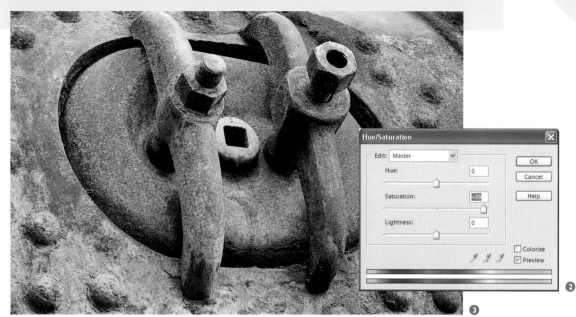

2 You need a duplicate layer for this technique. Select *Layer > **Duplicate Layer*** from the *Menu Bar* and click *OK* from the *Duplicate Layer* box. Select the *Hue and Saturation* palette again and this time use the shortcut Ctrl+U to bring up the palette. Move the *Saturation* slider most of the way to the right to inject some serious color into the subject.

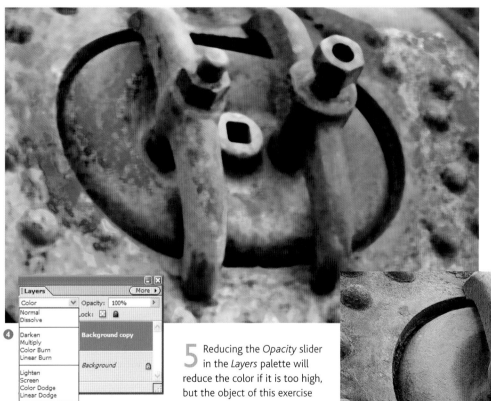

3 This process also introduces some unwanted side effects, such as a heavy pixel effect. This is unattractive, but can be fixed.

4 From the *Menu Bar* select *Filters > Noise > **Median*** and add about a 10 pixel *Radius*, just enough to smooth out those unattractive speckles. Click the *Layers* tab from the *Palette Bin* and from the drop-down blend modes select *Color*. Elements will blend the color layer with the original and you get the best of both worlds.

5 Reducing the *Opacity* slider in the *Layers* palette will reduce the color if it is too high, but the object of this exercise was to deliberately overemphasize the color.

To continue any further manipulations with an image like this, such as darkening the outer edges, select *Layer > **Flatten*** from the *Menu Bar* to flatten both layers together.

Removing a Color Cast

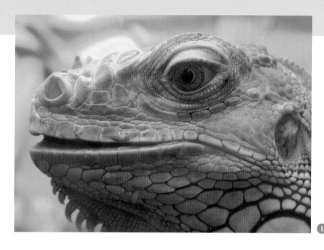

Cameras, whether they are digital or film, are calibrated for color so that they give the best color results at noon daylight. If you shoot late in the day or early morning, the color balance is much warmer and it is this effect that produces those lovely warm sunset colors.

While this color change works in our favor, sometimes it can do the exact opposite when shooting under fluorescent or tungsten light with your digital camera set for cloudy or bright conditions.

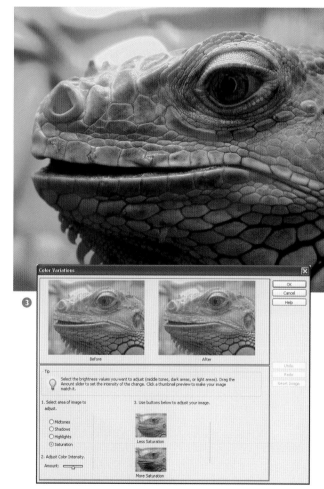

In this example, the image had to be grabbed while the animal was close enough for a dramatic shot, but it was shot under fluorescent light and the result has an all-over green cast. You can remove such casts or at least greatly improve them using Photoshop Elements. You are unlikely to be able to make a one-click global change, but rather a series of small changes.

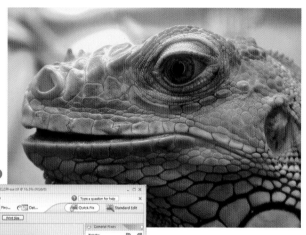

2 Click the *Quick Fix* icon from the *Shortcut Bar* and in the *Color* window click *Auto* and you will see a considerable change in the color. Click *OK* to accept the change or experiment with other *Quick Fix* options.

3 Select *Color Variations* from *Enhance > Adjust Color* and from the options select *Saturation*. You can click the *More Saturation* option to add some instant color back into the iguana.

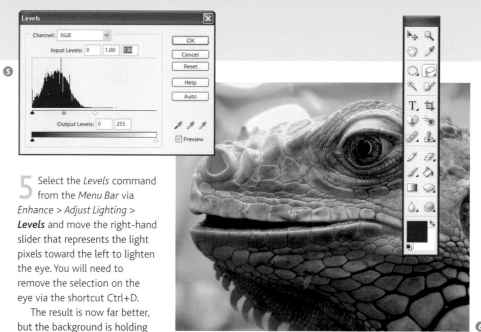

4 The iguana's eye needs some attention too; it needs to be lightened a little. You can do that by selecting the *Freehand Lasso* tool from the *Toolbar* and making a selection of just the eye. From the *Menu Bar*, choose *Select > Feather* and add about 3 pixels of feather to the selection line. This will ensure that your changes are unseen.

5 Select the *Levels* command from the *Menu Bar* via *Enhance > Adjust Lighting > Levels* and move the right-hand slider that represents the light pixels toward the left to lighten the eye. You will need to remove the selection on the eye via the shortcut Ctrl+D.

The result is now far better, but the background is holding the impact of the image back.

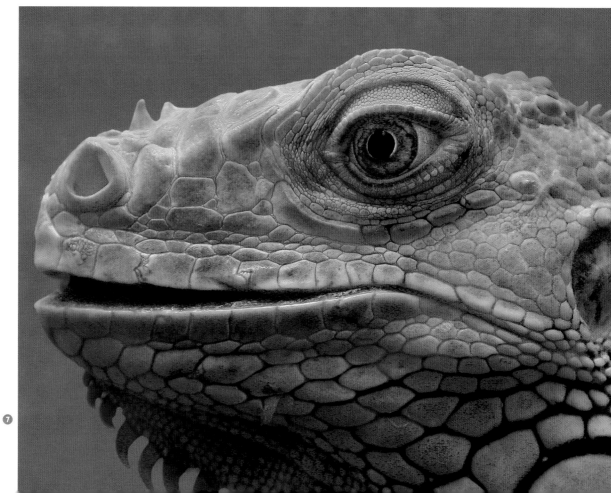

6 Make a selection around the outside edge of the iguana and feather the selection by 2-3 pixels. Using the *Clone* tool and with the image greatly enlarged, you can carefully clone around the background to tidy up those light distracting areas.

You need to remove some of the color from the background, which you can do with the *Sponge* tool. Select the *Sponge* tool from the *Toolbar* and from the *Options Bar* select a mode of *Desaturate* and a *Flow* of around 50%.

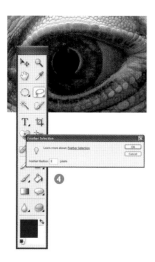

7 Gradually remove the green color from the background so that the color does not overpower the image. How far you take this is a personal choice, but the result can only be an improvement.

Removing Red Eye

Red eye can turn even the sweetest child into a demon, long before their teenage years. The problem occurs when light from an on-camera flash reflects off the blood vessels at the back of the subject's eyes. Despite the best efforts of camera manufacturers to eliminate it, it remains a common fault in portrait shots.

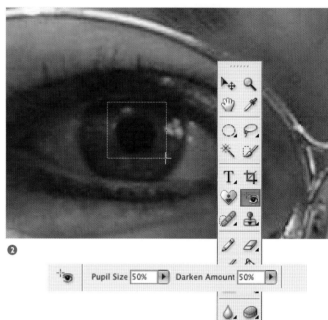

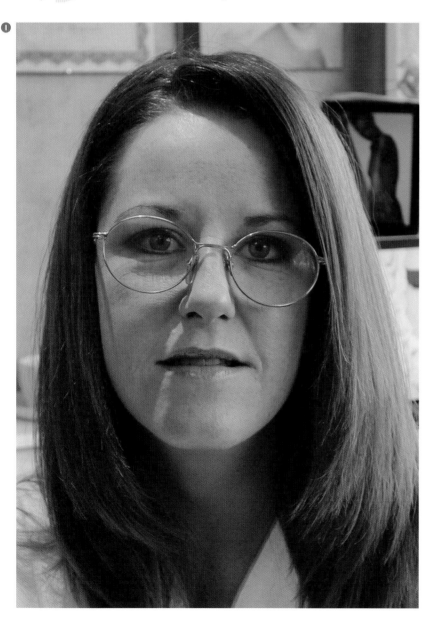

In fact, red eye is so common that Elements has a tool specifically designed to deal with it: the *Red Eye Removal* tool. It's one of the easiest and most effective tools in the program. There are only two options that come up on the *Options Bar* when the tool is selected, and if you work through this process step by step you will see how simple it is to use.

2 Using the *Zoom* tool from the *Toolbar*, enlarge the eyes in the image so that they fill the screen. The *Red Eye Removal* tool is far easier to apply with the image enlarged and you will also be able to evaluate your work better.

Select the *Red Eye Removal* tool from the *Toolbar*, and leave the *Pupil Size* and *Darken Amount* at 50% in the *Options Bar*. As you move over the image, you'll see a cross. Move the cross to the offending pupil and when at the edge click and drag a box over the red area.

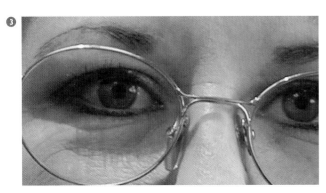

3 As soon as you release the mouse button the *Red Eye Removal* tool instantly corrects the red eye. However, in this case there is still a bit of red eye visible and this where the *Options Bar* comes in.

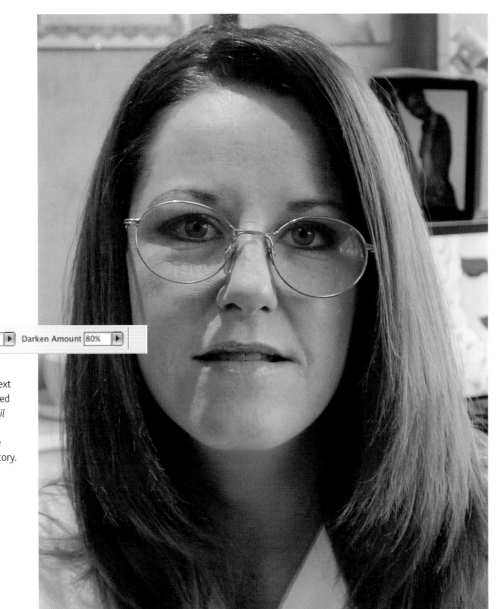

Pupil Size `80%` ▶ Darken Amount `80%` ▶

4 To ensure that on the next pass we pick up all the red eye, we've increased the *Pupil Size* and *Darken Amount* percentages to 80%, and the result is much more satisfactory.

Sharpening

One of the most misunderstood tools in Photoshop Elements is the *Unsharp Mask* (USM) from the *Filters* menu. The name of the tool alone can be misleading—it doesn't "unsharpen" anything, but is named after a traditional photographic technique used to sharpen edges.

This is one of those tools where a little technical information will help you to understand it better. The sharpening tools work by increasing the levels of contrast between adjacent pixels. Although there are other sharpness tools in the *Filter* menu, the *Unsharp Mask* tool affords the most control.

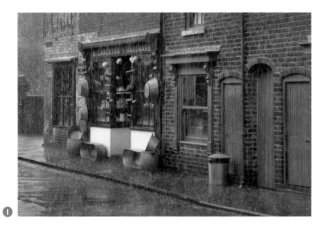

❶

I This example picture was taken in the pouring rain using a 6-megapixel digital camera. The first task is to enlarge the image using the *Zoom* tool. This allows you to see the effect of the sharpening as you apply the tool.

This enlargement can be an important point because the *Unsharp Mask* tool can be overdone. The consequence is a visible deterioration of the image quality. You need to squeeze as much *Unsharp Mask* into your images as you can without introducing the negative effects of the tool.

2 From the *Menu Bar* select *Filters > Sharpen > Unsharp Mask.* Elements will bring up the *Unsharp Mask* palette, with a preview window and three control sliders.

3 Drag the *Amount* slider to about 150-200% to determine how much to increase the contrast. This amount is generally the recommended standard setting.

Drag the *Radius* slider to the right or type in a value in the box provided. For high-resolution images of around 5-6 million pixels use a setting of 1-2. For lower-resolution shots (around 3 million pixels) a lower radius may be necessary.

The *Threshold* slider determines how different pixels must be from the surrounding area before they are considered edge pixels. In practice, low values produce a good result.

TIP

Once you have applied your settings, click the preview box in the USM *palette on and off while looking at the main image on screen to see the before and after effect. This will help you to appreciate not only the positive aspects of the* USM *tool, but also the negative ones that creep in if you increase the radius too far.*

❷

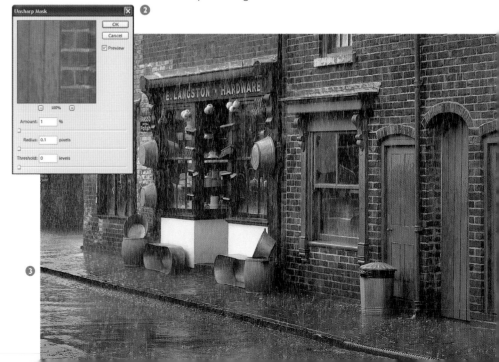

❸

❮ Although it is vital to use the USM tool carefully, in the right circumstances it can totally transform some images.

⌄ With animal subjects, the fur can often stand far more sharpening than the smoother tones of a background. In those circumstances, you can make a selection of what you wish to sharpen and add a few pixels of Feather. Apply the sharpening tool only to the main subject.

❯ This works particularly well on images that have a blurred background: the sort of background you may get when photographing an animal from a distance using the zoom lens. In these cases, you can get the maximum sharpening of the fur without affecting the smooth tones of the background.

photo retouching
techniques

By now you should be familiar
with the basic tools that
Photoshop Elements offers to fix
common photographic faults. But
Elements has more up its sleeve
than that. With the aid of some
more advanced features, you can
interactively retouch your photos,
removing ugly marks or scratches,
introducing new effects or
tweaking areas of color and tone
to add impact to the composition.
This chapter also reveals how you
can use Elements to bring old
photos back to life.

Removing Small Blemishes

From time to time you will need to remove small marks and blemishes that appear on your pictures. With some digital SLR cameras that have removable lenses you can get the odd speck of dust inside the camera, which may result in a small, out-of-focus shadow on the picture.

However, more often than not the small blemishes you need to remove are not camera faults at all, but man-made objects in the landscape that reduce the appeal of the picture. Discarded litter, TV aerials, and other unwanted clutter can spoil your images. Sometimes it is not possible to appreciate how badly these affect your shot until you get rid of these ugly distractions and compare the before and after images.

This type of work is often referred to as "gardening" in photographic circles. To do your "gardening," you need an appropriate tool, and the main tool for this type of work is the Clone Stamp *from the* Toolbar. *The* Clone *tool, as it's usually called, is probably one of the most well used within any version of Photoshop or Photoshop Elements. If you look at the* Options Bar *along the top of the screen, you will see that this tool has many options. The only option you need to concern yourself with at this stage is the brush size.*

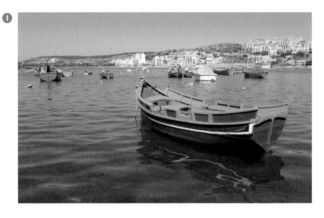

❶

This example image looks pretty good, but look again at all the clutter in the water. To save money, local fisherman have used plastic bottles as floats to tie up their boats and these rather spoil the charm of the picture. While the white bottles may be less evident at small print sizes or on screen, they would certainly be evident at foolscap size.

❷

2 Select the *Zoom* tool from the *Toolbar* and enlarge the image to about 200%. At this level of enlargement you can deal with each of these distractions more effectively.

Select the *Clone Stamp* tool and choose your brush size. This will depend on the size of the blemish you wish to deal with. Try to select a brush size that is similar in size to the blemish if possible. Make sure you select a soft-edged brush so your cloned pixels blend into the picture well. You need to ensure that your work is undetectable.

TIP

Use the [and] keys to the right of the P key on your keyboard to scroll up and down the brush sizes. This saves you continually having to go to the Options Bar *to change brush size.*

3 You can use the *Clone* tool to remove the blemishes and also remove the cranes up on the skyline to the right. How much "gardening" you do is a personal choice, but attention to detail is what makes some images stand out from the rest. In this example, I decided to remove a boat or two as well.

❸

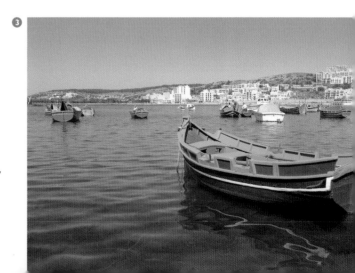

4 Hold down the Alt key and the clone cursor will change to a sample cursor. If you left-click over a part of the image, an area of color and texture the same size as your brush will be sampled. Thought needs to be given to where you sample from, so that you paint in the right tone and texture.

In this example, the correct place is just to the left or right of the white plastic bottles in line with the waves on the water. Left-click to make the sample and then release the Alt key and move over the edge of a plastic bottle. Left-click again and the pixels you sampled will be painted over the plastic bottle, concealing it.

Try to use separate clicks rather than a painting stroke. If you use a painting stroke, you may introduce an odd effect that looks like snakeskin. This is caused when you sample an

area sampled already. The sampled pixels are repeated in a pattern that soon becomes easily visible. Release the left mouse and change the sample point often and this effect will be minimized, making your work practically undetectable.

TIP

With the picture enlarged, hold down the space bar and the cursor will change to the Hand *tool. Left-click and drag while holding the space bar and you can move your enlarged image along to the next blemish. This is a great way to navigate around an enlarged picture.*

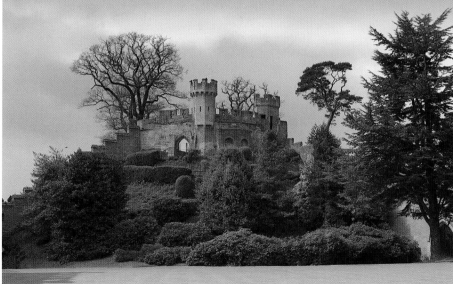

< ∧ *This technique can be used on a wide variety of images and subjects. In this image of a castle, the distractions are either man-made objects or people, but they can all be removed using the* Clone *tool.*

Removing Scratches and Dirt

One of the great advantages of digital photography is the fact that images from a digital camera are usually so clean. You get none of the problems that you can experience with film, such as scratches on the negative, dust scanned in with the print, or watermarks from the original processing. Once you start scanning in your best predigital efforts, however, all these problems soon come flooding back. If you want to retain and restore the best of your old photographs, you still need to find a way to remove these ugly blemishes.

When there are only a few marks on a picture, you can usually deal with them using the *Clone* tool, but sometimes a photo is too dirty to make that process worthwhile. As tempting as it is to give up and throw a problem image away, an irreplaceable family photo is not easily discarded. Instead, you can salvage that treasured photo with another Elements tool: the *Dust and Scratches* filter.

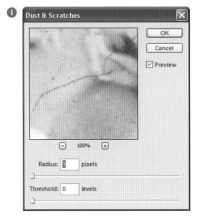

Any collection of scanned 35mm prints, slides, or negatives will show a few examples where dust, dirt, processing, or careless handling have taken their toll. This example is in awful condition, which makes it perfect for our tutorial.

Cleaning up the marks and scratches is a simple process, but there are downsides to it. Any filter that removes several scratches in a single pass will do so at the cost of sharpness. Whether the remedy assists the situation or makes matters worse depends on the image and its problems, but as the cleaning process is such a quick one, little is lost by trying and evaluating the result. It is not until you look at an image enlarged at 100% that you can see what you are up against.

Go to the *Menu Bar* and select *Filter > Noise > Dust and Scratches* and Elements will present you with the options dialog for the filter. Keep the image enlarged in the preview window, so that you can see the effect of the filter as you adjust the options. Click and drag the thumbnail in the preview window if you need to see another part of the image.

In this example, the marks are so widespread that you should apply the filter to the whole image. If only a portion is affected, select that area using the *Marquee* or *Lasso* tools before applying the filter.

Start the process by sliding the *Threshold* slider left to 0. The *Threshold* setting determines how sensitive the filter is to the marks on the image. Move it above 0 to limit the filter's effects if it is over-softening the image.

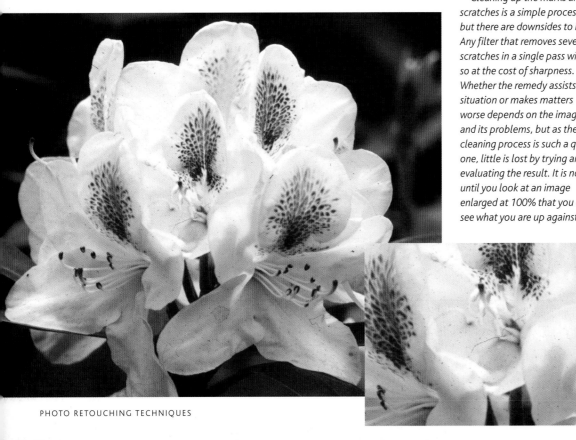

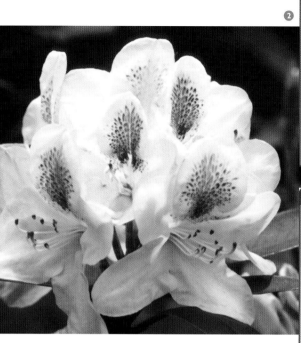

2 Drag the *Radius* slider to the right or type in a value into the box and observe the effect of the adjustment.

In this example, a 3-pixel *Radius* helps the situation, but does not entirely deal with all the dirt on the slide. For this shot, you would need to move the *Radius* up to 5 to get an acceptable result.

The final result looks a lot cleaner, but you can see that the filter process has taken some of the sharpness from the image. You can decrease the softening effect by moving the *Threshold* slider to the right. In this case, however, it doesn't assist very much before the scratches start to reappear.

TIP

A good way to evaluate many of the tools in Photoshop Elements is to enter your first choices into the options and click the Preview *checkbox on and off. Jumping between the before and after examples makes it far easier to adjust the settings and get the best results for the image.*

3 If the *Threshold* slider can't help, there is another solution. Go to the *Menu Bar* and select *Filter > Sharpen > **Unsharp Mask***. Keep the *Amount* at 200% and the *Threshold* at 0, but use a 3-pixel *Radius*. This brings back some of the sharpness without undoing the effect of the *Dust and Scratches* filter.

Using this technique has softened the image, but you can easily live with the results. If the image is an important family picture, it's well worth making such a small sacrifice.

Dodging and Burning

The term "burning" comes from a darkroom technique in which more exposure is given to one part of the printing paper to make it darker than the rest.

In the reverse of this technique, "dodging," light is held back from falling on a part of the photographic paper in order to lighten it.

To use these tools effectively there are some options that you need to know about, most importantly the *Range* and *Exposure* settings. Use the first to select which tones the tool works on, and the second to increase or decrease the level of the tool's effect.

2 If you click the *Range* drop-down menu, you will see that you can use these tools on either the highlights, shadows, or midtones within a picture. It is a great benefit to be able to adjust these tones one at a time.

These tools are best used with the *Exposure* set fairly low—around 5% or even lower. Any higher and the effect can be too harsh and obvious. To be effective, changes made with these tools need to be subtle and seamless.

1 To darken an area in an image, as in this example, you first need to enlarge the image using the *Zoom* tool. Then select the *Burn* tool from the *Toolbar* and set the *Range* option to *Highlights* and the *Exposure* to 5%.

You can gradually *Burn* (darken) the tones in the white feathers around the bottom of the picture. If you are using this tool for the first time, you may feel that work is progressing too slowly and be tempted to increase the exposure. You can get away with that sometimes, but a subtle approach usually gets better results.

3 Switch the *Burn* tool to *Shadows* or *Midtones* and you can affect those tones in exactly the same way. You can use the *Burn* tool at the top of the image as well. The process hasn't got rid of the out-of-focus letters in the background completely, but it has reduced their prominence.

❸

TIP

Don't try to use the **Burn** *tool set for* **Highlights** *on areas of a picture where there is no detail at all. The effect is usually just an ugly gray splodge. This tool needs some detail and tone to work with. If you have a problem area with no tone at all, you need to use a different option. Try using the* **Clone** *tool to copy in some detail.*

> *The* Dodge *tool works in exactly the same way, but lightens tones. With this sample image, you will see that even after altering the* Levels, *some areas of the picture could do with lightening. The* Dodge *tool is perfect for this task.*

Select the Dodge *tool from the* Toolbar *and use the same settings as described for the* Burn *tool. Choose a low* Exposure *setting and select* Highlights *as your* Range *choice.*

< *Use these settings carefully to avoid overdoing the dodging effect. This causes the highlights to burn out by removing the detail completely. The effects of the* Dodge *tool are often more subtle than the* Burn *tool; it has been used here to highlight the sparkle on the water.*

DODGING AND BURNING

Soft-focus Effects

Soft-focus has always been a popular addition to portraits, particularly female portraits. In conventional photography the technique required special filters. In Photoshop Elements, however, we can do without the special equipment and emulate the soft-focus style using a combination of layers and filter effects.

> Soft-focus effects used to be created using optical filters, either fitted to the lens when taking the photo or employed in the darkroom afterward. Photoshop Elements can emulate this soft effect. Like the old method, it is typically applied to female portraits.

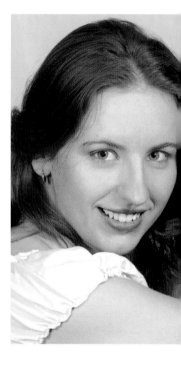

1 Layers are crucial to the creation of the soft-focus look, so begin by selecting the *Layers* palette from the *Palette Bin*. You need to make a duplicate of the background layer by selecting *Layer > Duplicate Layer*.

Alternatively, click and drag the thumbnail up and drop it on the left copy icon at the top of the *Layers* palette. Elements will create the layer copy for you.

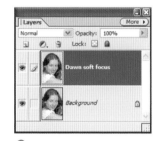

3 Go to the *Layers* palette and click on the *Opacity* slider, then reduce the *Opacity* to about 50%. Different settings suit different images, so reduce or increase the *Opacity* to arrive at an effect that pleases you.

The result of these manipulations is now very pleasant, with a delicate softness that you can tweak further using the *Opacity* slider.

2 Select *Blur > Gaussian Blur* from the *Filters* menu and select a *Radius* of about 10 pixels. This setting will vary depending on the size and content of the image, so experiment with higher and lower *Radius* settings until you get an effective soft-focus look on the skin and the hair. The effect after running the *Blur* filter is not completely flattering, as the filter blurs everything. The next simple step will fix that.

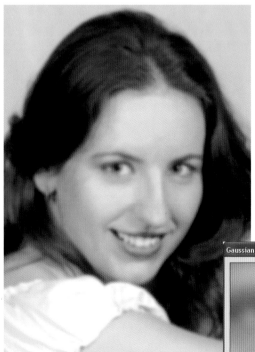

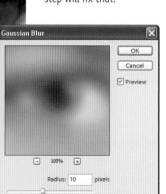

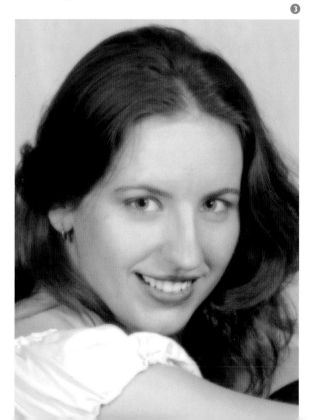

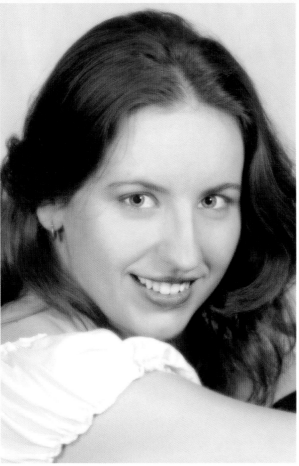

4 The one downside to this technique is that it takes away the sharpness of the eyes. However, you can fix that too if you wish. Enlarge the eyes using the *Zoom* tool from the *Toolbar*, then select the standard *Eraser* tool. Go up to the *Options Bar* and choose an *Opacity* setting of around 10% and a brush size about one-quarter the size of the eye.

Make sure that the upper layer in the *Layers* palette is selected and ready for editing, then erase the eyes from the *Gaussian Blur* layer, working gently to reveal the crisp detail in the layer below.

TIP

Hit the M key on your keyboard and then the number 5 key and Elements will reduce the Opacity of the layer to 50%. Use the 6 key instead and the Opacity becomes 60%; 7 equals 70%; and so on up to for 100% (the 0 key).

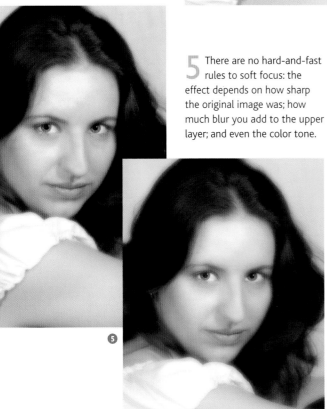

5 There are no hard-and-fast rules to soft focus: the effect depends on how sharp the original image was; how much blur you add to the upper layer; and even the color tone.

> *Soft focus can also be used on animals, but with slightly less* Gaussian Blur *and a lower* Opacity *for the blur layer. This gives a delicate and attractive quality to fur and feathers. As with the portraits, you can also use the* Eraser *to ensure that important parts remain sharp.*

Sharpening and Blurring a Selected Area

There are several ways in which you can affect just one part of an image using the tools of Photoshop Elements. The vast majority of the time you would make a selection of the area you wanted to edit. However, there is an alternative in the shape of the *Blur* and *Sharpen* tools, which are located on the *Toolbar*.

The difference with these tools from those found in the *Filter* menu is that you can apply the effect via a brush and control the strength of the brush from the *Options Bar*. You can apply just the amount of sharpness or blur you require in the precise location you need it.

The *Blur* tool can be useful in portrait images where you may wish to soften some isolated folds or lines in the skin.

> *In this example, the statue does not stand out from the background that well. You can rectify this with the* Blur *and* Sharpen *tools, using them both on the same image.*

As with most of the Brush *tools, you should make your changes with the image greatly enlarged. The first step, therefore, is to enlarge the image to around 200% using the* Zoom *tool.*

Select the Blur *tool from the Toolbar along with a soft-edged brush. The strength setting will vary depending on what you wish to blur and by how much; for this example, I set it quite high. The brush size needs to be small enough not to encroach onto the parts you do not want to blur. You can then carefully blur just one area of the image— in this case, the cut-out shape in the wall behind the statue.*

Now select the Sharpen *tool from the Toolbar and apply it to the statue. This will make the statue stand out even more from the blurred background. Once again, you need the image to be greatly enlarged to enable you to work more easily.*

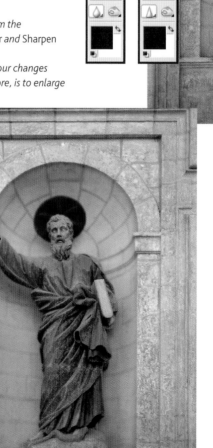

TIP

With the image greatly enlarged, you can move around it by holding down the space bar so the Hand tool appears. You can then click and drag the image along to the next area you wish to manipulate. Release the space bar and the Blur tool will return.

The strength setting for the Sharpen tool is a little more critical than the Blur tool, so start off with a low-strength setting. It is much easier to overdo the Sharpening tool than the Blur tool, and the "blocky" result is quite obvious.

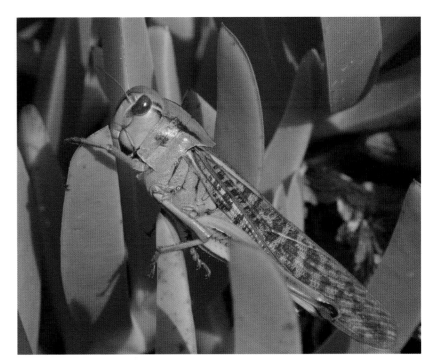

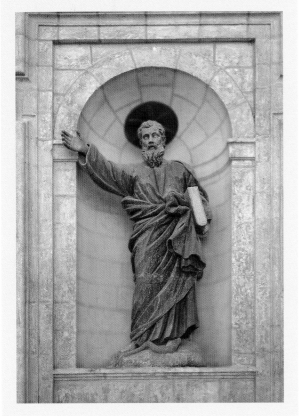

> *Quite often in digital photography you will need to combine tools for a better end result. This was the case with this insect picture. I used the Blur tool to blur the leaves closest to the insect, switching to the Sharpen tool to sharpen just the insect. What also enhanced this image was a selective darkening of the leaves using the Burn tool.*

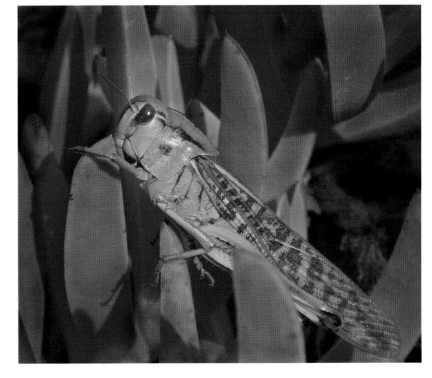

Depth-of-Field Effects

When you take photographs with a telephoto lens or move in toward your subject for some close-up photography, you expect the background of the subject to be blurred. We call this effect depth of field. While it has its downside, it can be used to add a sense of depth to an image or separate a subject from the background.

Mimicking depth of field

1 You can recreate this effect digitally by emphasizing one part of an image. In this shot of the interior of a hot air balloon, you can recreate depth of field by adding *Gaussian Blur* to certain areas.

2 From the *Menu Bar*, select *Layer* > **Duplicate Layer** and then click *OK* in the *Duplicate Layer* dialog that appears on the screen.

Go to the *Menu Bar* again and select *Filter* > *Blur* > *Gaussian Blur* and then add a pixel *Radius* of between 5 and 10 pixels.

3 If you click on the *Layers* palette in the *Palette Bin*, you can see that the original sharp layer is at the bottom of the layers stack and the blurred one above.

Now select the *Eraser* tool from the *Toolbar* and erase the bottom third of that blurred layer and the man who forms the center of interest. This will leave the sharp layer beneath showing through in all the right places. Select *Layer* > **Flatten Image** when complete.

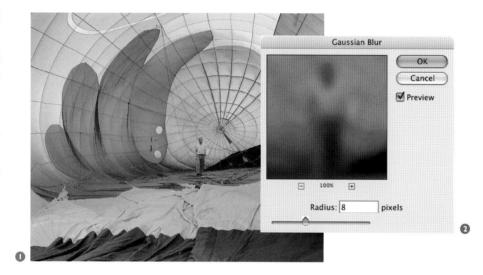

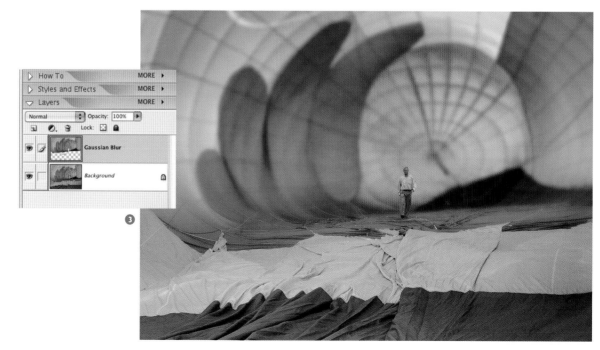

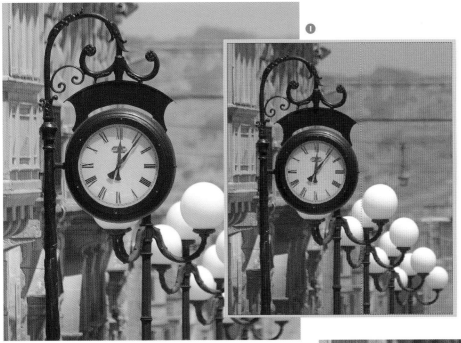

Easy depth of field

From the *Menu Bar* go to *Select* > **Feather** and add a 150 pixel *Radius* to the selection line. From the filters, you can apply the *Gaussian Blur* filter again to complete the effect.

2 In this second example, you can apply *Gaussian Blur* much more easily by selecting the *Rectangular Marquee* tool from the *Toolbar* and making a selection of the right-hand side of the image.

Isolate the subject

Depth of field is determined mainly by the lens, choice of aperture, and the distance from the subject. In most cases, it works in your favor as it isolates the main center of interest against an out-of-focus background. It also makes images more dynamic in the picture space. The example here demonstrates this effect well.

Saturating and Desaturating Color in a Selected Area

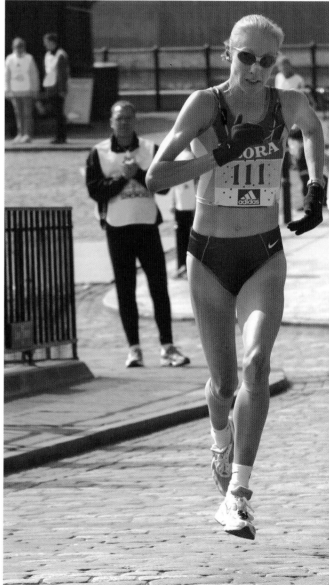

①

Some of your images may need to be improved by introducing extra color into a particular area of the picture or by removing some depth of color from another part. You can use the *Selection* tools for this type of work, or you can use another tool in the Photoshop Elements armory and avoid selections completely.

An alternative tool is the *Sponge* tool, which is found on the *Toolbar*, grouped with the *Dodge* and *Burn* tools. Select the *Sponge* tool and look up to the top of the screen at the *Options Bar*. You will see that there are relatively few options with this tool. Under the *Mode* setting, there are two options: *Saturate* and *Desaturate*. The *Desaturate* option removes color and the *Saturate* option increases color. Rather than affect the whole image or make a selection, you can use a brush to affect just a small area of the picture.

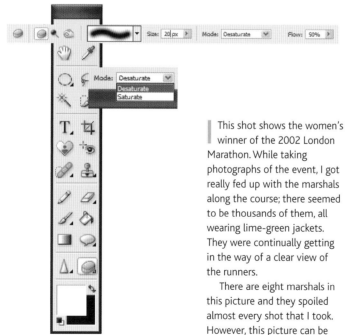

This shot shows the women's winner of the 2002 London Marathon. While taking photographs of the event, I got really fed up with the marshals along the course; there seemed to be thousands of them, all wearing lime-green jackets. They were continually getting in the way of a clear view of the runners.

There are eight marshals in this picture and they spoiled almost every shot that I took. However, this picture can be used to demonstrate how the *Sponge* tool can improve an image. I used it set to the *Desaturate* mode to remove the brightness of the color from the marshals' jackets.

2 Starting with the two figures top left, use the *Zoom* tool to enlarge the image so that the subjects are large enough to work on.

From the options, choose a mode of *Desaturate* and select a soft-edged brush with a diameter of about 40-60 pixels.

Adjust the *Flow* of the tool from the *Options Bar* and vary the brush size depending on what part of the image you are working on. For this particular task the *Flow* can be kept quite high given the bright color of the jackets, so you can start comfortably at 50%.

Gradually desaturate these two green jackets so that they are less intrusive in the picture, then do the same with the rest of the green jackets.

◀ *Increasing the saturation involves the same techniques that you have already used for the desaturating option. With this example, you could in fact employ both tools—one to desaturate the outer parts and the other to saturate the inner parts of the gold plaque.*

From the Options Bar, select the Saturation option to add color to the raised figure on the plaque. You need to work with the image greatly enlarged and adjust your brush size so that you can work comfortably. This tool is quick and easy to use without the need for complicated selections.

3 You could also use the *Burn* tool after desaturating the color of the jackets to darken them down still further.

Fixing Converging Verticals

Pictures from vacation destinations must account for millions of frames a year, be they digital or film. When we go to major places of interest it can sometimes be difficult to find a new angle on popular subjects. With so many great images from around the world filling our newspapers and magazines we can be forgiven for giving up before we start. We don't always have the advantage of that privileged viewpoint or a range of lenses to die for, but all is not lost.

Try looking for something a little different from the norm and you may be surprised with the results. I shot this picture of Sydney Harbour Bridge across the bay toward Sydney Opera House, but chose to shoot through the Harbour Bridge. I had to shoot upward with a wide-angle lens to avoid distracting parked cars, but that then caused the verticals to badly distort in the picture.

The tools of Photoshop Elements come to the rescue. Select *Image > Transform > **Perspective*** to straighten up the converging verticals.

2 With the image on screen, open the *Layers* palette from the *Palette Bin* and change the default background into a layer. You can do this by simply doubleclicking the thumbnail and renaming the layer in the *New Layer* box.

3 From the *Menu Bar*, select *Image > Transform > **Perspective*** and you'll see a bounding box around the image.
Drag the toggle at the top left corner out toward the left and you'll notice the right toggle mirroring your move. Keep going until you see that the verticals are straight.

4 If you switch to *Image > Transform > **Distort*** and click and drag the center toggle at the bottom of the bounding box downward a little, you can get rid of those distracting cars at the same time.

5 Click the tick on the *Options Bar* or hit Enter and Elements will correct the verticals for you.

At the end of the process, you will need to go to the *Menu Bar* and select *Layer > **Flatten Image*** to return the layer to the background.

TIP

With the Distort Transform *tool selected, you can either drag out the toggles left and right separately or hold down the Alt key, the Ctrl key and the Shift key together and the bounding box can be dragged out identically on both sides.*

TIP

You will need room around the image to drag out those toggles and straighten the verticals. If your image fills the monitor, you may need to make the image smaller. There is no need to change to the Zoom tool for this task. Hold down the Alt key and the space bar together and the Minus Zoom *tool appears. Click into the image to reduce the size. Release those keys and the bounding box will still be in place ready for your manipulations.*

◀ ∨ *By using the same techniques on this image, it is possible to drag the bounding box upward to give the castle more height and power as well as fixing the verticals.*

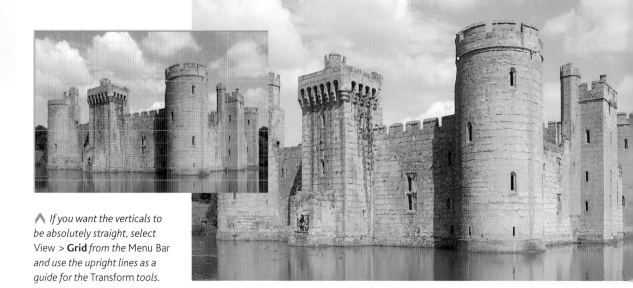

∧ *If you want the verticals to be absolutely straight, select View > **Grid** from the Menu Bar and use the upright lines as a guide for the Transform tools.*

Deliberate Distortion Tricks

Some of the most simple subjects can provide great images, and what more everyday object can you find than a fork? Where do you start to be creative with an image like this? Use the *Distortion* tools that are found in the *Filters* menu and you can add a new twist—literally— to what might seem like a mundane subject.

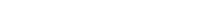

1 The first task with a project is to remove the black background from the fork in order to create a transparency— i.e. to have the fork floating on a transparent background. The similarity of tones in this image makes it difficult to use the automatic selection tools like the *Magic Wand*. Instead, use the *Polygonal Lasso* tool from the *Toolbar*. Working with the image enlarged to about 200-300% makes the selection task easier, so make use of the *Zoom* tool first.

2 To make a selection around the fork, left-click with the *Polygonal Lasso* tool on the edge of the fork and work around the fork in stages, clicking down in short steps. The steps can be longer on the straight edges, but use lots of short lines for the curves. With the image well enlarged this is a fairly easy task.

3 From the *Menu Bar*, choose *Select > Feather* and add a 1 pixel *Feather* to the *Selection*. Then go to *Select > Inverse* to inverse the selection; Elements now selects the black background rather than the fork. Change the background into a layer by doubleclicking the thumbnail from the layers palette and renaming it. Then choose *Edit > Cut* and you have your transparency.

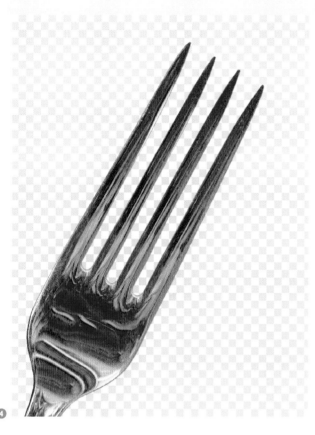

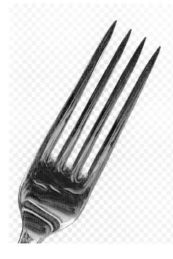

5 At this stage you need to
increase the canvas size;
you can do that from the
Menu Bar. Select *Image >
Resize > **Canvas Size*** and
Anchor the image to the left.
Increase the canvas *Width* by
a few inches.

4 Once you have the fork
transparency we can start
some serious improvements.
The fork is dull, so you need to
go to the *Levels* palette or the
Quick Fix option to apply *Levels*.
Then, in the *Color* palette in
Quick Fix mode, use the
Saturation slider to add some
serious color to the fork.

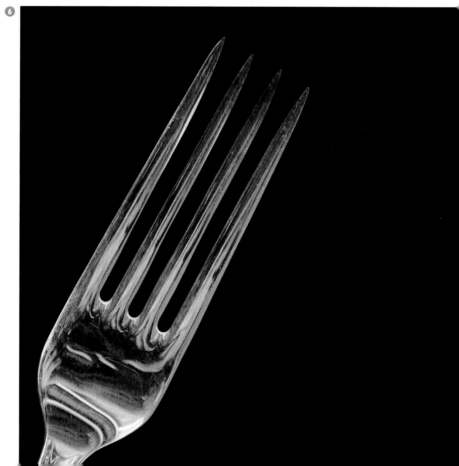

6 From the *Menu Bar* you
now need to create a new
blank layer via *Layer > **New
Layer***. You can select a name
for the layer or just click *OK*.
From within the *Layers* palette,
left-click and drag that new
blank layer beneath the fork
and flood it with black using
the *Paint Bucket* tool from the
Toolbar. This will give you a
better idea of how the image is
coming together than looking
at the tiny blue and white
squares will.

Deliberate Distortion Tricks continued

FREEHAND LASSO

CUT AND PASTE

DISTORT

FREE TRANSFORM

GRADIENT TOOL

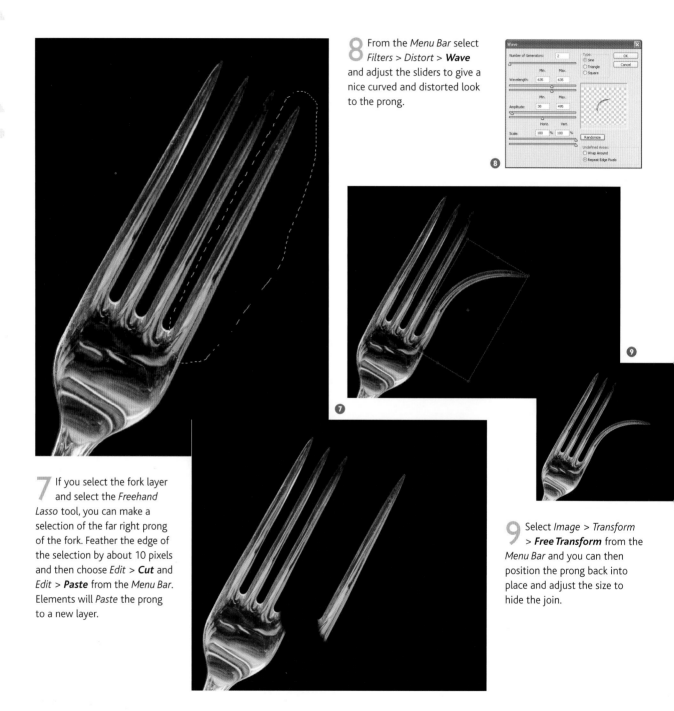

8 From the *Menu Bar* select *Filters > Distort > **Wave*** and adjust the sliders to give a nice curved and distorted look to the prong.

7 If you select the fork layer and select the *Freehand Lasso* tool, you can make a selection of the far right prong of the fork. Feather the edge of the selection by about 10 pixels and then choose *Edit > **Cut*** and *Edit > **Paste*** from the *Menu Bar*. Elements will *Paste* the prong to a new layer.

9 Select *Image > Transform > **Free Transform*** from the *Menu Bar* and you can then position the prong back into place and adjust the size to hide the join.

⑩

⑪

10 Another element is needed to complete the image; what better than the bold color of a tomato? Open the image and prepare it as a transparency in the same way that you did with the original fork. The *Magic Wand* will be able to cope, given the contrast between the tomato and the background.

11 Once you have the tomato prepared, select the *Move* tool from the *Toolbar*, click into the tomato image, and drag and drop it into the fork image to make another layer. Now you can position the tomato anywhere in the frame you wish. With a little work with the *Eraser* tool, you can create the effect of the tomato being pierced by the fork.

⑫

12 Look at the *Layers* palette, and you will see the layers and how this image has been built up. You can create a more dramatic background using the *Gradient* tool to complete the dynamic image.

Removing Unwanted Objects

In the course of your photography you will find that you cannot frame a shot as you would like. For example, in this picture of the harbor area in Hong Kong, the high-rise buildings and the cruise ship have considerable impact, but the overall image is spoiled by the ropes tying up the ship to the dockside.

The tools of Photoshop Elements can be used to completely remove disfiguring distractions such as the ropes. There are two techniques you can employ for this type of problem, and you will often find that you need to use them in combination.

2 Enlarge the image to something like 300-400%, concentrating on the part of the bow where the ropes cross.

3 Using the *Freehand Lasso* tool from the *Toolbar*, make a selection of both the bow of the ship and the water, making sure to select above where the rope crosses.

From the *Menu Bar*, go to *Select > **Feather*** and add a 10-pixel *Feather Radius*. This ensures that the selection, when copied, is soft and easy to merge with the remainder of the ship. From the *Menu Bar*, choose *Edit > **Copy*** and then *Edit > **Paste*** and Elements will paste the selected pixels to a new layer.

Patching and cloning

In our example we should first look at the docking ropes at the point where they cross the bow of the ship into the sea. While it might be tempting to reach straight for the *Clone* tool, it would be difficult to use in this situation. If you turn to a cut and paste technique you can do a better, more controlled job.

4 What you have done with this procedure is to create a patch on a new layer. Click the *Layers* tab from the *Palette Bin* and you will see the patch layer you have created.

5 Select the *Move* tool from the *Toolbar* and move the newly created patch down over the rope, lining up the patch with the edge of the ship.

If the feathered edge that you created for the bow edge of the ship needs any help to merge into the ship, use the *Eraser* tool on the patch layer. Make sure that the *Opacity* is set very low, to around 5%. You also need a soft-edged brush.

Save the image as a standard Photoshop layered file with the extension .PSD. You can then flatten these two layers together by selecting *Layer > **Flatten Image***.

6 You need the *Clone* tool next from the *Toolbar*, but for this task you are going to clone to a new blank layer. To achieve this, you need to create it from the *Menu Bar* via *Layer > New Blank Layer*.

From the *Option* bar of the *Clone* tool, tick the *Use All Layers* box. This allow you to sample textures and colors from the ship layer and paint those pixels onto the new blank layer. The benefit of cloning to a new blank layer is that you never apply changes to the original ship layer. All your cloning appears on the blank layer, which in turn allows you to ensure that your work is seamless before you combine the layers together. This is a great way to work as any mistakes can easily be erased.

Using the *Clone* tool, sample close to the area we want to clone, by holding down the Alt key and left-clicking the mouse. Release the Alt key and apply the sampled pixels over the other parts of the rope.

TIP

Change the sample point often and try to avoid making one sample and using that for the entire job. This method does work sometimes, but a more random approach produces more natural-looking results.

7 Start with the bow of the ship and then move onto the sea area. Because of the texture and colors of the sea, the cloning should be easy to conceal. Continue along the remainder of the rope.

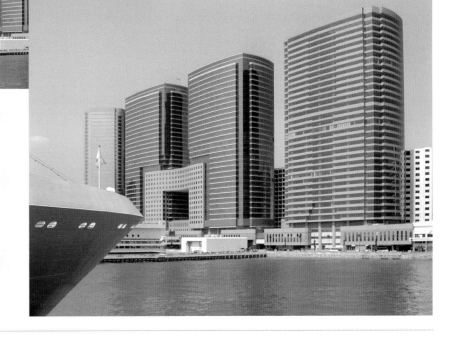

◄ *In this image of a kite festival, the expanse of cloudy sky has shown up a spot of dust on the camera's sensor, which appears as an ugly black splodge on the image. Instead of using the* Clone *tool to fix this, this time we're going to use the* Spot Healing Brush *tool. All we need to do is select a brush large enough to encircle the black blob, ensure that the Type is set to Proximity Match, click once, and the magical* Spot Healing Brush *tool does the rest. Nothing could be simpler.*

Copying Objects

Another way of improving images is by copying objects from one image to another, or within the same image. This is particularly useful when an otherwise attractive shot lacks a strong focal point to draw the eye. You could also take just one object and copy that to form an entire picture, as we've done in the example image below.

1 To start the process, you need to change the background into a layer from the *Layers* palette by doubleclicking the thumbnail and renaming it.

2 You first need to remove the sky from the aircraft image using the *Magic Wand* tool from the *Toolbar*. From the *Options Bar*, select a *Tolerance* of 32 and click into the sky. Most of the sky will be selected; any that is not can be added to by holding the Shift key and clicking in the unselected areas.

3 From the *Menu Bar* choose *Select > **Feather*** and add a 1-pixel *Feather* to the selection. From the *Edit* menu select *Cut*. (You can also use the shortcut Ctrl+X for this cut command.) You will see from the checkerboard effect that the sky area is now transparent.

Now turn the single aircraft into a squadron of aircraft by copying it. Click the *Layers* tab from the *Palette Bin*, open the *Layers* palette, and drag the thumbnail up the *Layers* palette and drop it over the left copy icon at the top. Elements will make a duplicate for you, which you can see shown as a thumbnail in the *Layers* palette.

4 You will not be able to see the other aircraft on screen until you select the *Move* tool from the *Toolbar* and move one of them aside. The copy process places the copied aircraft directly over the top of the original in perfect register.

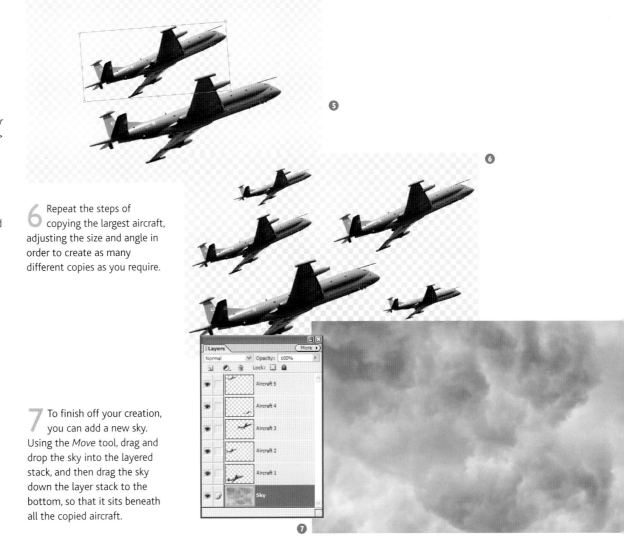

5 To change the size of the planes, go to the *Menu Bar* and select *Image > Transform > **Free Transform*** or use the shortcut Ctrl+T. Elements places a bounding box around the aircraft.

Hold down the Shift key to ensure that the aircraft is sized in proportion and reduce the size by dragging a corner toggle. If you want to change the flight angle at the same time, move the cursor outside of the bounding box and click and rotate the box.

6 Repeat the steps of copying the largest aircraft, adjusting the size and angle in order to create as many different copies as you require.

7 To finish off your creation, you can add a new sky. Using the *Move* tool, drag and drop the sky into the layered stack, and then drag the sky down the layer stack to the bottom, so that it sits beneath all the copied aircraft.

8 If you use the *Eraser* tool on some of the layers that contain aircraft, you can add another dimension, giving the impression of aircraft emerging from the clouds.

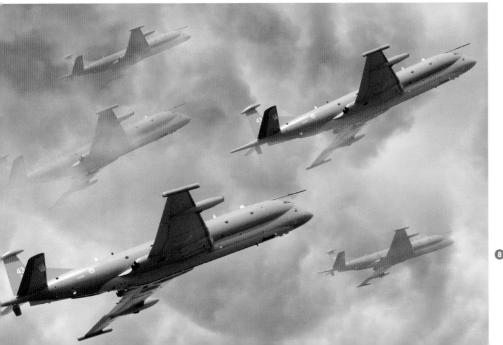

Replacing a Background

The background to an image can sometimes spoil the total shot. In many circumstances there is little you can do at the taking stage, but plenty you can do back on the computer with Photoshop Elements.

If ever there was a show-stopping color it has to be red. It attracts the viewer's eye into a picture no matter how small a part of the picture it occupies. Despite the eye-catching red in this image, the overall picture needs some work. The setting of a cluttered field is not the best backdrop, so we can remove the car from the field using Photoshop Elements and experiment with some other, more exciting backgrounds.

You can use *Selection* tools to get rid of the background, but using the *Eraser* tool is an option worth exploring.

1 Open the *Layers* palette from the *Palette Bin*, doubleclick the thumbnail and rename it in the box that appears on screen.

Using the *Zoom* tool, enlarge the car to about 300%; you need it this large to make the eraser cut-out technique easier. Select the *Eraser* from the *Toolbar* and a soft-edged brush about 6 pixels in diameter. With the mode set to *Brush* and the *Opacity* set to 100%, you can begin the erasing.

2 Click down right on the edge of the car with the *Eraser* tool. Hold the Shift key down and move a short distance along the edge of the car and click again. Elements will erase in a straight line between these two points. Because the image is so highly enlarged, you can work around the edge of the car in short steps. Make shorter steps on the curved sections and longer steps on the straighter parts.

3 It will not take you that long to work around the entire car, but keep the Shift key depressed as you work. When you get to the front bumper, you can leave the shadow area between the bumper and the car. That area won't show when you replace the background later. Once you have completely erased around the edge, you can switch to a hard-edged brush and erase the remainder of the background with a larger brush. This is a quick process once the edge of the car has been completed. The red roadster has left that cluttered field and is floating on a transparent background.

4 You now need to create a new background to show the roadster off. You will also need to create some additional space around the car by selecting *Image > Resize > Canvas Size* from the *Menu Bar*. Increase the *Canvas Size* a few inches in both the *Width* and *Height* boxes.

5 Select the *Move* tool from the *Toolbar* and move the car over to the right a little to improve the composition.

6 Open the *Layers* palette, and create a new blank layer by clicking the left icon at the top of the *Layers* palette. Click and drag that new layer beneath the car.

7 Select the *Eye Dropper* tool from the *Toolbar* and then click onto an area of dark red color on the car. You will see that you have selected that color and it now appears in your *Color Picker*. We can either use the shortcut keys Alt+ Backspace or select the *Paint Bucket* tool to flood the new layer with red.

8 To add interest to the background, select the *Gradient* tool from the *Toolbar* and black as the foreground color. From the *Gradient* tool *Options Bar*, select the *Linear* option and *Foreground to Transparent* from the drop-down menu.

9 You can now add a *Foreground to Transparent* gradient on the top and bottom of the red background. For more control, apply these gradients to new blank layers. Creating these gradients on new blank layers means that you can make a few dry runs first. You can also adjust them with the *Opacity* slider in the *Layers* palette. To create a gradient, drag out a line that tells Elements where to start and stop the gradient. You can add to the gradient where it needs it with the *Brush* tool.

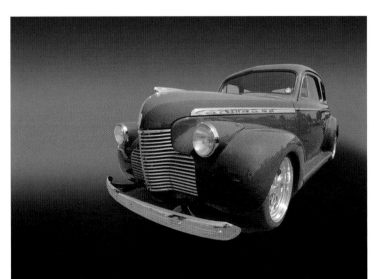

As all the elements have been applied separately to their own layers within the stack, we are free to experiment. Try other gradients or blend modes.

Retouching Landscapes
Levels and Gradients

Landscape pictures can be disappointing when they are transferred to the computer screen. The drama or serenity that appeared to be there at the taking stage often seem to be lacking when viewed later. You can use Photoshop Elements in a variety of ways to restore the drama to your landscape photography .

1 This picture, taken on the Great Barrier Reef in Australia during a short storm, is an example of drama that has been lost.

2 The most significant change you can make to start this process is with the *Levels* command. Call up the *Levels* command via *Enhance > Adjust Lighting > **Levels***, or alternatively use the shortcut Ctrl+L.

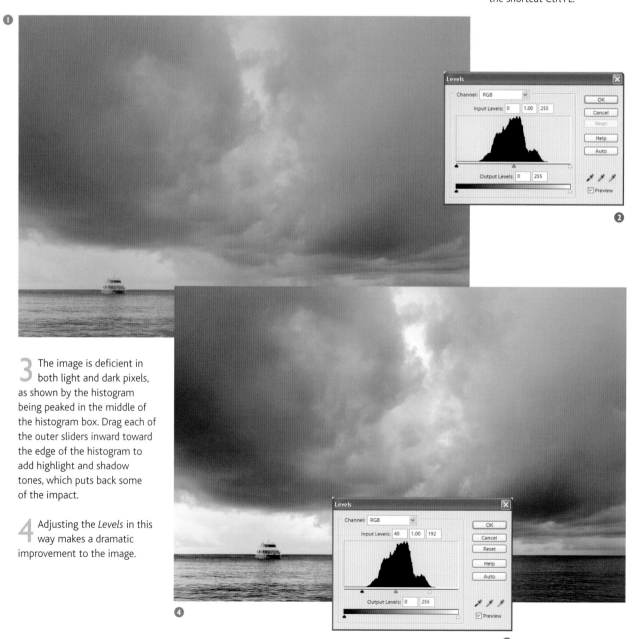

3 The image is deficient in both light and dark pixels, as shown by the histogram being peaked in the middle of the histogram box. Drag each of the outer sliders inward toward the edge of the histogram to add highlight and shadow tones, which puts back some of the impact.

4 Adjusting the *Levels* in this way makes a dramatic improvement to the image.

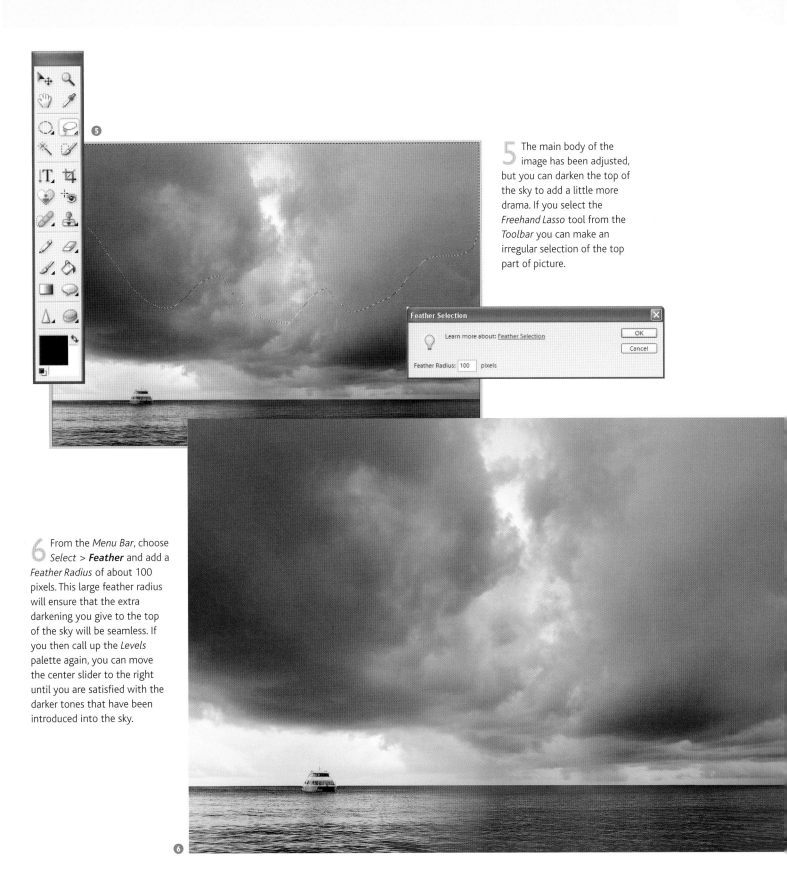

5 The main body of the image has been adjusted, but you can darken the top of the sky to add a little more drama. If you select the *Freehand Lasso* tool from the *Toolbar* you can make an irregular selection of the top part of picture.

6 From the *Menu Bar*, choose *Select* > **Feather** and add a *Feather Radius* of about 100 pixels. This large feather radius will ensure that the extra darkening you give to the top of the sky will be seamless. If you then call up the *Levels* palette again, you can move the center slider to the right until you are satisfied with the darker tones that have been introduced into the sky.

Retouching Landscapes continued
Graduated Filter Effects

Another way to improve a weak sky is to apply a graduated filter effect using a new blank layer and the *Gradient* tools. In conventional photography, a graduated filter is a filter that can be applied to a camera lens. It has a color at the top only, graduating to a clear bottom section. This effect can be created in Photoshop Elements.

1 Create a new blank layer over the top of the landscape and sample a dark tone from the original sky using the *Eye Dropper* tool. A neutral gray from the top right of the picture would seem the best option. That color will appear in the *Color Picker* on the *Toolbar* and we can then click the foreground color to bring the main *Color Picker* on screen.

Elements will already be showing us the color selected, by the position of the small circle over to the left of the palette. If you left-click about one inch below the original color setting you will retain the neutral gray, but darken it considerably.

2 Select the *Gradient* tool from the *Toolbar* and from the options choose *Linear,* then *Foreground to Transparent*. Draw a line down from the top of the image to just above the horizon and the gradient will be formed on the new blank layer.

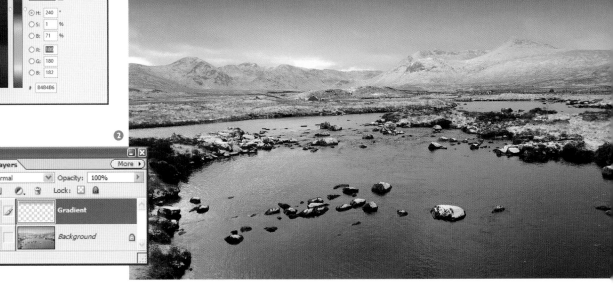

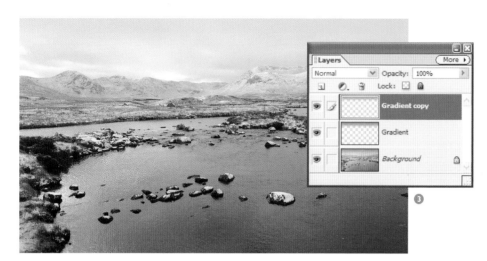

3 If you wish to reduce the gradient effect, you can reduce the layer opacity from within the *Layers* palette using the slider control. If you want to increase the density of the gradient, you can drag the layer thumbnail onto the copy icon in the layers palette to double the intensity.

4 You can use these same techniques to add delicate color into your skies in any shade you choose.

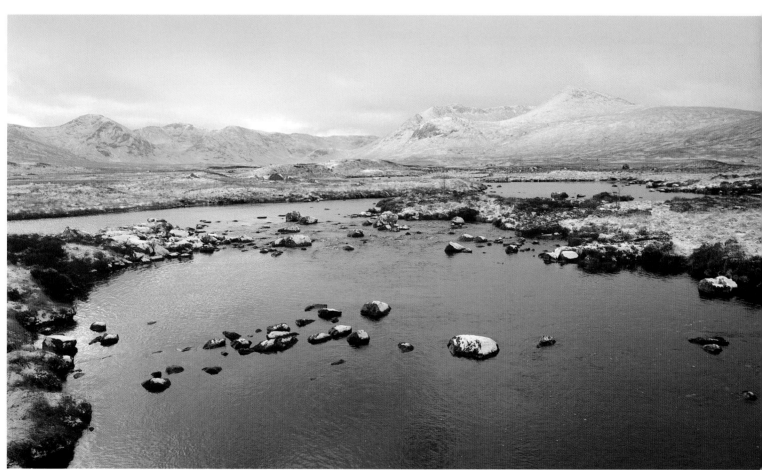

Retouching Landscapes continued
Replacing Skies

There are times when the contrast between the light and dark areas in a landscape is just too high to record correctly; this is true of both images taken with a digital camera and those scanned from film. In these conditions the sky records as white, and this is something that should be altered in order to improve a picture.

1 Your first task is to remove the existing sky; this is not a difficult task. First, click the *Layers* tab from the *Palette Bin* and change your background into a layer by doubleclicking the thumbnail and renaming it.

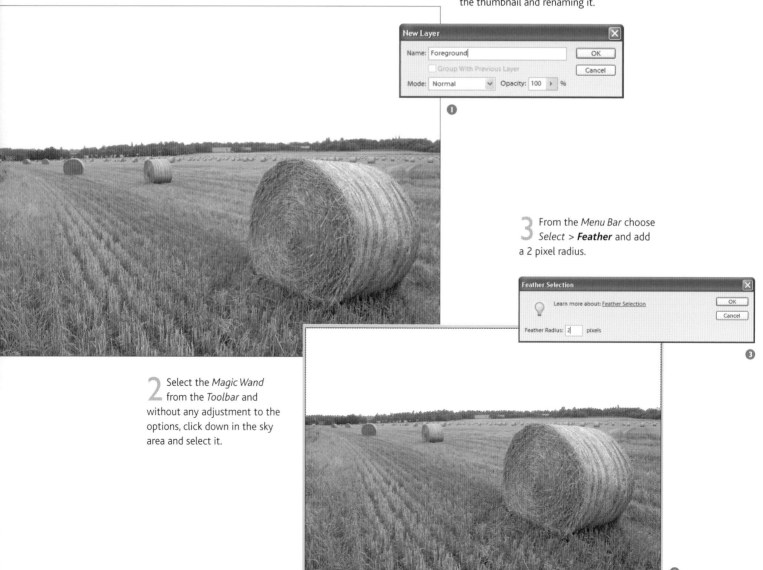

3 From the *Menu Bar* choose *Select > Feather* and add a 2 pixel radius.

2 Select the *Magic Wand* from the *Toolbar* and without any adjustment to the options, click down in the sky area and select it.

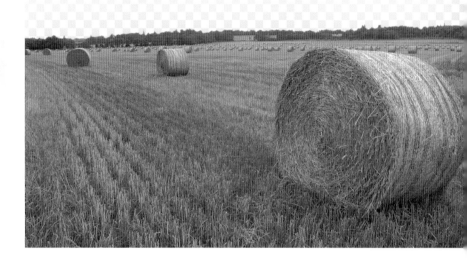

TIP

Sometimes when you cut out a light sky to introduce a darker one, the join between the sky and land can look odd. You sometimes get a halo effect as a few light pixels left from the removal of the lighter sky show up against the darker one. To alleviate this, go to the Menu Bar *via* Select > Modify > **Expand** *and expand your selection by 3 pixels. The expanded selection encroaches into the distant trees by a few pixels, but it won't be noticeable.*

4 Use the shortcut keys Ctrl+X to cut the boring white sky out of the image.

5 You need to select another sky to replace the one removed; a sky taken at the same time as the original landscape is ideal. After taking your landscape image, tilt your camera upward and take some shots of the sky, but with an exposure that allows it to record better.

Retouching Landscapes continued
Replacing Skies continued

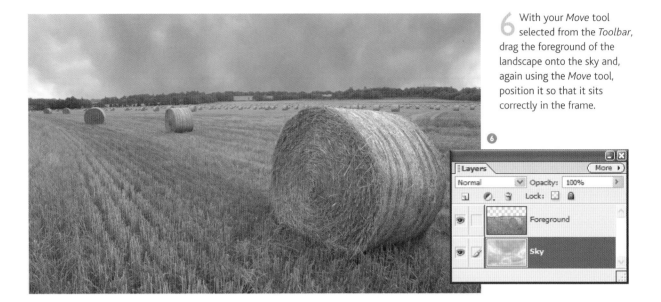

6 With your *Move* tool selected from the *Toolbar*, drag the foreground of the landscape onto the sky and, again using the *Move* tool, position it so that it sits correctly in the frame.

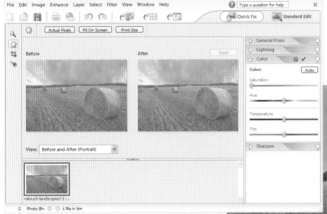

7 This image would look far better in black and white, so select the foreground layer from the *Layers* palette and click the *Quick Fix* icon on the *Shortcut* bar. Select the *Color* palette and move the *Saturation* slider completely to the left in order to remove the color.

8 Still in *Quick Fix* mode, click the *Auto* button next to *Contrast*; the foreground is now monochrome and has an improved level of contrast.
 Select your sky layer and repeat the *Quick Fix* color desaturation process. If you try the *Auto Contrast* on the sky, the result is likely to be too harsh, so omit that step.

9 With the sky still selected in the *Layers* palette, select *Image > Transform > **Free Transform*** from the *Menu Bar* and Elements will place a bounding box around the sky layer. Click the bottom center toggle and move that upward to adjust the perspective of the sky. This creates a more dramatic, stormy sky effect.

To complete the transform either hit the *Enter* key, click the tick on the *Options Bar*, or select another tool from the *Toolbar*.

10 Any intrusive areas that remain where the sky meets the foreground can be dealt with using the *Eraser* tool and a soft brush on the foreground layer. Save your image as a Photoshop file retaining the two layers and then flatten the image via *Layers > **Flatten*** to add the final touches.

Using the *Dodge* and *Burn* tools, lighten the lines of straw in the foreground and darken down shadow areas. Finally, use the *Clone* tool to clone away distracting highlights.

REMOVING CLOUDS

SELECTION TOOLS

GRADIENT TOOLS

SCREEN BLEND

TONES

Retouching Landscapes continued
Improving Weather

Photographers will always be at the mercy of poor weather, but we can at least use software to brighten up pictures taken on dull days.

The biggest change you can make to a landscape to give that sunny day feeling is the inclusion of some blue sky. Landscapes tend to have little tone in the sky on dull days, and clouds are a giveaway that a photo was not shot in sunny conditions. Remove the clouds and you can then add contrast and color using the appropriate Elements tools.

With this example image, the clouds are a problem and it is with these that you should start your manipulations.

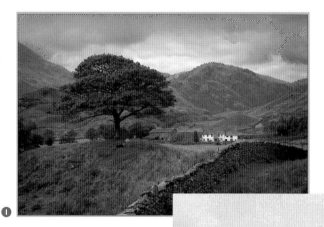

❶ The clouds in this picture just have to go. From the *Toolbar*, select the *Magic Wand* tool. Using the default setting, click inside the sky; most of the sky will be selected.

Using the *Freehand Lasso* and/or the *Polygonal Lasso* tool from the *Toolbar*, you can add or subtract parts of the selection until the sky is fully selected. Using the *Zoom* tool, enlarge the areas you need to adjust. By holding down the Shift key, you can add to your existing selection made with the *Magic Wand* with any of the other selection tools.

❷ In areas where your selection has encroached onto the land, you can hold down the Alt key and remove a part of the selection.

❸ With the sky fully selected, you can add a 2-3 pixel feather to the selection, then doubleclick the background thumbnail and rename it to change it into a layer. Hit the shortcut keys Ctrl+X and the sky will be removed.

❹ Return to the *Layers* palette in order to create a new blank layer and drag that layer down to the bottom of the layer stack. You can then flood that layer with white. Alt+Backspace will flood a layer with your chosen foreground color. This will give you a good base to add a gradient blue sky.

⑤

5 To give yourself ultimate control over the graduated blue color you will add next, create a new blank layer above the white layer. From the *Color Picker*, select an appropriate pale sky blue.

TIP

As an alternative, you can try adding some white fluffy clouds back into the sky. Copy a blue cloudy sky into the layered stack above the gradient layer and blend it into the gradient layer using the Screen *blend mode.*

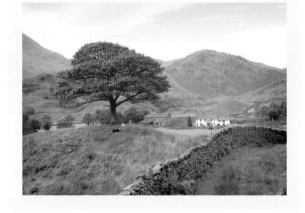

6 Select the *Gradient* tool from the *Toolbar*. From the options, select *Linear* mode and from the edit button *Foreground to Transparent*. Draw a line down from the top of the screen to tell Elements where to start and end the gradient.

⑥

7 From the *Layers* palette, select the original landscape layer and from the *Menu Bar* select *Enhance > Adjust Color > **Color Variations***.
Reduce the *Amount* slider, then lighten the image slightly using the *Lighten* button and add some warm tones with the *Increase Red* button.

8 As a final touch, increase the contrast of the landscape layer via *Enhance > Adjust Lighting > **Brightness/ Contrast***. Sunlit landscapes naturally have more contrast than a landscape shot under a dull, gray sky.

❼

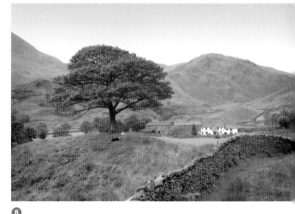

❽

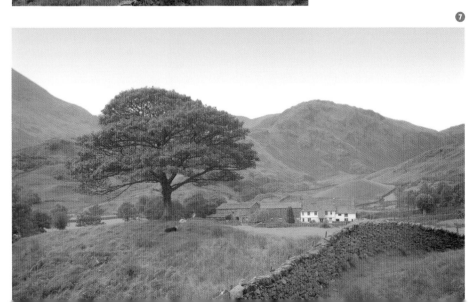

FEATHER RADIUS

DODGE TOOL

HIGHLIGHTS

EXPOSURE SETTING

MONOCHROME

Retouching Landscapes continued
Adding Extra Interest

Improving images involves enhancing the good parts of the picture, while subduing or correcting the less appealing parts. Your aim is to attract the viewer to the most interesting parts of the image and then keep them there as long as you can. This project, enhancing a moody landscape shot, is a perfect example.

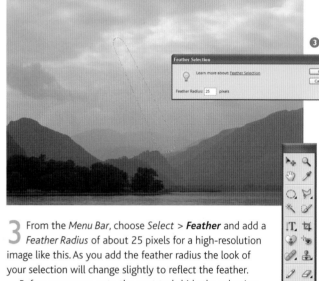

3 From the *Menu Bar*, choose *Select > Feather* and add a *Feather Radius* of about 25 pixels for a high-resolution image like this. As you add the feather radius the look of your selection will change slightly to reflect the feather.
 Before you move onto the next task, hide the selection, but leave it active. It is easier to judge your manipulations with the selection line invisible. Hit the Ctrl+H keys to hide the selection; the same key stroke again will reveal it.

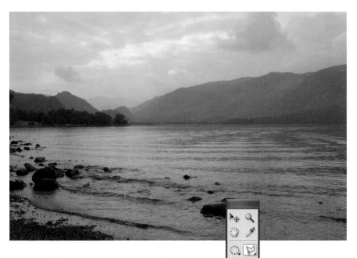

1 Sometimes you can be faced with a charming landscape or waterscape, which only needs something extra to lift it out of the ordinary. This waterscape has just a hint of a sunbeam in the distance, and you can use the tools of Photoshop Elements to enhance this.
 You need to carry out the standard remedial work before you start this process, such as adjusting levels and making any color balance changes.

2 Enlarge the image using the *Zoom* tool. With the 10 by 7 inch file at 300ppi, enlarge the section in the sky you want to work on by at least 100%. Working at these magnifications helps you to create seamless manipulations. Mark out the polygonal selection in the place where you want the beam to fall.

4 You will also be able to better evaluate what you are doing if the image is closer to the print size. If you click the *Zoom* tool and the *Fit on Screen* button from the *Options Bar*, the working size will be fine.
 From the *Toolbar*, select the *Dodge* tool and from the options at the top of our screen select a brush size that will cover the width of your hidden selection. Select *Highlights* as the *Range* setting and an *Exposure* setting of 2%. You need to be delicate with this process, so 2% is sufficient.
 Gently lighten the area to form the beam of light.

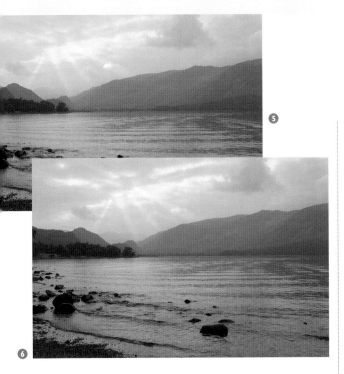

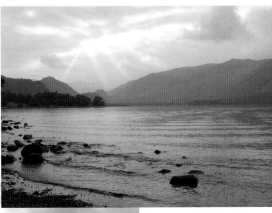

> ∨ *You can choose to stay with your color image or try some variations such as a monochrome image or a light blue tone via the Hue/Saturation palette.*

5 Repeat the process for as many beams as you want to introduce. Vary the width of the beams and the angle.

6 Using the *Dodge* tool, you can now lighten those small light areas of the sky where the beams seem to be coming from. The clouds would be naturally bright at these points but you still need to help them along.

∨ *The same techniques can be used to add drama to other images, but a subtle and gradual approach is essential.*

TIP

You can make a layer copy of your image before you use the Dodge tool so that from within the Layers palette you can switch between before and after images to judge the tone of the beam. It is easy to overdo this manipulation if you are not careful.

Retouching Landscapes continued
Improving Light

WARM TONES

PAINT BUCKET TOOL

BLEND MODES

ERASER TOOL

MERGE VISIBLE

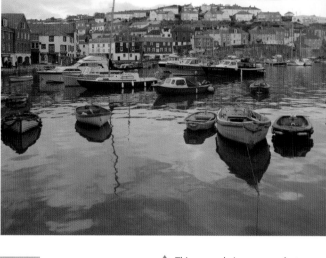

One thing that affects photographs more than anything else is quality of light. The warm tones of a summer evening can give almost any picture charm.

However, it is not always possible to capture an image in this way. The weather might be against you, but you can help the situation along with your software.

1 From the *Toolbar* select the *Magic Wand* tool. While holding the Shift key, select the entire sky area and feather the edge of the selection by 1 pixel. Change the background thumbnail into a layer by doubleclicking it and renaming it in the *New Layer* dialog. You can then hit the shortcut keys of Ctrl+X to remove the sky.

This example image was shot in very dull conditions, but at least I managed to capture a good range of tones with which to work. It takes a few stages and manipulations to make the picture look as if it was taken in warm evening light.

2 From the *Menu Bar* you need to create a new blank layer via *Layer > New > **Layer***. You can choose a name for the layer; I chose "Color." Click the *Color Picker* and pick a rich warm orange. Now flood the new layer with this color using the *Paint Bucket* tool from the *Toolbar*.

3 From the drop-down blend modes within the *Layers* palette, you need to select *Soft Light*. This will give an all-over warm tone, but it also fills the sky area. If you hold down the Alt key and move the cursor over the dividing line between the upper and lower thumbnail in the *Layers* palette, two linked circles will appear. Click, and Elements will wrap the color around the image and preserve the transparent parts.

4 You need to create the feeling that the low sun is picking out the buildings opposite. From the *Toolbar*, select the *Eraser* tool and a fairly large soft-edged brush. Gently erase the color from the foreground to leave only the buildings and some of the distant boats still colored.

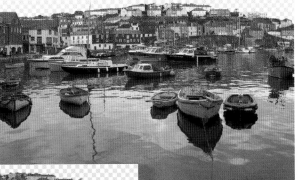

5 You can now save the project in its layered form as a .PSD file and from the *Layer* menu choose *Merge Visible*. The image now needs some attention to the levels. Turn to *Quick Fix* mode and click the *Auto* button in the *Color* palette.

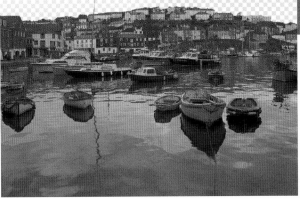

6 If you create a new blank layer and drag that layer to the bottom of the layers stack, you can create a new sky. In this situation the sky is unlikely to be completely blue, so pick a warm tone and a sky blue from the *Color Picker*. From the *Menu Bar*, select *Filters > Render > **Clouds*** to create a warm evening sky.

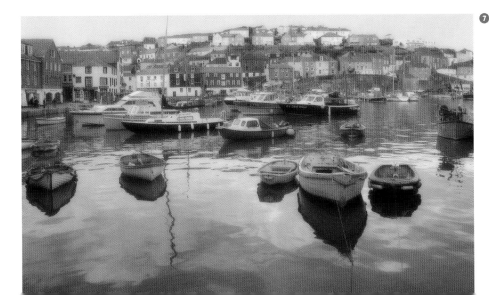

7 You can save the project and flatten the layers together at this stage or you could add a soft focus to add to the feeling of a warm evening light. A slight darkening of the foreground would help too.

Retouching Landscapes continued
Day into Night

Photoshop Elements is a powerful software program, and used carefully it can even turn day into night. As usual, you need to select the right image for this type of treatment as not every picture taken in daylight will react well to this process. This particular shot has a rugged, moody look that works perfectly.

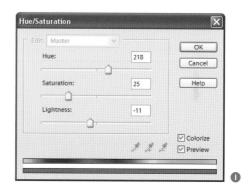

First, add a blue tone to the image via the *Hue and Saturation* palette. You can find this on the *Menu Bar* via *Enhance > Adjust Color > Adjust Hue/Saturation* or via the shortcut keys Ctrl+U. If you place a tick in the tiny *Colorize* box at the bottom right of the palette, you can then adjust the *Hue* and *Saturation* sliders to enhance the feeling of night.

2 If you want the night shot to be darker, select the *Levels* command via Ctrl+L and slide the center *Midtone* slider to the right a little.

∧ *Our example image contains scant contrast and a narrow range of tones. In normal circumstances, you could use the* Levels *palette to adjust the levels and transform the image. However, for this technique, you can make use of the tones being flat by turning the daytime image into a nighttime effect.*

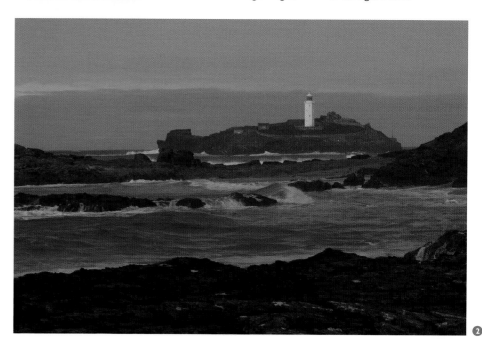

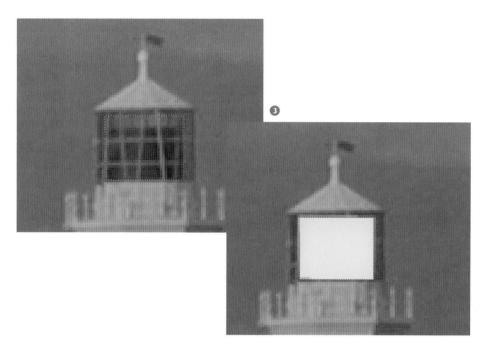

3 To take the nighttime conversion one stage further, you can add a light to the lighthouse and a light beam spreading out across the bay. From the *Menu Bar*, create a new blank layer via *Layer > New > **Layer***; you can choose any name in the new layer dialog. You will create your main light on a separate layer so you have complete control over it.

Enlarge the top of the lighthouse using the *Zoom* tool. Then, using the *Polygonal Lasso* tool or the *Rectangular Marquee* tool, make a selection around the area you wish to illuminate. You can then flood the selection with yellow to form the light.

4 Remove the selection via the Ctrl+D keys. From the *Filter* menu select *Blur > **Gaussian Blur*** and from the *Blur* options add about a 5 pixel radius of *Blur* to make the lamp more convincing.

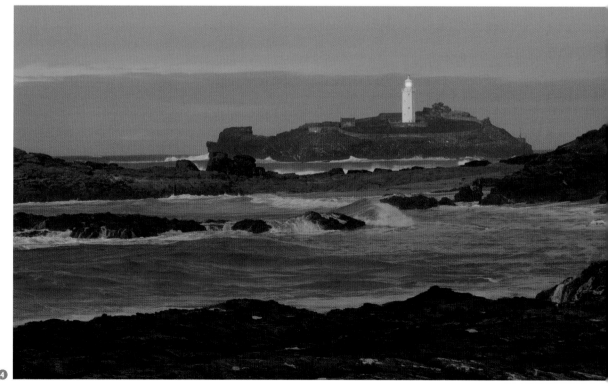

Retouching Landscapes continued
Day into Night continued

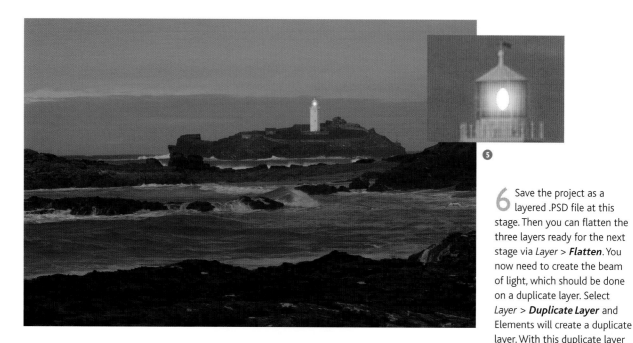

6 Save the project as a layered .PSD file at this stage. Then you can flatten the three layers ready for the next stage via *Layer > **Flatten***. You now need to create the beam of light, which should be done on a duplicate layer. Select *Layer > **Duplicate Layer*** and Elements will create a duplicate layer. With this duplicate layer selected, use the *Polygonal Lasso* tool to create the shape of a spreading light beam. Feather the edge of the selection by 25 pixels.

5 Although the light looks OK, it is not quite there. Most lamps have a hot spot or bright part, and you can create that on another blank layer. Create the new layer as before, draw an oval selection in the center of the yellow light, and flood that selection with white. Add a little *Gaussian Blur* to the white to form a convincing bulb for the lighthouse.

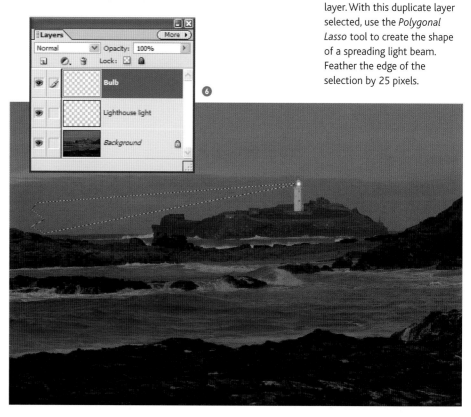

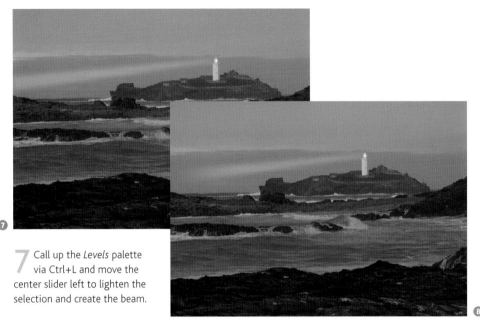

7 Call up the *Levels* palette via Ctrl+L and move the center slider left to lighten the selection and create the beam.

8 The new beam works quite well, but it ends too abruptly. You can put that right using the *Eraser* tool from the *Toolbar* with a low *Opacity* setting. Gradually erase the end of the beam from the upper layer. This reveals the layer beneath, which does not contain the beam.

9 The final stage could be to add a *Black to Transparent* gradient to the top of the image. You could also light a couple more windows using the technique already described. Lastly, crop the image and add a few tiny points of light with the *Pencil* tool to create stars in the night sky.

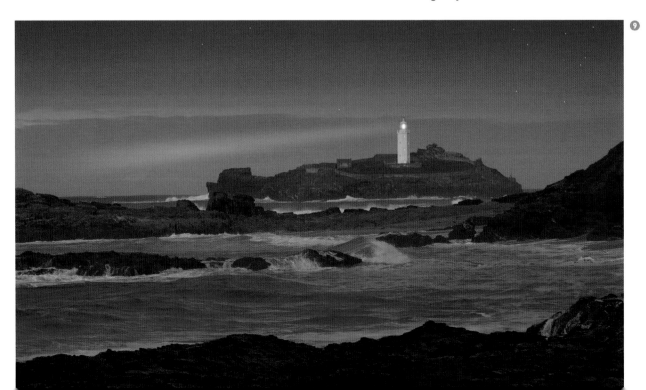

Retouching Portraits
Eyes and Skin

CLONING

ADJUSTING COLOR

MATCHING PIXELS

SHARPENING

UNSHARP MASK

When it comes to improving portraits, you need to be far more critical with your work than you might be with other images. People's faces are so well known that even a slight change can alter their appearance, and a heavily retouched portrait can end up looking fake or "plastic." This will be spotted instantly by the viewer.

Enhancing the eyes

1 First select the *Zoom* tool and enlarge the eyes so they are easier to work on. You will notice that another fault becomes evident—the number of highlights in the eyes.

Deal with those first by using the *Clone* tool. From the *Options Bar*, select a small, soft-edged brush about 8-10 pixels in diameter. Hold down the Alt key and left-click to sample color and texture close to the spot you wish to eradicate. Release the Alt key and apply the sampled pixels over the highlights. As long as you work carefully, there is no need to make a selection first.

With a little care you can erase all the highlights, except the ones that you want.

2 With the image still enlarged, make a selection of the whites of the eye ready to lighten them. You could use the *Magic Wand* tool, but there is a greater need for accuracy with eyes so a better option is to use the *Polygonal Lasso* tool.

Click down right on the edge of the white of the eye and in short steps manually create a selection. If you hold down the shift key, you can make a similar selection of the other eye. It is vital that both eyes are adjusted the same. From the *Menu Bar*, select *Enhance > Adjust Color > **Remove Color*** or use the shortcut keys Shift+ Ctrl+U. This correction will remove the blue cast from the baby's eyes.

∧ *Adjusting the whites of the eye is a task we will need to master particularly with shots of babies. We will often find that they can appear quite gray, especially in their early years. In our example picture of Luke this is certainly the case, in fact, the whites of the eye are a soft blue-gray.*

TIP

Where you clone from is the most important issue to ensure that the pixels you apply match perfectly. Where you are cloning along edges of pupils or eyelids, you should sample in line with the natural folds of the skin or tones in the eye.

3 From the *Menu Bar*, select the *Levels* palette via *Enhance > Adjust Lighting > **Levels*** or press Ctrl+L. You can see the lack of highlights in the flat area to the right of the *Levels* histogram. Move the right-hand slider toward the end of the histogram's downward slope, but be careful not to overdo this.

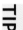

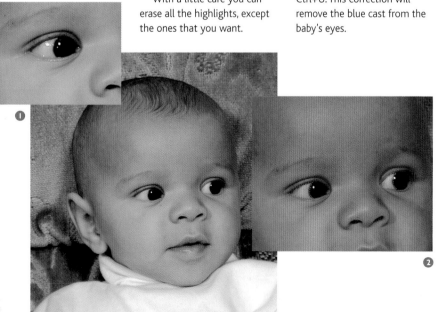

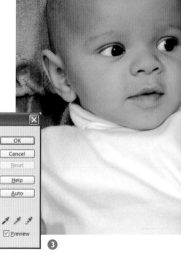

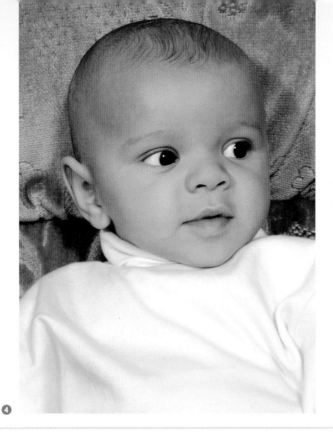

4 While trying to improve images like this, you need to take a step back and look for other areas of the image that are distracting. The bottom corner of this image, for example, cuts right through the baby's hand, which isn't very attractive. You can use the *Clone* tool to clone and follow the fold of the white top.

TIP

Hold down the Ctrl key and press H on the keyboard and the selection will be temporarily hidden. The same key stroke will reveal it again. You will be able to evaluate your manipulations of the eyes better with the selection hidden.

④

Sharpening the face

1 A baby's picture rarely requires sharpening, as we expect to see a soft skin, but with an adult male portrait the reverse is true.

❶

2 When it comes to sharpening a portrait, you need to be careful not to overdo it. However, with this portrait, it is possible to increase the *Unsharp Mask* settings further than usual, because you expect to see strong, sharp features in a portrait of a young man. You still need to deal with the highlights in the eyes and whiten the eyes if necessary.

From the *Menu Bar*, select *Filter > Sharpen > **Unsharp Mask***. From the *Options*, push the *Radius* slider as far as you can without introducing an unwanted pixel effect.

3 A radius of 1.2 worked best for this image from a 6 megapixel camera.

❸

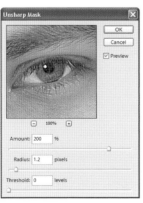

❷

Retouching Portraits continued
Eyes and Lips

In portrait photography, the eyes and mouth are often the most important aspects of the picture. To improve images, you can lighten and sharpen lips, eyes, and teeth and enhance the color of the lips.

The tools within Photoshop Elements handle these manipulations without difficulty.

If you look at the mouth greatly enlarged, you will see that there are some highlights on the teeth and gums that need to be dealt with. Using the *Clone* tool with a small soft brush about the same size as the highlight, you can quickly remove these. Afterward, carry on and deal with some of the highlights on the lower lip.

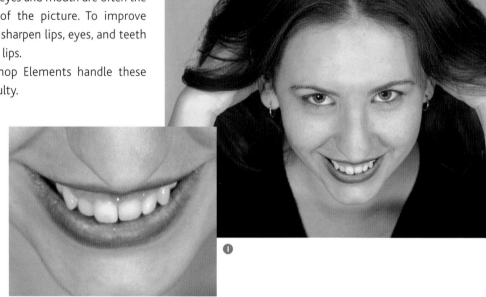

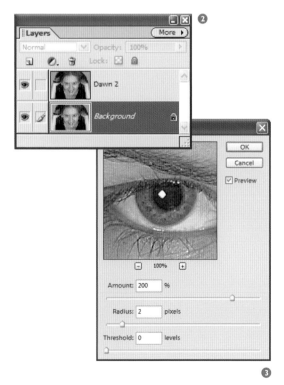

2 You need to sharpen the eyes and possibly the lips in this portrait, but do you need to sharpen the whole image? The rest of the face and the hair look fine. To sharpen just part of an image, you would normally turn to a selection. On this occasion, however, you can create an adjustment layer.

From the *Menu* bar, select *Layer > **Duplicate Layer*** and type a name of your choice in the *Duplicate Layer* box. If you open the *Layers* palette from the tab in the *Palette Bin*, you can turn off the new layer you have just created for a moment and select the background layer for this next step.

3 Go to the *Menu Bar* and select *Filters > Sharpen > **Unsharp Mask***. As you are going to sharpen only a few selective parts of the image, you can afford to push a little more sharpness into those areas. You don't need to be too concerned with the detrimental effect of excessive sharpening on smooth tones elsewhere.

TIP

When you need to deal with larger light areas on places like the lips, you can reduce the Opacity *of the* Clone *tool to between 20 and 40% and build up the tone with successive clicks of the* Clone *tool. This is far more forgiving than working with an* Opacity *of 100%.*

4 From the *Layers* palette, select and turn on the duplicate layer you created earlier and select the *Eraser* tool from the *Toolbar*. The duplicate layer is covering the sharpened layer completely, but if you select a soft brush of about the size of the pupil, you can erase the parts of that upper layer that you want sharp—i.e. the eyes and mouth.

This method gives you the best of both worlds, with the sharp parts from the layer below showing through. You need to flatten the two layers together when complete.

5 The teeth also need lightening a little, so select them with the *Magic Wand* tool. Hold the Shift key and click around the teeth until they are selected. From the *Select* menu, add a 3-pixel Feather to the selection and using the shortcut Ctrl+L, open the *Levels* palette. You can lighten the teeth with the center *Midtone* slider, moving it slightly to the left.

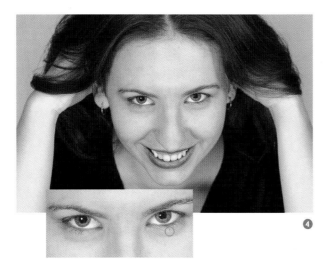

6 To adjust the color of the lips you first need to create a new blank layer. Then, from the *Blend* options in the *Layers* palette, select *Color*. You can paint onto the lips any shade of color you want and the lip texture will show through. Why not enhance the subject's natural lip color or go for a more extreme alternative?

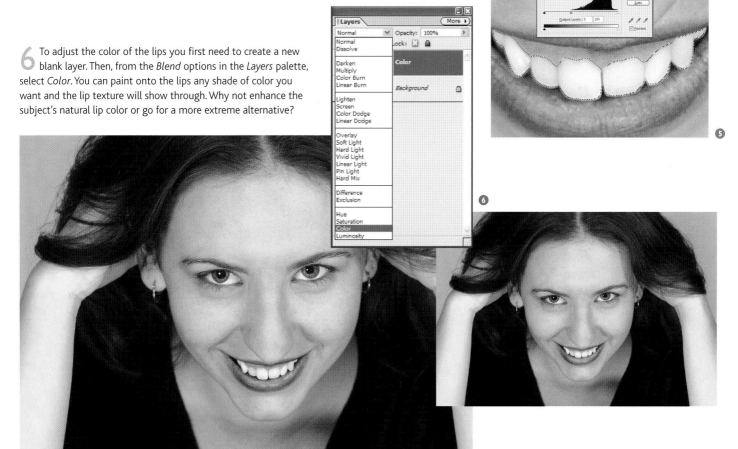

Retouching Portraits continued
Skin Tones

AUTO COLOR

CORRECTION

YELLOW TONES

OPACITY

CLONING SKIN

SOFT FOCUS

Portrait photography, especially if taken inside, is often affected by the colors and tones of the surroundings. Sometimes that will work in your favor, sometimes not. Using Photoshop Elements, you can change the skin tones of your portraits to match what you recall, or, better still, what your sitter would have wanted. In this example, Dawn's skin appears to have taken on a yellow cast where the light was reflected from the wood paneling in the room where the shot was taken

❶

Start by creating a duplicate layer, via *Layer* > **Duplicate Layer**. Enter any name of your choice in the dialog box.

2 From the *Menu Bar*, select *Enhance* > **Auto Color Correction** or use the shortcut Shift+Ctrl+B. Elements does a fairly good job on the image. The yellow color has gone, but the image is now on the blue side, making the skin tones appear too cool.

❸

❷

3 We need a color somewhere between the original image and the adjusted layer. You can obtain this by opening the *Layers* palette and reducing the *Opacity* of the auto color corrected layer. A 50% *Opacity* blends the two well. You can merge or flatten these two layers together using the command in the *Layers* menu.

4 You can begin the process of enhancing Dawn's complexion by dealing with the shine on her skin. From the *Menu Bar*, select *Layer > New > **Layer*** and from the *Toolbar* select the *Clone* tool. You are going to clone to a new layer so you don't alter the original image. All the clone work will appear on this new layer until you are happy to combine them later. From the *Clone* tool *Options Bar*, tick the box that says *Use All Layers*.

Your soft-edged brush must be varied in size to suit the area you are working in, and it is best used around a 30-40% *Opacity*. Starting with the forehead greatly enlarged, sample some skin tones that do not show any shine and, using a series of clicks, build up the tone on the new blank layer.

You can extend this method to any lines or wrinkles on the face and around the eyes.

5 The same technique can be applied to remove freckles—in this case on the model's arms. Using the *Clone* tool at 80-100% *Opacity* will deal with freckles very effectively. Remember that you are still cloning to a new blank layer. Turn the layer off from within the *Layers* palette for a moment and look at the difference you have made to the portrait.

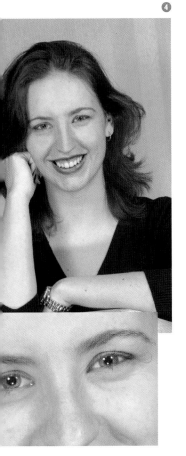

TIP

It is usually acceptable to remove lines, moles, and freckles, but be careful with the laughter contours of a face or you may change the person's whole appearance—and not for the better.

6 You now need to carry out the tasks described earlier, such as cloning out highlights in the eyes and lightening the whites of the eyes.

To give Dawn that classic "cover girl" look, you can also add a soft focus (see pages 54–55), and then make some fine tweaks of color via the *Color Variations* palette.

Retouching Portraits continued
Coloring Hair

You can use the tools of Photoshop Elements to change the color of hair as well as eyes. Combine layers, blend modes, and a soft brush, and you can easily brush on a new or different hair color. The same technique can also be usefully employed to remove gray hair. There is no need to stay natural—if you want, you can also experiment with some strange and crazy colors.

1 Start this project by clicking the *Layers* tab from the *Palette Bin*, then create a new blank layer by clicking the left icon at the top of the *Layers* palette. From the drop-down blend modes within the *Layers* palette, select *Color*.

With the *Color* blend mode activated, this layer retains any color that you apply without it obscuring the hair texture underneath. As you add the color to a new layer, you can also erase any mistakes without affecting the main image.

2 Select an appropriate color from the *Color Picker*— a dark red, near to brown, is probably the best choice for Dawn's hair. With the image greatly enlarged, apply the color to the new blank layer using a soft-edged brush. As you work around the hair, you can adjust the brush size and the *Opacity* to make the work easier. Use a lower *Opacity* on the edges of the hair and a smaller brush.

3 You do not have to color every individual hair for the transformation to be successful. The more effort you put in, the better the result will be, but the really fine hair on the outer edges needs only a hint of color.

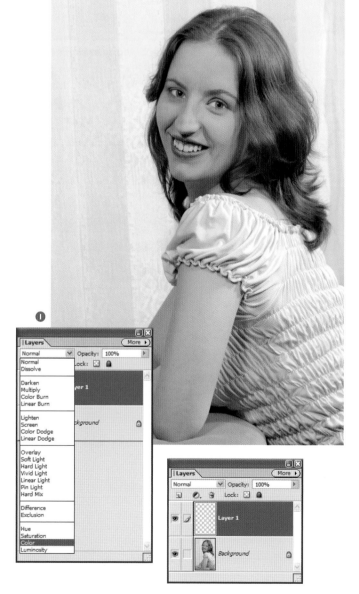

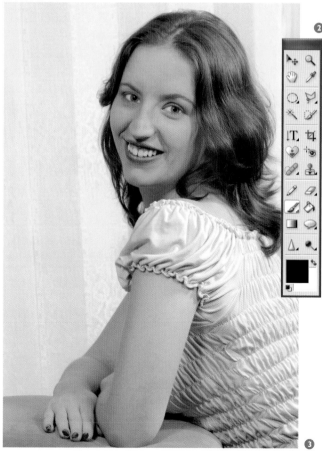

TIP

The color you choose for this process needs to be darker than usual because the process has a lightening effect. It may take some trial and error to select the right tone for your subject.

4 If you open the *Layers* palette and temporarily turn off the main picture of Dawn, you will see the hair shape you have created.

Creating the color on a new layer means that you can switch to the *Eraser* tool to remove color from any areas where you have applied too much or the color has spilled over into the background.

5 There is another benefit to working on a new layer. Open the *Layers* palette and drag the hair color layer down over the center copy icon to make a duplicate. Click the *Lock* box at the top right of the *Layers* palette—this restricts any changes that you make to the hair layer to the areas where you have already painted.

Turn off the original hair color layer, select another color from the *Color Picker*, and flood your second hair color layer. Use the shortcut keys of Alt+Backspace to flood the foreground color. The result is an instant hair color change.

Wild styles

Using these techniques, you can change the eye color too to give Dawn a complete new look. You can balance Dawn's hair, eyes, and lipstick, or give her a fun, wild look.

Restoring Old Photographs

It won't be long before you are asked to put your digital skills to work repairing a damaged or faded family picture. When you set about restoring an old or damaged picture, you tend to have scratches and tears to deal with, but how would you deal with a picture that has not only faded badly, but faded to different degrees across various parts of the image?

Photoshop Elements comes to the rescue yet again with the tools to do the job.

TIP

When you are making repairs of this nature, you may not be sure if the color you have chosen is the right one, so try checking with the owner of the picture. Often color will not be that crucial—after all, it's the people in the picture that are most important. However, if you were restoring an image of a wedding dress, for instance, the color may be very important to the bride.

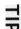

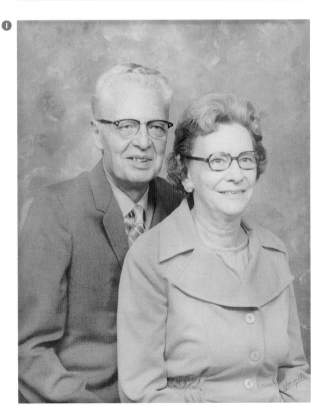

With the old picture on screen, you can see how badly faded it is. Some of that damage can be put right using the *Levels* palette.

2 To adjust fading, you can use the *Quick Fix* options from the *Shortcut* bar, or you can call up the *Levels* palette using the shortcut keys Ctrl+L. In this case, the *Auto* key did a good job. It has repaired some of the colors in parts of the image, although not the badly faded areas, which will require further attention.

3 You need to work in layers for this repair, so open the *Layers* palette from the *Palette Bin* and create a new blank layer by clicking the left icon of the three at the top of the *Layers* palette.

❸

4 You need to apply the correct color to the new blank layer to repair the fading, so the next step is to sample the correct color from the partially corrected image, starting with the background.

Select the *Eye Dropper* tool from the *Toolbar* and left-click within the image to sample the correct color of the background. You will need to make a judgment on where the best color is; in this case it is probably the bottom right of the picture. Once you have sampled that blue color, choose a soft-edged airbrush of about 100 pixels in diameter.

❹

5 Start at the top left corner of the image and spray the blue sampled color into that area. The effect does not look that impressive because the color is covering all the texture in the background.

6 You can fix this by going back to the *Layers* palette. From the drop-down blend mode menu choose *Color*, and, as if by magic, texture will appear in the background. You can continue the task over the whole of the background area. Carefully color the background, taking care around the edges of the other areas of the picture. If you work with the image well enlarged, the procedure is fairly simple.

Once this task is completed, save the image as a Photoshop file and flatten the two layers together via *Layer > **Flatten Image***. Repair any blemishes or spots on the background using the *Clone* tool from the *Toolbar*.

❺

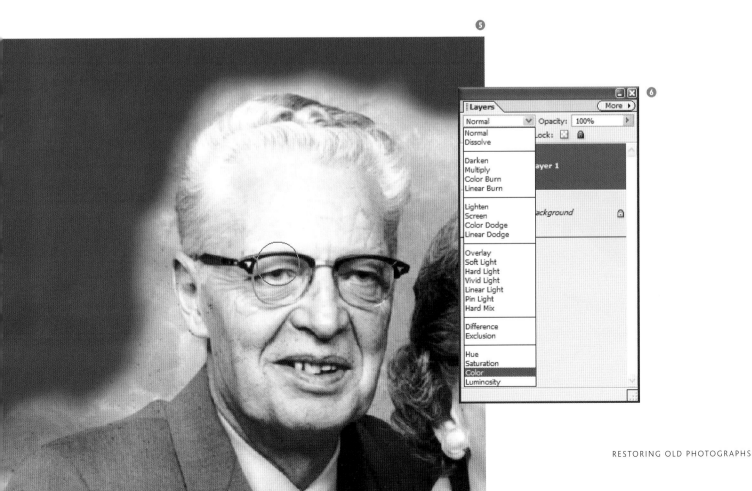

❻

Restoring Old Photographs continued

7 Repeat the process described in steps 3-6, but this time target the lady's green jacket. Using this method, you can now change the colors you have applied at any time.

8 Open the *Layers* palette and select the color layer that you have already created for the lady's coat. Tick the *Lock transparent pixels* box at the top of the *Layers* palette. Select a different shade of green, or another color altogether, from the *Color Picker* and hit Alt+Backspace. The color will flood the shape you have created for the coat to produce a complete and instantaneous color change. Once the color shape has been created, changing the color is easy as long as you lock the layer first to preserve its transparency.

9 Save and flatten the image. Repeat steps 3-6, but this time working on the man's jacket. You can work through the remainder of the repairs in the same way.

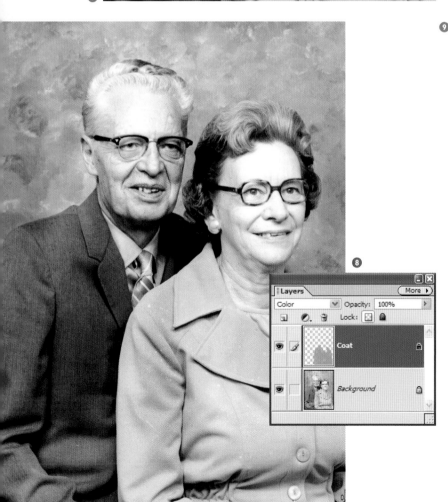

10 The problem area in this image is the skin tones; it is never easy to get them right and there isn't a good color to sample from in the original picture. Select a pink shade by clicking your foreground color and selecting an appropriate shade from the *Color Picker*. A degree of trial and error is needed. Given the success of the color restoration, this image would be considered a great success by the owners.

Dramatic restorations

The same techniques were used in this example, where the early color tints had faded to the point where the photo could almost be taken as a monochrome shot. Predictably, it was the skin tones that caused the most difficulty, but the end result is still a vast improvement.

TIP

Vary the size of the brush as you work to make your task easier. You can also reduce the Opacity setting of the Airbrush as you work close to the hair and clothes. These options are found at the top of the screen in the Options Bar. If you make a mistake with this color, you can switch to the Eraser, remove it, and do it again.

Fixing Damaged Photographs

One of the most rewarding jobs we can do with Photoshop Elements is to renovate an old photograph. Antique shots are always very interesting, as when we look back at pictures from years ago we get a real sense of the people and places being shown.

Our example image was one of a number of old photographs that formed part of a family's collection. The images are fascinating in their own right, even without the personal connection.

The pictures were scanned on a flatbed scanner in the normal way. Flatbed scanners do a great job with prints, but if you want to scan slides or old glass negatives you will need one with a transparency hood.

Renovating an old image is a great way to learn how to use Elements as it requires a number of skills that will be useful when working on other types of image.

TIP

Always add 1-2 pixels of monochrome noise from the filter menu to any computer-generated color you add to a photographic image. It helps to blend old and new elements together and looks more natural when printed.

It's often difficult to know where to start with renovation work, especially when you look at a section of the photo enlarged. The best way to proceed is by starting with the obvious things first. Once the biggest problems have been sorted out, the rest look less intimidating.

2 A good place to start is with the *Crop* tool from the *Toolbar*. Don't be keen to crop away too much of the damaged edge of an image, but some of the edge damage can be safely removed.

3 The sky in the image is a fairly uniform gray, so rather than repair the many scratches and blemishes in the sky it is probably best to replace it. Before you start to make any selections of the sky select the *Eye Dropper* from the *Toolbar* and sample two of the gray tones from the old sky before you get rid of it.

Select the darkest gray of the sky you can find as your foreground color with a left mouse click. Hold down the Alt key and click again in the lightest tone of gray just where the sky meets the top of the trees. This will ensure that when we add a new sky it will balance perfectly with the foreground and be the same tones as the one we removed.

The first step in removing the old sky is to select it. In this case, where there's little contrast between the sky and the background, the best tool to use is the *Polygonal Lasso*.

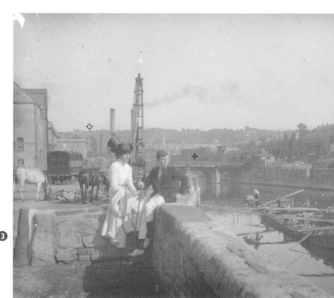

4 Enlarge the image greatly and make a selection around the edge of the sky. As we click down where the sky meets the buildings Elements will anchor the *Polygonal Lasso*. Move a couple of inches along the edge and click again. On curved areas, these steps should be shorter, while on straight edges they can be quite long. At first glance this looks a daunting task, but it doesn't take long. Using this method, you can make selections around areas of very fine detail.

TIP

If the selection process goes wrong or you have to leave it part finished you don't have to throw your hard work away. To pick up and add to an existing selection, either hold down the Shift key or click the Add to Selection *icon on the* Options Bar.

5 If you have to save your work for another time, you can save your selection as well. From the *Menu Bar* choose *Select > **Save Selection*** and give the selection a name in the dialog that appears. You can load the selection at any time in the future as long as you save the whole image in a Photoshop .PSD format.

6 When you have completely finished your selection, go to *Select > **Feather*** and add a 2-pixel *Radius* feather. Double click the Background thumbnail and rename it to turn it into a layer, then choose *Edit > **Cut*** from the *Menu Bar* to totally remove the sky.

7 You can add the new sky right away by clicking the *Create a new layer* icon, the left of the three icons at the top of the layers palette. Click and drag the new layer to the bottom of the stack.

Fixing Damaged Photographs continued

GRADIENT TOOL

LEVELS

CLONE TOOL

UNSHARP MASK

FLATTEN LAYERS

8 Select the *Gradient* tool from the *Toolbar*, and then choose *Linear mode* and *Foreground to background* from the options. Elements will allow you to draw a line from the top edge of our picture to where the trees meet the checkered background, and this will create a gradient using the two tones of gray you selected earlier. You should save the project and flatten the foreground and sky layers together at this stage.

9 Select the main image layer and call up the *Levels* palette from the menu via *Enhance > Adjust Brightness and Contrast > **Levels***. Move the outer sliders inward toward the edge of the histogram. This adjustment has a significant impact on the image, really bringing the tones to life.

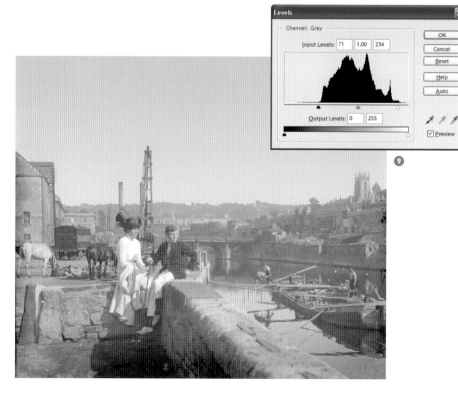

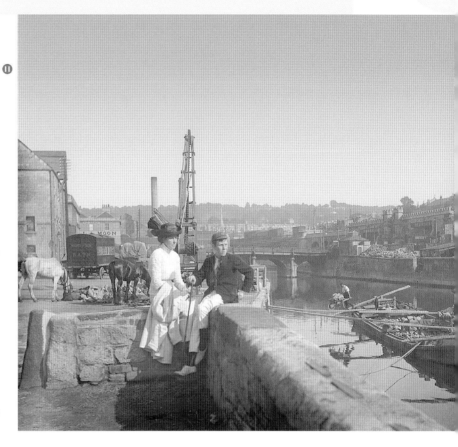

10 At this stage you need to select the *Clone* tool from the *Toolbar* and carefully start to repair the many scratches and marks that cover the picture surface. Given the age of the image it is not really surprising that there is still a fair amount to do.

Hold down the Alt key and Photoshop allows you to sample an area close to a mark, scratch, or blemish. Using a click, move, click motion you can transfer the sampled pixels over the scratch or mark, making a seamless repair.

The cloning task is best done with the image greatly enlarged and you can clone to a new blank layer if you wish. The advantage of working on a new blank layer is that you are never making changes to the original image, which allows you to make good any mistakes easily. Create a new blank layer as you did for the sky and, with the *Clone* tool selected, click the *Use All Layers* box from the *Options Bar*. Any cloning you now do will be to the new layer and not the original.

The cloning task isn't hard, but to get the right result you need to choose your clone source position carefully. For example, if you wish to remove a scratch from brickwork, you must make sure that you clone from an area with similar tones and shades to retain the texture of the brick and mortar. With a little care the repair becomes seamless. You can use the same technique to repair a tear or crease in a damaged photo.

Use a soft-edged brush and work around your image repairing the various marks and scratches until you have eliminated as many of them as possible. *Zoom* in close to check your work afterward.

11 The final task is to sharpen the image. The amount of sharpening you give to an old picture is a personal choice. Use the *Unsharp Mask* filter, but make sure you don't introduce pixelation effect by overdoing it. When finished, save the image then flatten the layers together via *Layer >* **Flatten Image**.

It is a good idea at this stage to compare the original with the final image. Bring them both on screen together and select *Window > Images >* **Tile** and both pictures will be placed side by side for comparison. You should see a remarkable change for the better.

Repairing the effects of time
The same methods were used on this antique photo. Clever cropping and tonal adjustment has bought it back to life .

creative
digital imaging

Once you become confident in
your image-editing skills, you will
learn that Photoshop Elements
isn't confined to improving your
photographs. Using layers, filters,
and blend modes, you can also
use it to transform photographs
or parts of photographs into
new and exciting works of art.
From complex montages to
pseudo-watercolor paintings
to attractive pattern pictures
and more, there is almost nothing
you cannot do with the right
technique and a little imagination.
This chapter shares some of the
best techniques—imagination is
one thing that you will have to
provide for yourself.

Flipping Effects

One of the creative ways you can improve your images is by using a flipping technique. This is a simple process, but it can be very effective on the right subject. It is a good idea if you can give some thought to techniques such as these at the shooting stage. While digital imaging techniques are good and can correct many of the faults introduced during the shooting of a picture, it is best to be aware of what you intend to do at the taking stage.

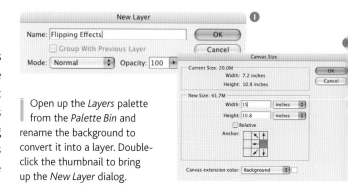

1 Open up the *Layers* palette from the *Palette Bin* and rename the background to convert it into a layer. Double-click the thumbnail to bring up the *New Layer* dialog.

2 You need to create canvas space for the flipping technique. To do that, go to the *Menu Bar* and select *Image > Resize > **Canvas Size***. Clicking in one of the nine squares at the base of this palette anchors the image to that side or corner—pick the middle-right square for this image. You need to double the width of the canvas, but if you overdo it you can always crop back to size later.

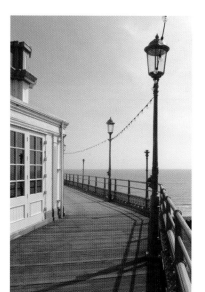

< *This example image was taken with the flipping technique in mind. I framed up the shot as best as I could so it would make half the picture.*

3 You now have the space to create a mirror image of the picture. This will occupy the blank left half of the canvas.

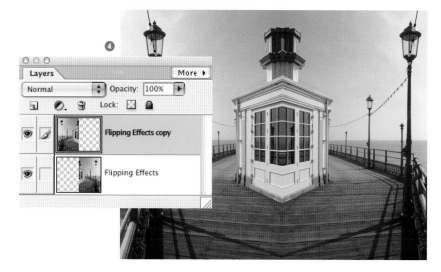

4 Open the *Layers* palette and drag the thumbnail up the *Layers* palette and drop it on the left copy icon at the top. Elements will create a duplicate layer. You can rename it, if you wish, by right-clicking the thumbnail.

From the *Menu Bar*, select *Image > Rotate > **Flip Layer Horizontal*** and Elements will create the mirror image. Use the *Move* tool from the top right of the *Toolbar* to move the left half of the image into place. The image now looks a little squat, but you can fix that by adding some width to the image. Save your work as a Photoshop .PSD file before moving on.

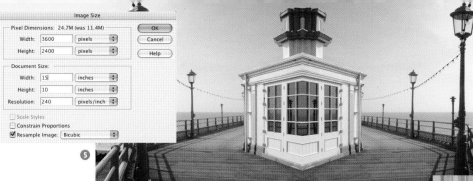

5 From the *Menu Bar*, select *Layer > **Merge Visible*** and Elements will join the two layers together. Select *Image > Resize > **Image Size*** from the *Menu Bar* and you can add some width to the image without affecting the height. You can do this by ticking the *Resample Image* box and by removing the tick in the *Constrain Proportions* box. Highlight the width and type in a new width setting.

6 Our image needs a focal point and what better than a person on the pier. The boy was taken from another photo taken in a similar position on the same day. This makes it easier to merge into the image.

TIP

Holding down the Ctrl key will turn any tool you have selected into the Move *tool. Release the Ctrl key and the original tool returns. This is a useful shortcut when you are moving and arranging objects in the picture space.*

7 Open and enlarge the image containing the boy and make a selection around him and his shadow. The *Freehand Lasso* tool will be adequate for this task. Add a *Feather* of 1-2 pixels to the selection and select *Edit > **Copy*** from the *Menu Bar* to copy the selection to the Elements clipboard.

Click out of that image and back into the original one and select *Edit > **Paste*** from the *Menu Bar*. Elements will paste the selection into the layers stack. You can then use the *Move* tool to move the boy into place. Use the *Free Transform* tool to reduce his size if he looks out of scale with the environment.

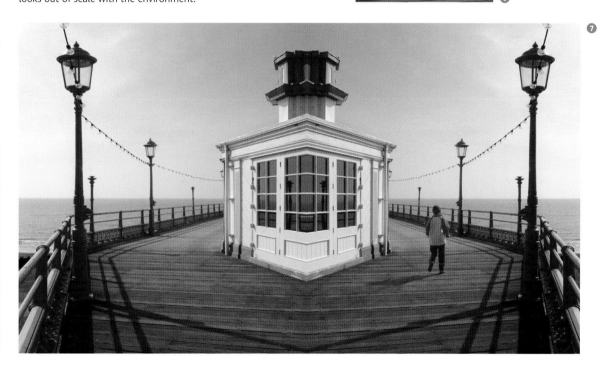

◄ *You can use the flipping technique in other ways. Here I copied the landscape, then flipped it vertically to create a basic "reflection."*

Action and Movement

Capturing movement in pictures at the taking stage demands some simple skills like panning with a moving subject. The background will blur, leaving the subject crisply focused. That's the theory, anyway, even if things don't always work out as you would wish!

You can improve your pictures by adding action and movement using the tools of Photoshop Elements; one of the most effective is *Radial Blur* from the *Filters* menu. This effect is similar to the zoomed effect created by zooming a telephoto lens during an exposure.

∧ *This example image was shot in very bright conditions, and the feeling of movement has not been captured as well as it could have been. Using Elements tools can introduce some action.*

1 This shot will be improved by the application of the *Radial Blur* filter, but not if you apply it to the image as a whole. The surfer—the center of interest—would be lost if you did.

Select the *Freehand Lasso* tool from the *Toolbar*. Your selection does not need to be precise and will only take seconds to do. Just follow the rough shape of the surfer and his surfboard.

2 From the *Menu Bar*, choose *Select* > **Feather**. For this task you need a high feather value of at least 100 pixels. The selection is currently covering the center of the image, but you need the center protected and the edges selected. Do that by choosing *Select* > **Inverse** from the *Menu Bar* or use the shortcut Ctrl+Shift+I.

3 Go to the *Menu Bar* again via *Filters* > *Blur* > **Radial Blur** and Elements will present you with the *Radial Blur* dialog. For this technique, select *Zoom* as the *Blur Method*.

Choose *Draft* from the *Quality* setting. The *Zoom* amount is a personal choice and you can try out a few different settings. Here, I used a setting of 40.

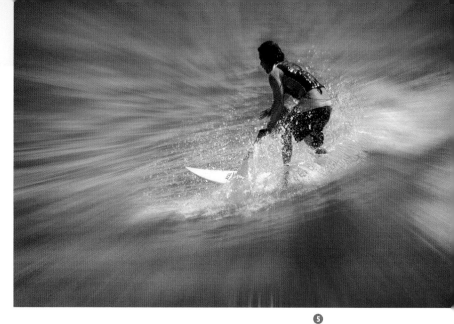

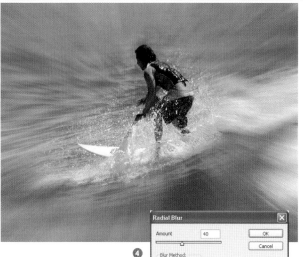

4 If you click into the thumbnail on this palette, you can drag the *Zoom* effect and place the center of it roughly over the center of interest on the picture, which is the surfer. Click *OK* and Elements will do its work. Hit Ctrl+D to remove the selection and evaluate your work.

5 To enhance the overall effect of the picture, you can also darken the outer edges a little. Make a freehand selection around the outer edge in a rough oval shape and then inverse the selection. Add a 150-pixel *Radius* and using the *Levels* palette (Ctrl+L) move the center *Midtone* slider to improve the impact.

TIP

Use the Draft *setting to see a quick preview before running* Radial Blur *at* Best. *The filter can be slow to run at* Best, *so experiment in* Draft *then redo it.*

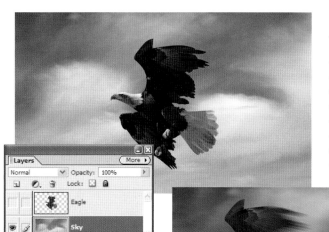

∧ In the second example, you can again use the Blur *tools, but this time the* Motion Blur *filter. Cut the eagle out from its original background and make sure that both it and the sky sit on separate layers.*

∨ *With the sky layer selected, you can introduce a* Motion Blur. *You must ensure that the angle of the blur matches the bird's flight.* Motion Blur *can also be applied to the eagle layer via a feathered selection. If you make a feathered selection of the back of the bird, it will ensure that the head, eyes, and beak remain sharp.*

∨ *Another advantage of having each part of the image on a separate layer is that it gives you the ability to change the composition by moving the bird.*

Color to Black and White

Light rarely gives the correct exposure or contrast for all the different tones in our pictures, making most exposures a compromise. How many times do you have a great sky and almost black foreground or a great foreground and a white sky?

Here, we are going to reduce a color image to monochrome and adjust the various tones so that the end result has a crisp black and white sparkle.

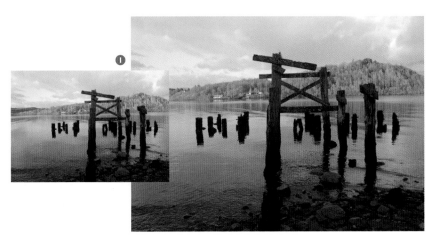

I You can convert the image to monochrome in a number of ways, but the quickest method is to use the shortcut Shift+Ctrl+U.

2 Begin by making tone and contrast adjustments to different parts of the image. This usually entails selections, but not in this case. Start by getting some balance between the darker foreground and the lighter distance.

Open the *Layers* palette from the *Palette Bin*. Click the *Create adjustment layer* icon at the top center of the *Layers* palette, and then select the *Brightness/Contrast* option.

∧ *With an adjustment layer, you are not changing any of the tones in the original image, only on the adjustment layer. Click the* Layers *tab in the* Palette Bin *and you will see the adjustment layer and the mask that Elements attaches.*

3 You need to introduce more contrast to the central part of the water in the image. Move the Contrast slider slowly upward, concentrating on getting the tones right in the area you want to affect. Ignore the effect that this manipulation may have on the sky and the rest of the image, as you can deal with that next.

4 You can now use the adjustment layer to balance the tones. Select black as the foreground color and the *Linear Gradient* tool from the *Toolbar*. Set the *Gradient* options to *Foreground to Transparent*. Draw a line down the image, extending from the top of the sky to about two-thirds of the way down. Elements will apply a gradient to the adjustment layer and mask the sky. You now have a beautiful blend of the top and bottom tones.

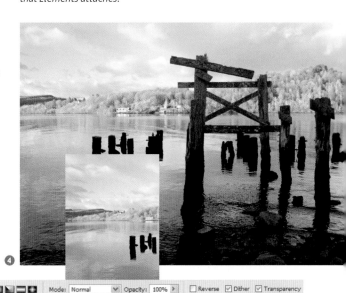

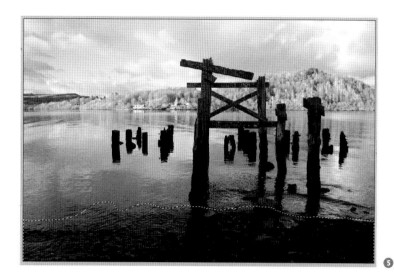

5 These manipulations still leave the immediate foreground stones a bit dark, so let's deal with these next. Open the *Layers* palette and select the original landscape at the bottom layer of the stack, then make a simple *Freehand Lasso* selection of the foreground. From the *Select* menu, choose the *Feather* command and add a 100-pixel *Feather* to the selection. This ensures that changes you make in the foreground will blend well into the middle distance.

6 Call up the *Levels* command via the shortcut Ctrl+L and adjust the sliders to lighten the foreground tones. You can do the same thing to the sky by making a quick, irregular-shaped *Freehand Lasso* selection first.

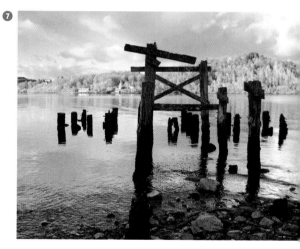

7 Adjusting the tones and contrast separately in different parts of the image has made quite a difference.

You can also clone out the distracting white building on the other side of the water and then flatten the image using the *Layer > Flatten Image* command.

8 The sky top right is a little weak in tone. This can be adjusted with another adjustment layer or a freehand selection. Lastly, you can add some *Unsharp Mask* to sharpen the image, then compare it with the original shot.

The changes that have been made to different parts of the image have made good the camera's compromise exposure. This image has been adjusted using both selections and an adjustment layer, but you can decide which way of working you prefer.

Toning

Using the standard tools of Photoshop Elements you can apply many toning effects, that, when used correctly, can alter and enhance the mood of your pictures and improve them immensely.

The important part of toning is to select the right pictures to apply the tones. That is not to say you cannot apply any tone to any image, but some tones will definitely seem more appropriate than others.

In this example image, the original color does not add much to the picture. The fact that this is a very old cottage means that it lends itself very well to sepia toning.

1 There are many ways to create a sepia tone. You could use the *Quick Fix* tools, but the best option is found in the *Menu Bar*. Select *Enhance > Adjust Color > Adjust Hue/ Saturation* or use the shortcut Ctrl+U to bring up the *Hue/ Saturation* palette.

To begin the sepia-tone process, tick the *Colorize* box at the bottom right of the *Hue/Saturation* palette. The whole tone of the image should change instantly.

2 You can now adjust the *Hue*, *Saturation,* and *Lightness* sliders to achieve the sepia tone. Apply a setting of 25 as the *Hue* value and 10 for the *Saturation* value to start with. These settings will create a sepia tone, but further adjustments to the sliders allow you to create just the right depth and color.

This shot from a 35mm scanned monochrome negative is an excellent choice for a sepia tone. The settings used for the cottage work equally well for this early car.

Another favorite tone is a blue tone. It is created in exactly the same way, but with a slight change of settings. A Hue value of 215 and a Saturation value of 25 creates a pleasingly serene shade of blue. This winter landscape lends itself especially well to the treatment.

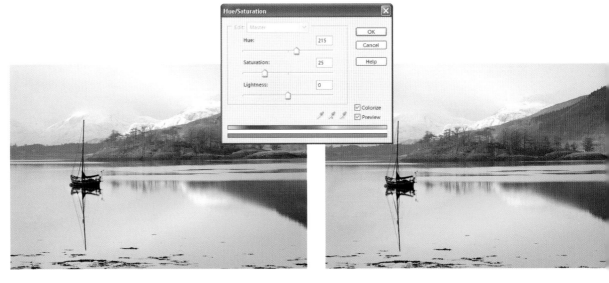

This toning technique can be used more creatively by combining several tones in one image. The background sky in this example was toned by making a selection with the Magic Wand tool and feathering the edge of that selection by a pixel value of around 25-30. The Feather command is found via Select > **Feather**. The Magic Wand picks up only part of the sky, allowing you to tone that area. You can then repeat the process on different parts of the sky, introducing a different tone with every selection.

Each time you carry out this process, you will get a different effect depending on what the Magic Wand automatically selects.

Spot Color

Using an adjustment layer is a great way to color your images selectively to bring out interest or detail in them. Having made one, you can use a brush to select which parts of the image it will or will not affect. Here we use this method to add a sepia tone to an image, then reveal the green flag and the red of the guard's buttonhole.

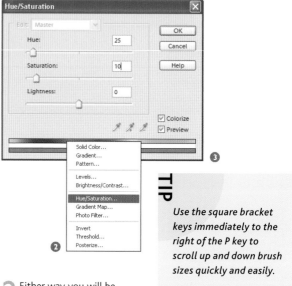

3

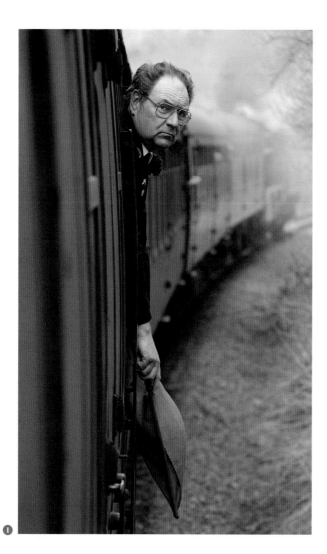

1

Open the *Layers* palette via the *Palette Bin*, then create a new adjustment layer by clicking the icon at the top center of the *Layers* palette, or by selecting *Layer* > **New Adjustment Layer**.

2 Either way you will be presented with a list of possible adjustment layers. Go down to the third section and choose *Hue/Saturation* from the options.

First of all, click the *Colorize* box in the *Hue/Saturation* dialog window, then move the sliders until the saturation reads about 10 and the hue 25. If you want to save time or be exact with your settings, you can ignore the sliders and type the numbers directly into the boxes above.

3 As seen in the previous tutorial, this procedure produces a good sepia tone. When you are completely satisfied with the shade and depth tone, click *OK*.

TIP

Use the square bracket keys immediately to the right of the P key to scroll up and down brush sizes quickly and easily.

4 One of the advantages of working with an adjustment layer is that at any time while you are working on an image, you can doubleclick the adjustment layer thumbnail on the *Layers* palette and the *Hue/Saturation* dialog window will open.

An adjustment layer can also be saved and brought back into play at a later date, as long as you save the file as a Photoshop .PSD file.

4

5 To bring back the original green of the flag, first enlarge the image until the flag in the guard's hand fills the screen; it is much easier to mask the flag at this size. Select a soft-edged brush and choose black as the foreground color. You can then carefully spray black onto the sepia flag and the original green will begin to show through. Using varying brush sizes and a varying *Opacity* setting we can reveal the green flag from the layer beneath.

If you make an error while spraying black onto the adjustment layer, change the foreground color to white and repair the overspill. White applies the adjustment, black removes it.

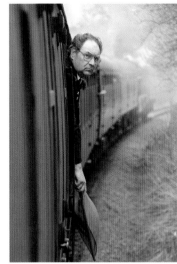

5

6 Finally, use the black paint to reveal the red of the carnation on the guard's lapel.

6

▶ *You can use this adjustment layer trick in many different settings. In this second example there was no real center of interest until I reduced the whole image to monochrome and revealed just three people at the table in color.*

Hand Tinting

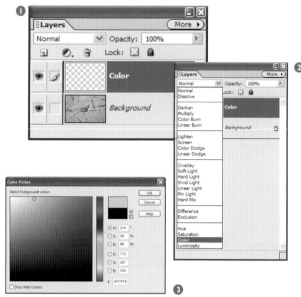

Have you ever wondered why children's coloring books are so addictive? Many adults can't resist the temptation to pick one up and try doing it themselves—when no one is watching, of course. It's therapeutic and satisfying, and perhaps that's why hand-tinting images is so much fun; for a short while, you can become an artist.

1 You will need to add your color onto a new blank layer. Go to the *Menu Bar*, select *Layer > New > Layer* and in the box that appears type "Color" as the layer name.

2 You need to change the blend mode from within the *Layers* palette so that, as you apply color, the texture of the rock shows through. Click the *Layers* tab from the *Palette Well* and select *Color* from the drop-down menu.

3 Next, choose a color to work with from the *Color Picker* palette. It is best to stay with delicate tones for this technique.

∧ The tinting process works better and looks more attractive with delicate colors, so pick an image that will lend itself to such treatment. Here, I chose a close-up of a piece of rock.

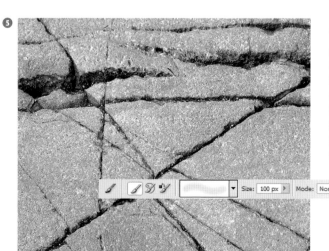

4 Select the paintbrush from the *Toolbar* and an *Opacity* setting of about 10% from the *Options Bar*. Use a soft-edged brush at about 100 pixels diameter. You will need to vary the diameter of the brush as you work so that you can keep your color within the sections of the rock.

5 To apply the color, carefully paint inside one of the rock sections on the new blank *Color* blend layer.

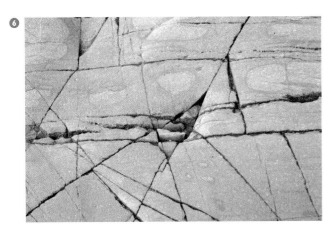

6 Select other appropriate colors from the *Color Picker*, and paint in other sections of the rock's surface.

You can leave one of the rock shapes blank in order to insert a picture into that space later. You can then create the illusion that you have painted that picture too.

7 With the lighthouse image on screen, select the *Move* tool from the *Toolbar* and drag and drop the lighthouse into the rock picture. Call up the *Transform* tool using the shortcut Ctrl+T and, while holding the Shift key, drag a corner toggle to size the image to fit this section of the rock.

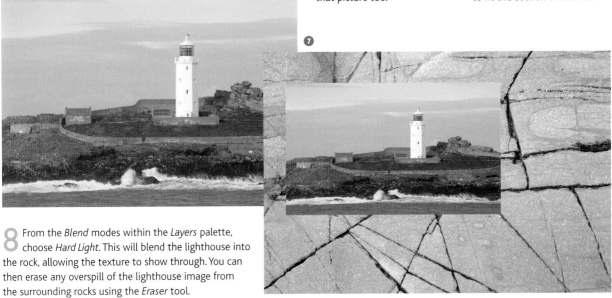

8 From the *Blend* modes within the *Layers* palette, choose *Hard Light*. This will blend the lighthouse into the rock, allowing the texture to show through. You can then erase any overspill of the lighthouse image from the surrounding rocks using the *Eraser* tool.

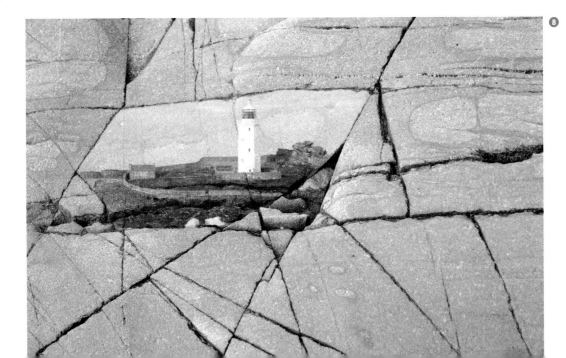

Vignetting

When a good shot is spoiled by distractions at the sides or corners of the image, there are several approaches you can take. Cropping can eliminate the problem, or you can clone out those ugly dark corners. Some photographs benefit from a different approach. A vignette not only adds charm to a portrait, it also covers up the offending areas.

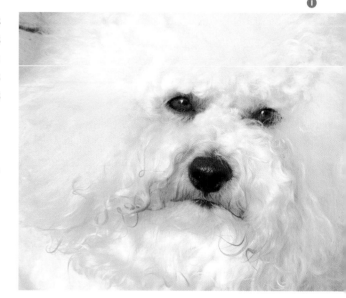

When taking pictures of pets, it is important to get down to their level. That is what I did with this example picture of Skipper. The close-up nature of the image has given it impact, but there are some distractions around the edge of the image that need to be dealt with. The vignette approach would be perfect for this example.

2 You can create a vignette directly onto the image on screen, but that limits your control of the vignette. A better way of working is to use a new blank layer. Go to the *Palette Bin*, click the *Layers* tab, and then click the left-hand icon of the three at the top of the *Layers* palette to create a new blank layer.

TIP

You can rename any layer by right-clicking the thumbnail and typing a name in the new layer box.

3 Select the *Elliptical Marquee* tool from the *Toolbar* and draw out an oval shape, centrally placed over the picture, starting in the top left corner. This selection will allow you to make changes only to the central area of the picture, so switch the selection to the outer edges via the shortcut Shift+Ctrl+I.

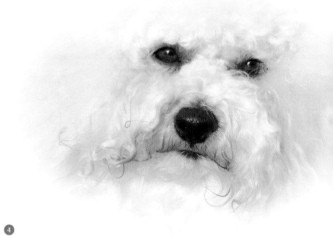

4 To create an effective vignette, you need to feather the edge of the selection via *Select > **Feather*** from the *Menu Bar*. Choose a high *Feather Radius* of about 100 pixels to obtain a soft, graduated edge to the vignette.

With white selected as the foreground color, hit Alt+Backspace or use the *Paint Bucket* tool from the *Toolbar* to flood the oval shape with white. Remove the selection via the shortcut Ctrl+D and you have your vignette.

5 It is a good idea to add 1-2 pixels of monochrome *Noise* to any computer-generated color that you add to an image. While this is almost undetectable on screen, the smooth tones of computer color can look a little plastic when printed. Go to *Filter > Noise > **Add Noise***. The palette that appears on screen may seem to be blank, but Elements has just drawn the information for the thumbnail from the center of the screen, which in this case is transparent. Click and drag the thumbnail to the left or right and the vignette will come into view.

6 Sometimes you will want to increase the intensity of the vignette. Click and drag the vignette layer down the *Layers* palette and drop it over the center *Copy* icon. This creates a duplicate of the vignette layer and the intensity of the feathered edge is intensified.

∧ *Creating the vignette on a separate layer allows you to adjust the vignette easily using the* Opacity *slider in the* Layers *palette. Although this vignette works well with the example image at 100%* Opacity, *you will sometimes need to reduce the intensity of the vignette for a better result.*

∧ *Vignettes don't have to be white; black can be more appropriate as long as it is in keeping with the image. The selection also doesn't have to be an oval or elliptical shape. With this picture, the selection was made via the* Freehand Lasso *tool. As the image had a much higher resolution, the* Feather Radius *needed to be increased to 200 pixels.*

> *Once you have flooded the selection and removed it via Ctrl+D, you can add to the vignette with the* Brush *tools if necessary. Almost any color can be used for a vignette—the important thing is that your choice balances well with the image.*

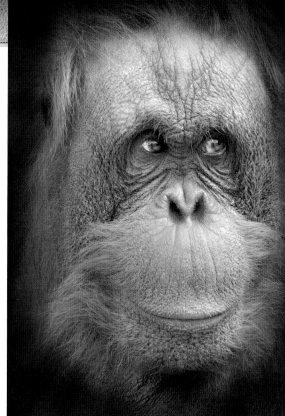

Aging Effects

Whenever you attempt to change the mood of an image, your first consideration should be selecting the right image. It is important to apply the right techniques to the right picture.

This is true of many digital techniques, and the addition of filters is one example. If you select the wrong image with the wrong effect you are unlikely to improve your images very much.

Creating aged effects can add something to an image. Old pictures generally have a certain charm, and you can create and convey that to a viewer.

The aim is not to be deceitful and trick the viewer, but to create an effect without destroying the appeal of the picture. This is rarely a one-click process, and you may have to make several manipulations to achieve the desired effect.

Using the shortcut Ctrl+U, call up the *Hue/Saturation* window and tick the *Colorize* box down on the bottom right. For a sepia tone, the *Hue* setting needs to be around 25-30 and the *Saturation* around 10. As aged pictures are often faded, you can also adjust the *Lightness* slider a little to simulate that effect.

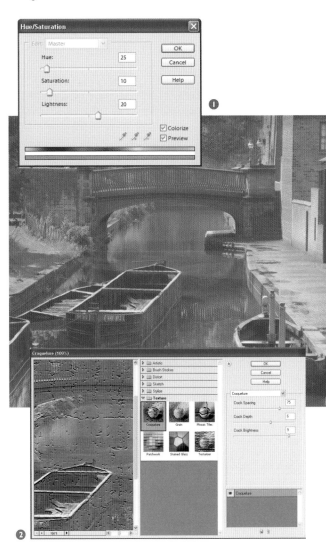

∧ *This image was carefully selected to ensure that it would react well to an aging effect technique. A sepia tone is often associated with an aged image so try that first.*

2 You can use the *Craquelure* filter to break up the surface of the image. However, this filter does not work very well on high-resolution images and, as this image came from a 6-megapixel camera, the resolution needs to be reduced to get a reasonable result. This is not a problem as you are deliberately reducing the image quality for effect anyway.

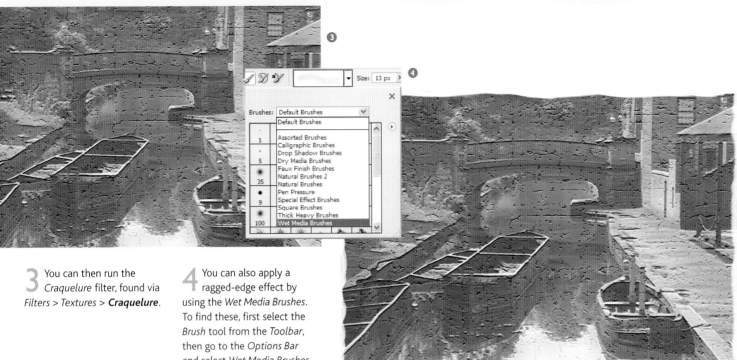

3 You can then run the *Craquelure* filter, found via *Filters > Textures > **Craquelure***.

4 You can also apply a ragged-edge effect by using the *Wet Media Brushes*. To find these, first select the *Brush* tool from the *Toolbar*, then go to the *Options Bar* and select *Wet Media Brushes* from the pull-down menu.

5 Select brush number 8 and white as the foreground color, then manually create an irregular border around the image.

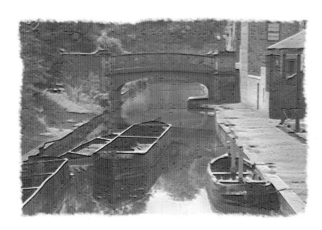

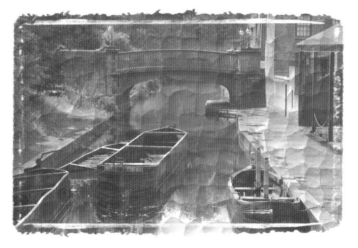

∧ Take time to experiment with the image. You may want to make use of the Dust and Scratches *filter from the* Noise *menu along with the* Craquelure *filter and other brushes to create an irregular effect.*

> *If you go outside of the Elements effects to third-party filters such as Dreamsuite Photographic Edges, you can find specialized filters, such as Mud Cracks, which also create an aged effect. Other filters within the Dreamsuite package even create the effect of tape stuck onto the picture's surface.*

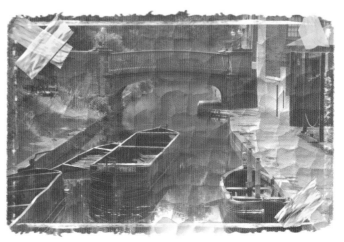

Painterly Effects

Almost all image-editing software comes with effects filters that are fun to try out, and Photoshop Elements is no exception. As well as the filters that are a part of Elements, you can add more filters made by other software developers. These filters are usually installed into the plug-ins folder within the Photoshop Elements program structure. As you load up Elements, it reads the third-party filters and adds them to your filter list.

Adding filter effects to images is great fun, but they can become tedious if you overuse them. Filter effects are easy to apply and are often used on the wrong image to cover up mistakes and errors. To work well, filter effects need to be used sparingly and on the right choice of picture.

⋀ *To really get people's attention, you need to avoid using the same old filters and create something different that cannot be obtained by a single click of a button. This technique came from Barry Colquhoun, who kindly shared it with me. It involves a blend of four layers and filter effects, but is simple and easy to do.*

The technique does not work so well on images with fine detail or those with large expanses of even tone such as a blue sky. Good choices are images that fall somewhere in between, like the one shown here.

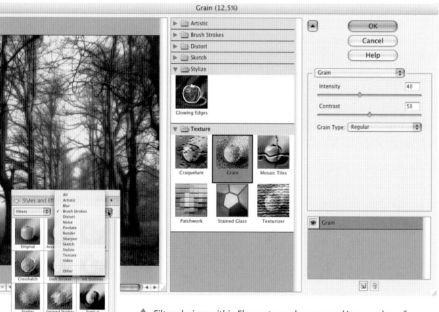

⋀ *Filter choices within Elements can be accessed in a number of ways. You can either select the* Styles and Effects *palette from the* Palette Bin *and access your filters via the thumbnails (shown left), or you can select* Filter Gallery *from the pull-down* Filter *menu on the* Filter Bar. *Both these methods will give you some idea of what effect that particular filter will apply. Click the thumbnail and the settings and a preview of that filter applied to your image will be presented to you. If you already know which filter you wish to use, you can go direct to* Filter *from the* Menu Bar *and pick your choice from the menu.*

With filters, the effect varies depending on the image's resolution. Filters work on pixels, so more pixels means the effect is less apparent.

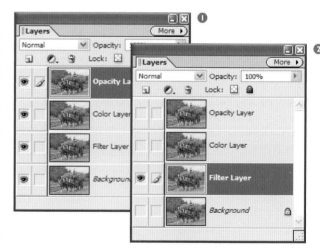

I For this filter process, you need to make a number of layer copies. From the *Menu Bar* select *Layer* > **Duplicate Layer** to make a layer copy. In the new layer box, type the name "Filter Layer." Repeat this process to create a third layer copy and call this "Color Layer." Repeat again and call the fourth layer "Opacity Layer." These names reflect the process you are going to apply to each layer.

Click the *Layers* tab from the *Palette Bin* and you will see the four layers. The bottom layer, or background, is going to sit there just as insurance. This is advisable as filter processes sometimes affect parts of the image a little too much. Keeping an intact original means that you can start afresh if you have to.

2 For the moment we need to turn off the top two layers and the Background by clicking the eye icon. The layer we need to start our filter process is the second layer, the one that we called "Filter Layer" in step 1.

❸

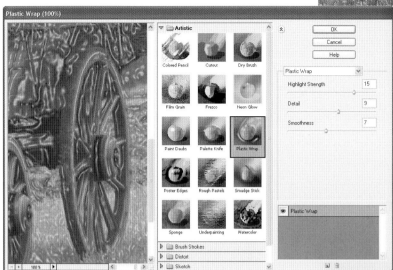

3 Start by selecting *Filter > Artistic > **Plastic Wrap*** from the *Menu Bar* and the options (and a preview) for this filter will appear on screen. In most cases the default settings work fine, so stay with those, at least to start with, and click *OK*.

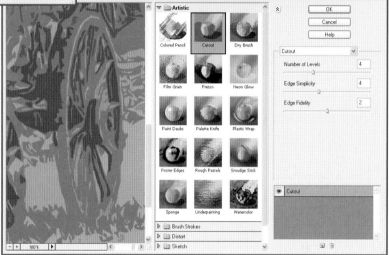

4 The result that appears on screen after the filter has run is not that attractive, but don't abandon it just yet. Go back to the *Filter* menu for the next stage via *Filter > Artistic > **Cut-out***. Again the default settings of 4, 4, and 2 will work well. Apply the *Cut-out* filter to the same layer as the *Plastic Wrap* filter.

5 The result still doesn't look that impressive, and it has lost a lot of color as well. This will be addressed later, but for now, save your work and move on.

❹

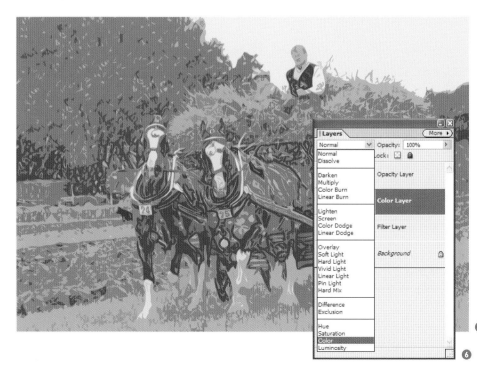

6 Turn to the "Color Layer" to correct that loss of color. Open the *Layers* palette and select the "Color Layer" by clicking into the thumbnail; the layer will become selected ready for editing. This will hide the filtered layer below. The next step is to blend the "Color Layer" with the one below using blend modes.

Go to the blend modes drop-down in the *Layers* palette and select *Color*. Elements will now blend the color of this layer with the filtered layer below.

❺

❻

Painterly Effects continued

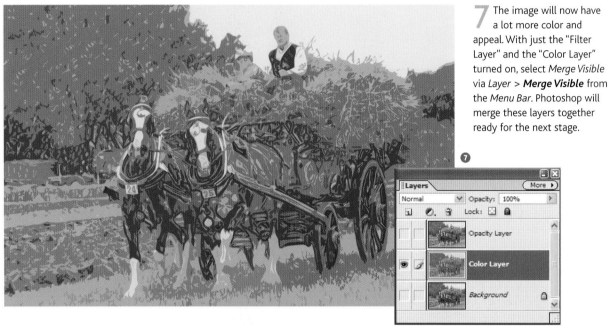

7 The image will now have a lot more color and appeal. With just the "Filter Layer" and the "Color Layer" turned on, select *Merge Visible* via *Layer > **Merge Visible*** from the *Menu Bar*. Photoshop will merge these layers together ready for the next stage.

8 Now turn on the "Opacity Layer." Using the *Opacity* slider, you need to allow a little of the original image to blend with the filtered part. Reduce the *Opacity* to zero then slowly move the slider back up the scale to get just the right balance between the filtered and the unfiltered layer.

9 You can merge these two layers together once you are happy with your blend. This leaves you with just two layers; Background and the "Opacity Layer." Take a moment to consider what else needs to be done to achieve a really good result. With this technique, a lot depends on the image used.

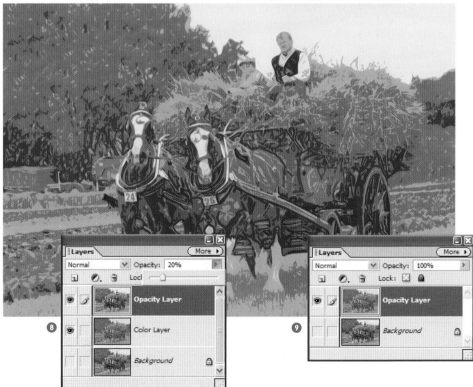

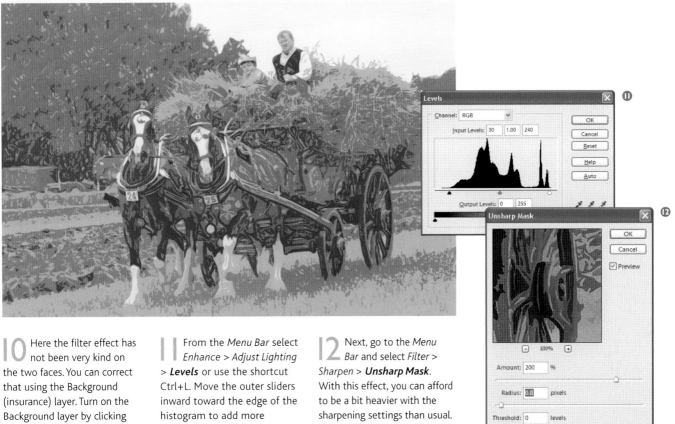

10 Here the filter effect has not been very kind on the two faces. You can correct that using the Background (insurance) layer. Turn on the Background layer by clicking the eye icon, but select the "Opacity Layer" for editing.

Using the *Eraser* tool, gently remove the filtered detail from the upper layer to reveal the unfiltered faces from the layer below. You need the image well enlarged to make this task easier. Then, from the *Layer* menu, select *Flatten Image* and Elements will convert the remaining two layers to one.

11 From the *Menu Bar* select *Enhance > Adjust Lighting > **Levels**** or use the shortcut Ctrl+L. Move the outer sliders inward toward the edge of the histogram to add more contrast to the image.

12 Next, go to the *Menu Bar* and select *Filter > Sharpen > **Unsharp Mask***. With this effect, you can afford to be a bit heavier with the sharpening settings than usual.

13 Finally, call up the *Hue/Saturation* dialog window via *Enhance > Adjust Color > **Adjust Hue/Saturation*** or use the shortcut Ctrl+U. This process can often stand a little more color *Saturation* than usual. Here, +20 *Saturation* was added for the final result.

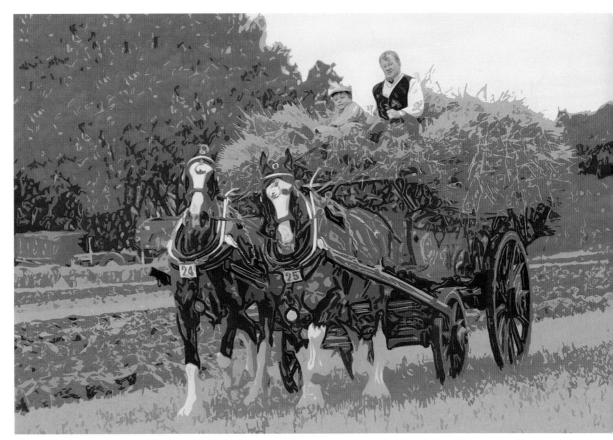

Painterly Effects continued
Watercolor

While the artistic filters seem to be the natural choice if you are trying to recreate a painted style in Photoshop Elements, they aren't the only choice or necessarily the best choice. Alternative filters, or even combinations of filters, can sometimes produce more effective results, as you can see from this example.

∨ *This image was shot with a 3-megapixel camera. Its clear lines and bright colors are perfect for an artistic treatment.*

To start the filter process, make a duplicate layer in the same way as before.

2 From the *Menu Bar* select *Filter > Blur > Smart Blur* and the options for this filter appear. From the *Quality* option select *High* and from the *Mode* option *Edge Only*. The *Radius* and *Threshold* sliders enable you to create more or fewer edge lines, but for this image leave them at the default setting. Click *OK* and Elements will create white lines on a black background.

3 You actually need black lines on a white background for this technique. This is simply achieved via *Image > Adjustments > Invert* or via the shortcut Ctrl+I

④

⑤

5 From within the *Layers* palette, click into the original layer at the bottom of your layers stack to select it for editing. From the *Menu Bar* select *Filter > Pixelate > Crystallize* and choose a *Cell Size* of about 20. You then need to soften the edges of those "crystallized" shapes to create more of a watercolor effect. Do that via *Filter > Blur > Gaussian Blur*, adding a 5-pixel *Radius* blur.

4 Click the *Layers* tab again from the *Palette Bin* and from the drop-down *Blend* modes select *Soft Light*. This will give the image a watercolor effect as the lined layer is blended with the original layer in the layer stack.

⑥

6 The layer blend process you have used has caused the tones in the combined layers to be a little weak, but that works in your favor to give the image a convincing watercolor effect. Now flatten the layers by selecting *Layer > Flatten Image*.

Adding Texture

Adding texture to digital images may seem an odd thing to do. It involves taking images, often from high-quality cameras and lenses, and then degrading the quality of the image with the application of a filter.

So, why would you do it? Because, on the right subject, it adds to the charm of the picture and helps to improve it. As with filters, textures should be used sparingly and with an appropriate image.

∧ The resolution of an image affects how the texture will appear. In this example, the same image is shown with the same texture applied using exactly the same options. However, one image is 300ppi and the other is 72ppi. Both images are 10 by 7 inches, and you can clearly see that the lower-resolution image shows the effect of the texture far more clearly. If they were both printed at this size, the texture in the 72ppi version might seem heavy and clumsy, while the higher-resolution image would not show the effect very much at all. In fact, it might even look like an error rather than an attempt to improve the image.

1 To apply textures, you need to select the right image. This shot has already been treated with a watercolor effect, so using an appropriate texture will add something worthwhile to it. This image is 10 inches on the long side and has a resolution of 300ppi.

2 Select textures by clicking the *Filters* tab from the *Palette Bin* and choosing a filter via the thumbnails. If you doubleclick the *Texturizer* thumbnail, the *Options* palette opens up. Clicking on the *Texture* drop-down menu enables you to take a look through all the options you have at your disposal.

TIP

Rule one has to be to save your image without a texture before proceeding any further. It is always good practice to save your images with and without a texture. You never know when you may want to use your image without the texture and you cannot remove one at a later date.

3 You can also click the plus or minus icons below the thumbnail to adjust the image/thumbnail size so that it matches the print size of the image. This helps you to evaluate the scale and relief of your texture.

Choose the *Burlap* texture and adjust the scale and relief settings. For a high-resolution image such as this a high setting will generally be required in the scaling slider. A low-relief setting generally works best for many of the *Texture* tools.

TIP

Always evaluate the effect of any texture you place on your image at the size you intend to print the image. Select the Zoom *tool from the* Toolbar, *then click* Print Size *on the* Options Bar. *Textures that look fine on screen can look too heavy in print.*

4 Adjust the *Light Direction* and you will see the effect of your choice in the thumbnail. Click *OK* and you can appraise the image on screen at the print size. At this stage you can still use the *Undo History* if you feel that the settings are not quite right and want to run them again.

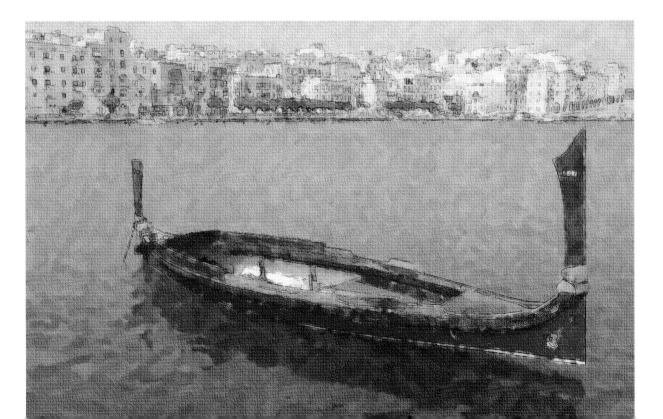

Adding Texture continued

TEXTURIZERS

LOAD TEXTURE

FROSTED GLASS

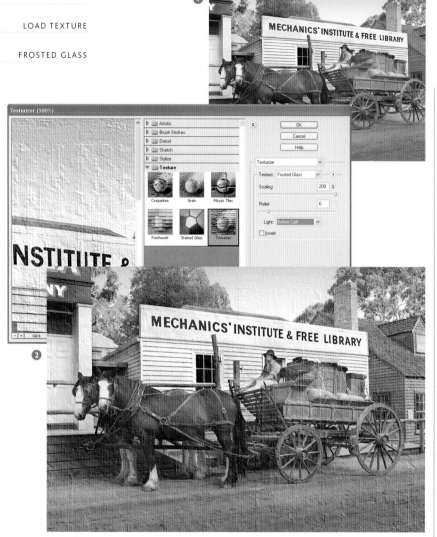

Combining textures

1 We can also include more than one texture on our image if we wish.

In our example we can add a coarser texture to the outer edge of our image and a finer one on the inside. This is best accomplished with a selection.

2 There are two approaches we can take here. We could use the *Lasso* tool from the *Toolbar* to create this selection freehand if we wish. Otherwise, we could use the *Elliptical Marquee* tool to create a more uniform selection.

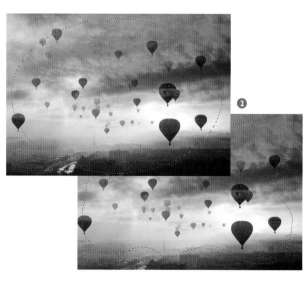

Additional textures

1 This second example is another image that lends itself well to a texture effect. With the image on screen, choose *Filter > Texture > Texturizer* from the *Menu Bar* and select *Load Texture* by clicking on the black arrow in the right-hand part of the dialog window. This brings up a *Look in* drop-down box. Look in the folder where Photoshop Elements has installed itself on your hard drive, and find a folder called Presets. This contains additional textures.

2 Select *Frosted Glass*; this is a larger-scale texture that works better with higher-resolution images.

Each texture will have a different affect on your images, so experimentation is the key. That is why you should always save a copy of the original, untextured image in a safe place before starting.

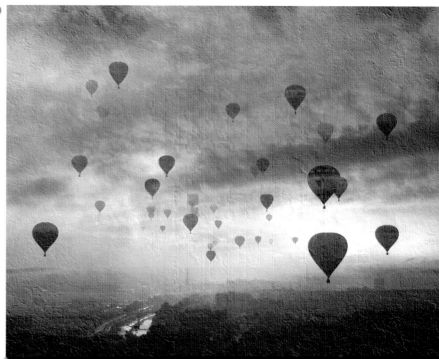

3 Before we apply any texture effects we need to *Feather* our selection to ensure a gentle blend between the two texture effects. On this 5-megapixel image a feather *Radius* of about 150 pixels will give us the result we need. Find the *Feather* command in the *Select* menu and experiment until you get the right setting.

4 Go to the *Texturizer* and select the texture effect you require for the center of our image. *Frosted Glass* is one of those textures that can be found in the Elements Presets folder, as described on the opposite page.

5 To add a texture to the outer edge of the image we must first inverse our selection via *Select > Inverse* or via the shortcut Ctrl+Shift+I. We can then choose another texture effect like *Rust Flakes* to complete the effect. Not all combinations work well together, so use a bit of trial and error to find something that works on your image.

6 As usual with Photoshop Elements, only our imagination limits what we can achieve with our software.

TIP

It can be a bit of a journey to find these filters, so it is a good idea to locate the folder and copy it to a more convenient place on your hard disk.

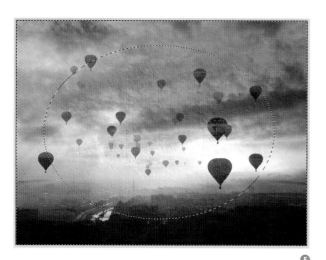

∨ *This Civil War montage has been filtered with the* Rust Flakes *texture found from the* Load Texture *option.*

Other Effects

QUADRANT FILTER

NEON NIGHTS FILTER

FLUORESCENT CHALK

SKETCH FILTER

NOTE PAPER FILTER

As well as Elements' *Filters*, there are also a collection of other *Effects* that can be accessed via the *Styles and Effects* palette in the *Palette Bin*. Illustrated on this page are a small selection of such effects.

The first thing to remember with all *Filters* and *Effects* is that they will vary slightly depending on the resolution of the image; experimentation is the key. The worst that can happen is that you have to hit the *Undo* key. You can never be entirely sure what effect a filter will have on an image until you try it out.

◄ *Elements' vast array of filters and effects are found in* the Styles and Effects *palette in* the Palette Bin. *By using the drop-down menus you'll find specialist effects for images, frames and text, each with a thumbnail preview that gives you an idea of what the effect will look like.*

∧ ➤ *The* Quadrant *filter (top) divides your image into four equal sections and applies preset duotone effects to each, while the Blizzard filter (right), as its name suggests, creates a snowstorm effect.*

∨ *The* Neon Nights *filter darkens the entire image, and then picks out significant edges and depending on the brightness values of the edge, applies a neon effect.*

∧ Fluorescent Chalk *is a painterly effect that emphasizes your image's edges and then flattens the remaining tones and colour values.*

Sketch Filter

1 This image of a mountain cottage is a good example of where using layers can help an effect. Click the *Layers* tab from the *Palette Bin* and create a duplicate layer. The quickest way is to click and drag the thumbnail up the *Layers* palette and drop it over the left icon at the top.

2 Select *Filter > Sketch > Note Paper* from the *Menu Bar* and the options for the filter will open up. You can now increase the *Image Balance* slider to create the effect— somewhere around 45 gives a good result.

3 The effect doesn't look very impressive yet, but try blending the layer with the original layer below. Open the *Layers* palette and select *Darken* from the drop-down blend modes.

4 The result is an image that appears with just parts of the image in relief. The effect looks particularly attractive when printed onto matte paper.

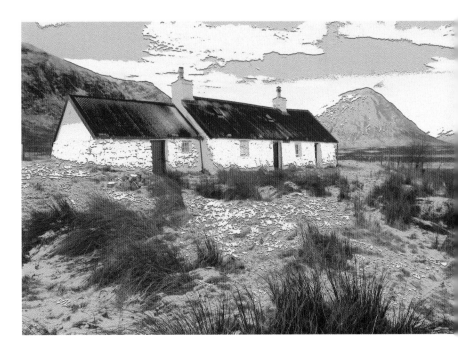

Other Effects and Filters continued

Colored Pencil Filter

1 This lighthouse picture is an image from a 3-megapixel camera. As before, you need to make a layer copy of the original image before applying any filters.

2 Selecting the *Eye Dropper* tool from the *Toolbar* allows you to sample colors from within the picture. I selected two shades of blue from the distant hills. With the *Eye Dropper* tool, a left-click selects the foreground color; hold the Alt key and click again to select the background color. The *Colored Pencil* filter makes use of the colors in the *Color Picker* when it processes the image.

3 Select *Filter > Artistic > Colored Pencil* from the *Menu Bar* or from the *Styles and Effects* palette in the *Palette Bin*. Run the filter with the *Paper Brightness* set around 39. You can then use the *Eraser* tool to remove some of the filtered layer to reveal more of the original lighthouse layer below. You can decide just how much of the filter effect you want and where you want it to show.

4 You can then flatten the image from the *Layer* menu and add a *Texture* filter to complete the work.

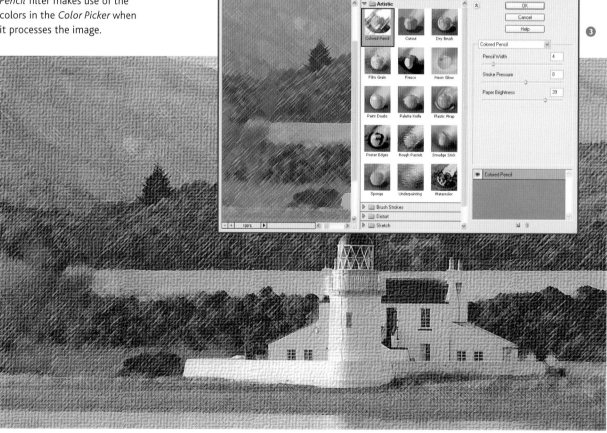

Diffuse Glow Filter

1 Start the filter process by making a duplicate layer from the *Layer* menu.

2 From the *Menu Bar* select *Filter > Distort > **Diffuse Glow*** and adjust the settings to 8 for *Graininess*, 12 for *Glow*, and 3 for *Clear*, then click *OK*.

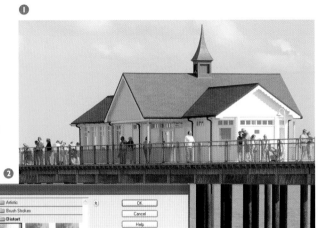

3 The filter process loses some detail in the sky and at the top of the building, so use the *Eraser* tool to erase some pixels from the *Diffuse Glow* layer to reveal these parts of the original layer beneath.

4 You can choose to present the image in color or remove the color and present it as a monochrome image. To remove the color, select *Enhance > Adjust Color > **Adjust Hue/Saturation***. Alternatively, use the shortcut Shift+Ctrl+U.

Other Effects and Filters continued

GLOWING EDGES

OVERLAY MODE

DRY BRUSH

ERASER

FILTER OPTIONS

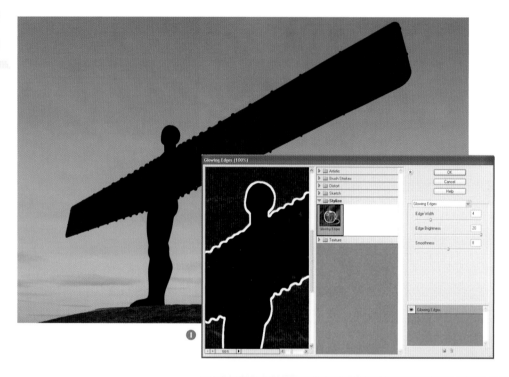

❶

Glowing Edges Filter

▽ *You see a lot of images where the* Glowing Edges *filter has been applied, and they all tend to look much the same. You can use your software and apply some creativity to come up with something more imaginative. This image shows Antony Gormley's vast sculpture,* The Angel of the North *near Gateshead in England.*

Start this technique by creating a layer copy, as you have with the other filter examples. Then select *Filter > Stylize >* **Glowing Edges** from the *Menu Bar.* The options for this filter are a personal choice, but I chose an *Edge Width* of 4, an *Edge Brightness* of 20, and a *Smoothness* of 8.

❷

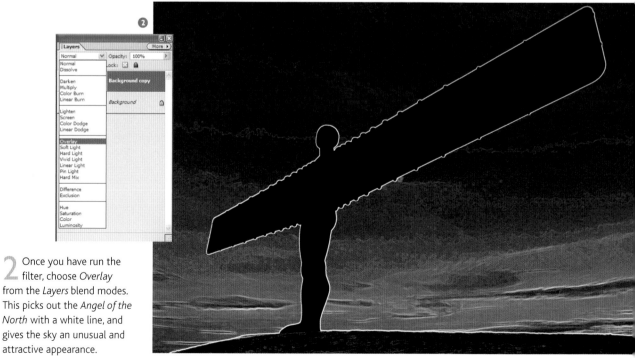

2 Once you have run the filter, choose *Overlay* from the *Layers* blend modes. This picks out the *Angel of the North* with a white line, and gives the sky an unusual and attractive appearance.

Dry Brush Filter

One of the most attractive filters is the Dry Brush *filter from the* Artistic *group. This filter is more affected by image resolution than* Glowing Edges, *so this image was reduced to a 72dpi file of around 2.7 megabytes.*

Make that all-important layer copy and select *Filter > Artistic > **Dry Brush**.* The default settings work just about right for this image.

2 The *Dry Brush* filter adds an attractive look to the image, but as often happens, it also obliterates some of the finer detail. You can fix that using the *Eraser* tool. Select a soft-edged brush around 40 pixels in diameter and erase some of the filtered layer over the cottage and boathouse. I included the landing stage to the left in this step, because there was some nice detail there that had been lost with the addition of the filter.

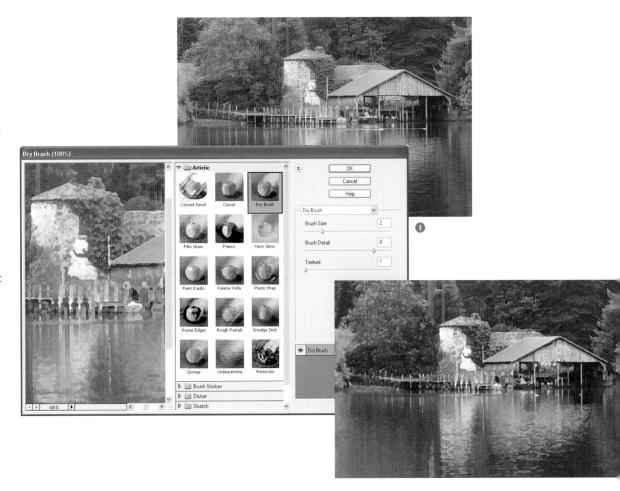

❶

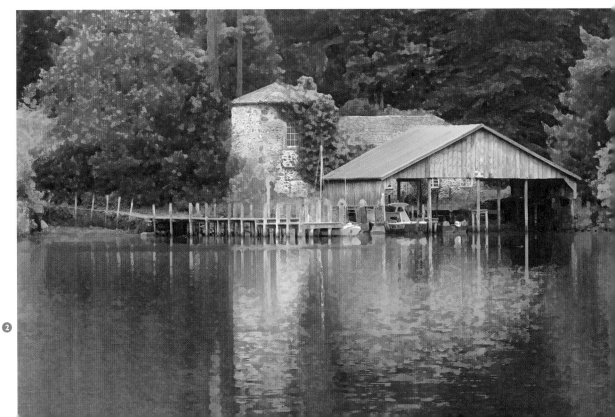

❷

Digital Respray

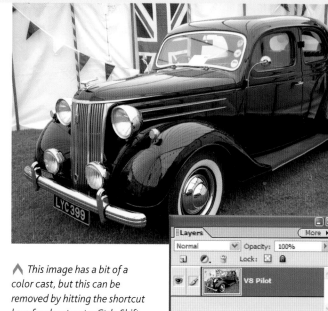

Have you ever fancied your car a different color, but been put off by the cost and hard work of spraying it? Well, you can now respray it digitally using Photoshop Elements. Not only will it save you a fortune in spray-paint or garage fees, it could also save you from an embarrassing lapse of good taste.

1 The first task is to remove the background to make a transparency. To do this you can use either the *Polygonal Lasso* tool or the *Selection* brush.

This image has a bit of a color cast, but this can be removed by hitting the shortcut keys for desaturate: Ctrl+Shift +U. You also need to change the Background into a layer by doubleclicking the thumbnail to rename it.

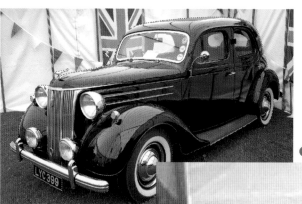

2 Using the *Zoom* tool, enlarge the image to somewhere around 300-400%. This makes it easier to make the selection. Click down on the edge of the car and Elements will anchor the *Polygonal Lasso* tool. Move a short distance and click again. Make short steps on curves and longer steps on the straighter edges.

3 From the *Menu Bar* go to *Select > **Feather*** and add a 1 pixel *Feather* to the selection.

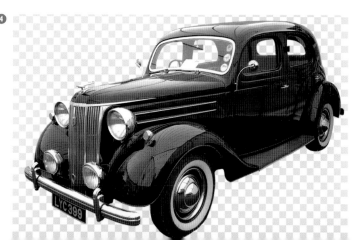

4 Inverse the selection via the shortcut Shift+Ctrl+I. Elements will switch the selection so that the entire background is now selected. Choose *Edit > **Cut*** from the *Menu Bar* or hit the shortcut Ctrl+X to cut away the background. This leaves the car floating on a transparent base, and you can repeat this process for the areas inside the windows.

Go up to the the *Menu Bar* and select *Layer > New > **Layer***. You can enter any name in the new layer box that appears. Pick a mid-blue from the *Color Picker* and flood the new blank layer using the *Paint Bucket* tool.

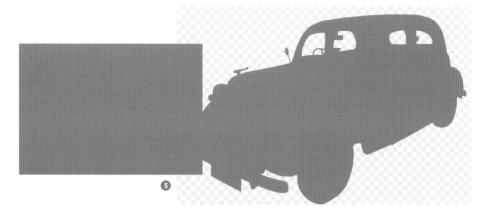

5 The result doesn't look that good yet. The car is blocked out on the layer beneath by the blue layer. Open the *Layers* palette and hold down the Alt key. Move the cursor over the dividing line between the top and bottom layer and the cursor will change to two linked circles. Click and Elements will wrap the color around the car shape.

6 Open the *Layers* palette again and reduce the *Opacity* of the blue layer to 70% using the slider at the top right of the palette. From within the *Layers* palette, select the *Soft Light* blend mode from the drop-down menu. The car now looks as if it has been resprayed. However, the "painter" hasn't masked off all the chrome parts or the wheels. These areas will be fixed next.

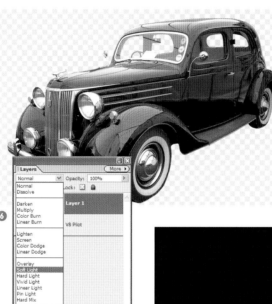

7 Select the *Eraser* tool from the *Toolbar* and a soft-edged brush. You need to erase color from the color layer in areas of the car that don't require any color. Once you have completed that, you can create another new blank layer for the background. Drag that layer to the bottom of the stack and flood it with black using the *Paint Bucket* tool.

◁ *All the hard work is now done, so make sure you save your project as a Photoshop .PSD file. You have given the car a convincing respray. Why not use another image in place of the colored layer next time? The effects can be quite striking if you use a flower, for example.*

Adding Type

Creating text and text effects using Photoshop Elements can be purely functional—to title an image, for example—or it can be much more inventive. You can even use text interwoven with an image.

When text is created, Elements places it on a new layer, so you can import previously created text into another image by dragging and dropping the layer in the same way as you would for any layered composition.

2 Select the standard *Horizontal Type* tool and click into the picture space. You will be presented with a flashing cursor of the sort you might see in a word processor. If you look at the *Options Bar* at the top of the screen, many of the choices may also look familiar. These include *Font*, *Font Size*, *Font Color*, *Bold*, *Center Text*, *Left Align Text*, and so on.

1 Go to *File > **New*** from the *Menu Bar* and you will be presented with an *Options* palette. You can choose a custom size for your new page or select one of the many options from the drop-down menu. The other options are pretty standard and include *Background Color* and *Mode*. Most of the time you are likely to be working in RGB and the background color can be your own preference. You also have the option to work in transparent mode.

With the new page created, select the *Type* tool. This is represented by the letter T on the *Toolbar*. There are four options grouped together, including *Horizontal* and *Vertical Type* and *Horizontal* and *Vertical Type Mask* tools.

3 Click in the *Text Color* box, select *Black* and type the word "Size" on screen. The word is likely to be fairly small. Highlight the text and increase the type to 72pt. This is as large as the standard text sizes go.

4 You can in fact make the text much bigger than the 72pt maximum value that appears in the drop-down menu. Highlight the text value on the *Options Bar* and type in any value of your choice.

You can reselect the *Type* tool at any time and highlight the text to change all or any of the options available from the *Options Bar*. The text remains live and editable all the time.

3 Size

4 Size

The Beauty of Landscape

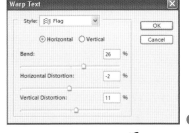

1 Photoshop Elements can be used to make a slideshow (see pages 196–97). For now, let's create a title for a slideshow of our images. You need to create a new document as you did earlier and decide on the title text. If you choose a title such as "The Beauty of Landscape" you can create each word on a separate layer if you wish. This is not essential, but it does give you far more control over where the words appear on the page.

Select the font and font size and after typing each word click the tick on the *Options Bar*. Each time you will need to click back into the image to get the type cursor to appear before typing the next word.

2 If you open the *Layers* palette from the *Palette Well*, you will see that each word is located on a separate layer and that each layer has been titled. You can select each layer and adjust or move each word around the picture space.

3 You can now click into each layer and adjust the text to a pleasing design, varying the font sizes and position until you arrive at an attractive layout.

4 If you highlight the word "Landscape" and click the *Create Warped Text* icon from the *Options Bar*, many more text effects open up. Choose *Flag* and, using the sliders, adjust the amount of distortion you want in the text.

If you save your text image as a Photoshop file, you can return to it at any time and the text will remain live—i.e. you can highlight and change it in any way you choose.

A subtle green color might be more suitable for the title of a landscape slideshow, so you could simply highlight the text and change the color.

5 If you want to move all four words around the page together you need to link them. If you turn off the background layer and select one of the word layers, you can link them by clicking the small square to the right of the *Eye* icon. A small linked chain icon appears. You can then move all the text layers together with the *Move* tool. This linking works with the other tools of Elements as well, such as the *Transform* tools.

The Beauty of Landscape

The Beauty of Landscape

The Beauty of Landscape

Adding Type continued

> *You can create some far better text styles using the* Styles and Effects *palette, and selecting* Layer Styles *and any of the other pull-down menus, such as* Bevels, Drop Shadows, *or* Inner Glows. *Many other variations and options open up if you select the* Effects *and* Text Effects *menus in the* Styles and Effects *palette.*

With the "Landscape" layer selected, you can click into any of the thumbnail options such as the Drop Shadows *and your shadow choice will be created on the text.*

TIP

From the drop-down menu inside the Styles and Effects *palette, you can view a substantial collection of effects and styles at the click of a button. To check out many of the layer styles on the text, it helps to have all the words on one layer, but you sacrifice some flexibility when you merge them all together. To avoid doing so, try this tip:*

Create a new blank layer at the top of the layer stack and turn off the white background layer. With the blank layer selected and the word layers turned on, hold down the Alt key and from the options in the Layers *palette select* Merge Visible. *Elements will merge the four layers of text together in the new layer, but will leave the originals intact.*

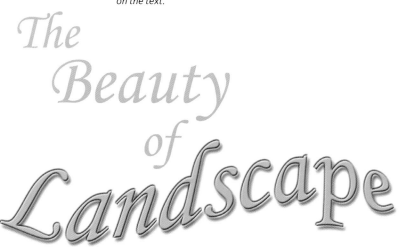

∧ *If you experiment with these options you will find that you can add more than one style to the text. Here, both a* Drop Shadow *and a* Bevel *effect have been used.*

> *To adjust any of these settings, you can open the* Layers *palette and doubleclick the* Layer Style *icon to the right of the thumbnail. Elements will open up the* Style Settings *dialog and you can adjust the effect.*

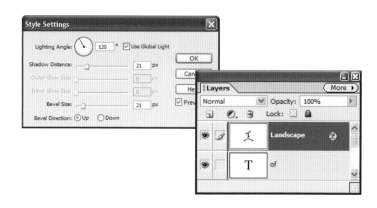

> Take time to experiment with the huge choice of effects on offer. The Chrome *settings* look very realistic and some of the styles under the Complex *heading are interesting.*

The
Beauty
of
Landscape

The
Beauty
of
Landscape

The
Beauty
of
Landscape

∨ While you are having all this fun in the Styles and Effects *palette, do not lose sight of what you want the title for. A set of landscape slides probably demand a subtle title. Do not forget that even at this stage you can still alter your original text. The layer styles will update to match your changes.*

∨ If you want to add other effects to your live text such as erasing an area of it, you need to right-click the thumbnail layer and select Simplify Layer *before applying the* Eraser *or one of the other tools.*

∨ If the basic letter styles are not enough, you can select Text Effects *from the* Effects *tab and apply one of those options.*

Effects

Photographic Text

MASK TOOL

CUT AND PASTE

BEVEL

DROP SHADOW

CUT-OUT

The *Text* tools within Photoshop Elements along with the *Styles and Effects* palette give you a lot of creative freedom, but you can also make text from your own images.

The text you create should be appropriate for the purpose. An example would be a series of images on the theme of water—what would be more fitting than to make your text from an image of water?

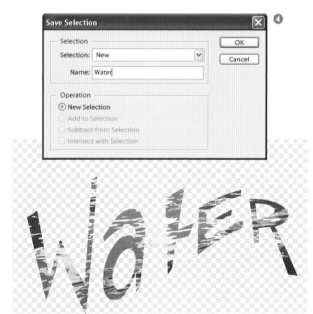

2 Click and hold the *Type* tool icon from the *Toolbar* and select the *Horizontal Type Mask* tool from the options that roll out. Click within the picture space and you can then type your chosen text. You will see the majority of the image masked, apart from the text.

3 Highlight the masked text to make changes to the font and font size and warp the text from the icon on the *Options Bar* in the same way as standard text. When you are happy with your text, click the tick on the *Options Bar* and Elements will create the text as a selection.

1 In this example, text was created from an image of reflections in the water of a harbor. Before you begin to create your text, you should carry out the usual remedial work on the image such as adjusting levels and correcting color. You should also change the background into a layer by doubleclicking the layer thumbnail and then renaming it.

4 If you select any of the *Selection* tools from the *Toolbar*, you can drag the text selection around the image to place it just where you want it. You can also save any selection you make for later use. From the *Menu Bar* choose *Select* > **Save Selection** and type a name into the box provided.

Your selection will then be saved with your image as long as you save the image as a Photoshop file. You can then retrieve it at any time via *Select* > **Load Selection**.

5 Add 1 pixel of *Feather* to the text selection and then cut and paste the selection to a new layer. To do this you can select *Edit* > **Cut** and then *Edit* > **Paste**. If you look into the *Layers* palette, you will see the two layers. Turn off the original layer and the "Water" text made from the image of water can be seen.

6 You can now use either of the two layers to create some eye-catching text. First, you need to create a new blank layer, flood that with white, and drag it to the bottom of the layered stack. With a white background you will be able to see more clearly the text effects you are creating.

7 With just the background turned on and the Water text selected you can add some interest to the text.

8 With just a couple of clicks from within the *Styles and Effects* palette you can add an interesting *Bevel* and a *Drop Shadow* that will bring the text alive.

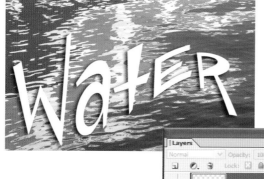

9 If you turn off the water text layer and select the original water layer, you can apply layer styles to that too. If you apply an inner shadow you can create the effect of lifting the word "Water" above the water image.

▼ Often the least complicated effects work best—this example was produced from a simple shot of the sky.

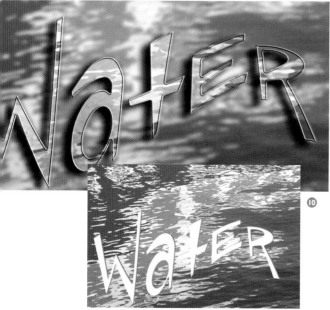

10 If you apply a low drop shadow, we appear to be looking through a cut-out beneath the water layer. Alternatively, use both layers, increase the saturation of the text even more, and apply a filter to the whole—the *Median* filter was used here.

Adding Shapes

Occasionally you will want to add some graphic shapes to your projects, particularly CD covers, business cards, and letterheads. Photoshop Elements provides many such shapes for you to choose from. The *Shape* tool on the *Toolbar* has a number of options grouped with it; just click and hold and they will all roll out.

To create shapes, you need to create a new document by selecting *File > **New***.

2 You can select any layer by clicking into the layer thumbnail, which then allows you to edit the shape. You can change to a different color simply by selecting a new foreground color and flooding the color into the shape. You can use the *Paint Bucket* tool for this task or the shortcuts Alt+Backspace and Ctrl+Backspace.

< *Once a* Shape *tool has been selected the specific optionsfor that tool will appear in the* Options Bar.

3 Click the *Show Bounding Box* option from the *Options Bar* and select a layer. Click into the shape on that layer and you can alter the size and shape by dragging the toggles around the edge of the bounding box. You can then commit that new shape by clicking the tick on the *Options Bar*. Hold the Shift key while dragging a toggle and the shapes will retain their original shape and only the size will change. If you drag the toggle without holding Shift you will also alter the shape.

∨ > *The* Shape *tool works in a similar fashion to the* Text *tool in that every shape you draw will fill with your foreground color. The shapes will also appear on their own separate layers, as you can see if you open the* Layers *palette by clicking on the tab in the* Palette Bin.

4 Select a layer and click the *Simplify* button on the *Options Bar*. The shape then becomes a transparency with the familiar Photoshop checkerboard effect.

There are other options for use with the *Shape* tools. With the *Square* and *Oval* shape tools, you can select the pixel radius from the *Options Bar*. If you select the *Polygon* tool the option becomes a choice of how many sides you want the shape to have.

> There are just too many shapes to list, and each can be drawn out in several ways, from long and thin to short and fat.

5 If you select the *Custom Shape* tool from the options, a myriad of choices appear. Click the small black triangle icon at the top right of this palette and many more shapes open up.

2 You need to prepare the photographic part of the project. In this case, the model needs to be separated from the background. Use the *Eraser* tool to accomplish this to get a gentle blend around the hair. Select the *Move* tool from the *Toolbar* and have both your shape and your photographic image on screen. Click into the photographic image and drag and drop it into the shape layer. You also need to place Dawn behind the shape. Do this by changing the stacking order. Drag the photographic layer beneath the shape.

Adding shapes to photos

1 You can not only add layer styles to your shapes, as you did with your text, but you can also add shapes to your photographic subjects.

Create a new canvas that is a similar size and resolution to the image you wish to use. You can then draw out the shape of your choice and add an attractive style from the *Styles and Effects* palette.

3 Using the *Eraser* tool, you can erase certain parts of the shape to create the impression that Dawn is entwined with it. Finally, experiment with different backgrounds to find something that complements the finished image.

Creating Line Work

A huge variety of clip art is available for use in all sorts of projects, such as word documents, letterheads, and business cards. Some of it is good, some of it is bad, but most of it is generic and not particularly distinctive. Why bother with it at all, when you can create your own line work or clip art from photos with Photoshop Elements?

Line work with Smart Blur

From the *Menu Bar*, select *Filters > Blur > **Smart Blur***. In the drop-down *Quality* box on the *Smart Blur* palette, select *High*, and then choose *Edge Only* from the *Mode* box.

The slider setting will vary depending on the image you have chosen, so you have to experiment to get the right effect. However, the default setting can be remarkably close.

∧ *Sometimes when you create line work from photographs the filter can create too many lines, making the result fussy. You can control the lines that are created by adding a tiny amount of Gaussian Blur. You only need 1-2 pixels of blur to take a little of the sharpness off the image.*

2 Your line art will appear as white lines on a black background, but you can reverse that easily from the *Menu Bar*. Select *Image > Adjustments > **Invert*** or use the shortcut keys of Ctrl+I.

TIP

If you need to make the lines a little thicker you can do so via the Menu Bar. *Select* Filters > Artistic > **Poster Edges** *and the lines will thicken slightly.*

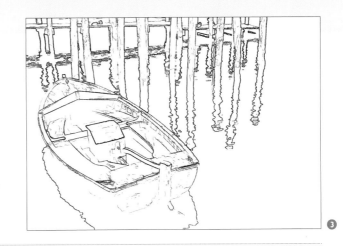

3 Now select a hard-edged brush from the *Toolbar*. With white as the foreground color and the *Opacity* set at 100%, you can touch up your line art, getting rid of lines that are not needed. Here, I removed the mooring ropes and some of the pier on the upper right. If your line art is to be used on a business card or letterhead, you may need some room for text.

Combining line art

I As with your other creations, you can combine line art works in a single image. This "hand-drawn" seagull was created in the same way as the boat on the opposite page.

Before you drag and drop it into the layer stack, you must remove all of the white background so that only the seagull shape remains. Rename the seagull background to change it into a layer, then doubleclick it and add a name in the New Layer box.

If you select the *Magic Wand* tool from the *Toolbar* and untick the *Contiguous* box, all the black edges of the gull will be selected as you click on a line. Inverse the selection via the shortcut Ctrl+Shift+I, so that the selection is now picking out the background.

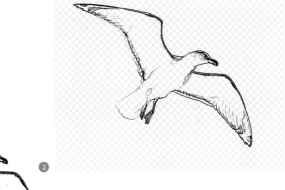

▽ In some cases you want your line art completely isolated. In the previous example, the boat dock scene would very likely need a black line around the edge. This piece of line art, however, could be transported into almost any document.

2 Select *Edit* > **Cut** from the *Menu Bar* and your seagull will now be sitting on its own transparent background.

3 With the *Move* tool selected, drag the gull into the sailboat line art. Using the *Transform* tools, you can then size the gull and position it where you want it.

Making Montages

Montage images can be great fun to produce. They consist of two or more pictures fused together to create something unique—an image that could not be created at the touch of a button. Montages can be as fantastic or as realistic as you like. The key thing is to make your images blend together as seamlessly as possible.

> *This is an example of a two-image montage, in which the American Stars and Stripes flag is introduced into an image of a bald eagle.*

1 The first task is to remove the blue background from our eagle. This can be done by selecting the *Magic Wand* tool from the *Toolbar*. Click down into the blue background of the eagle with the *Tolerance* set to 32 (the default). Elements will select some of the background, but not all of it.

2 Hold down the Shift key and you can add to a selection. Click down elsewhere in the blue background and with a few clicks you can have all the background selected.

3 From the *Menu Bar* choose *Select > Feather* and add a 2 pixel *Feather* to your selection. This is necessary to prevent the edges of your cut being too sharp. Click the *Layers* tab from the *Palette Bin* and doubleclick the eagle thumbnail. From the *New Layer* palette rename your background layer using a name of your choice.

4 Now select *Edit > Cut* from the *Menu Bar* or use the shortcut keys of Ctrl+X. The checkerboard effect tells you that the background has been removed and the area is now transparent. This is a good time to save your project as a Photoshop .PSD file.

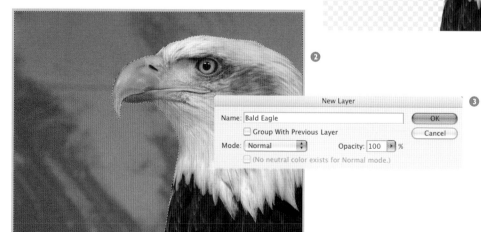

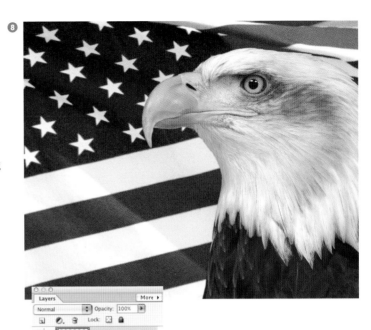

5 With the eagle transparency and the Stars and Stripes on screen, select the *Move* tool, click into the eagle image, and then drag and drop it out onto the Stars and Stripes. While your *Move* tool is still selected, drag the eagle into place to the right of your image space.

6 Click on the *Layers* tab from the *Palette Well* and you will see your new two-layered montage.

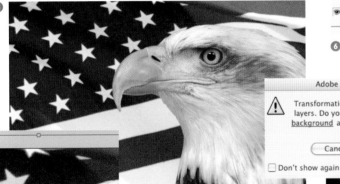

9 With the flag on a separate layer to the eagle you can, if you wish, select *Gaussian Blur* from the *Filters* menu and add a 15 pixel *Blur Radius* to make the eagle stand out even more. Save the picture as a Photoshop .PSD file. This will retain the layers. You can flatten the image from the *Menu Bar* via *Layer > **Flatten Image***.

7 The image looks pretty good, but you could use your *Transform* tools to extend the flag upwards to lose the unsightly folds at the top of the flag. Click the *Layers* tab from the *Palette Bin* and click into the flag or background layer to make it ready for editing. From the *Menu Bar* select *Image > Transform > **Free Transform*** and a small dialog box appears. This dialog box indicates how well Elements has been programmed. It knows that you cannot transform the background and offers to change it into a layer for you. Click *OK* and the *New Layer* dialog appears. Enter a name, then click *OK* again.

8 Elements will then place a bounding box around your flag layer. You need to click the center toggle at the top and drag the bounding box, stretching the flag upwards. Click the check mark on the *Options Bar* when the procedure is complete.

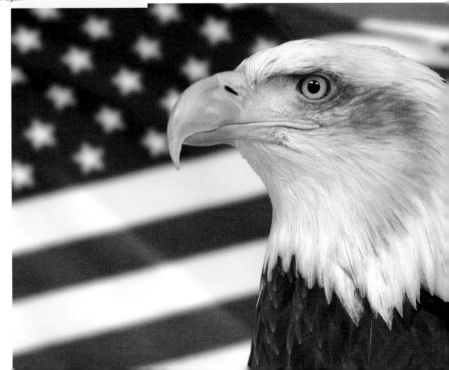

Making Montages continued
Multi-image Montages

It sounds obvious, but the first thing to consider when putting together a number of images to create a montage is where to start. A good idea is to select a base shot on which to overlay other images.

Three key factors to creating a successful montage are: good color balance between the images you use; good composition (which you will have to create as you build your montage); and a good subject. Color balance can be adjusted much later in the creation process once you have assembled all the components of the montage.

It is unlikely that you will have an exact mental picture of how your final montage will look before you start. Montages tend to evolve and you have to be prepared to import other images into your montage and be ready to change those that don't work. Images from a steam railroad were chosen for this example; all these various images are of the same place and were shot at the same time.

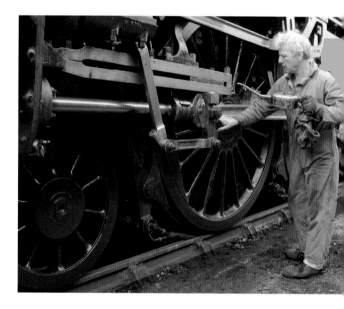

The starting image already has a good composition; it also helps that the focal point of the image is a person. As you overlay images onto this one, you can build on the strength of that composition.

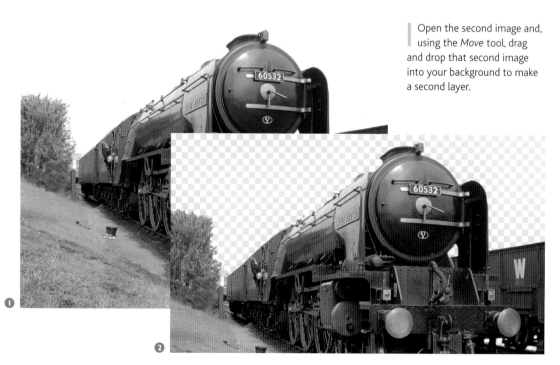

1 Open the second image and, using the *Move* tool, drag and drop that second image into your background to make a second layer.

2 The train then needs to be reduced in size. It might also help if you get rid of the white sky before starting any blending. You can do this easily using the *Magic Wand* tool. Click into the sky and Photoshop will select it for you. Feather the edge of the selection by 2-3 pixels using the *Feather* palette from the select menu. Choose *Edit > Cut* from the *Menu Bar* to action the removal. If you click the eye on the background layer, you will see that all the sky is gone. The squares tell you the area is transparent.

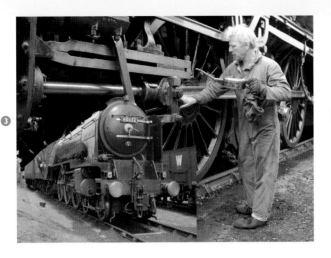

3 You need to resize the steam train by selecting *Image > Transform > Free Transform* from the *Menu Bar* (Ctrl+T). Photoshop will place a bounding box around your image. While holding down the Shift key to ensure that your size remains in proportion, drag a corner toggle to the size you require.

4 Save your project as a Photoshop file at this stage and call it something like "Project 1." Select the *Eraser* tool from the *Toolbar* and a soft-edged brush of between 100-200 pixels in diameter from the *Options Bar*.

TIP

It is a good idea to rename your layers as you import them by right-clicking the thumbnail in the Layers *palette. It may help you to select the correct layer later when you could have quite a few in your layer stack.*

5 Set the *Opacity* of the *Eraser* to no more than 20% and gradually erase unwanted detail on the steam engine layer, blending it gradually into the image below. How much you erase is a personal choice, but stay on the safe side as you can always return to this layer later and erase a little more. Save your work again at this stage and call it "Project 2."

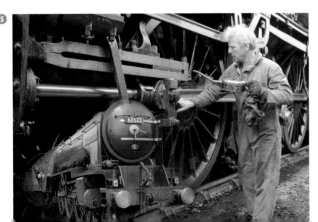

6 You need to import your third image of the brass nameplate into the montage in the same drag and drop way we used earlier. Use the *Transform* tools (Ctrl+T) as before to size and position the nameplate. Then select *Hard Light* from the drop-down Blend menu in the *Layers* palette. This *Hard Light* blend process will help the nameplate to blend into the other two layers. You can help that further using the *Eraser* as before.

Making Montages continued

TIP

The Hard Light *or* Soft Light *blend modes can work well with these types of images, but also consider the* Opacity *slider in the* Layers *palette—it will allow you to reduce the opacity of any layer to any degree.*

7 The process from here is a repeat of what you have already done, but you can experiment with blend modes and layer opacity, finishing off the blends with the *Eraser*. Save your project often so that you can return to a previous state at any time.

Add the white dial to your layered stack, resize it, and after choosing *Hard Light*, use the *Eraser* again and blend the edges into the montage. Save your project after each addition. Repeat this with the other nameplate. *Hard Light* won't help here, so use your *Eraser* tool to blend it fully into the image. Add the remaining brass image in the same way as before. When you are happy with the montage, save it in its layered form as a Photoshop file and choose *Layer > **Flatten Image*** from the *Menu Bar*.

TIP

When you have the Free Transform *bounding box surrounding an element of your montage, you can click inside it and drag it around, or move outside the box and click to rotate your layer. Take some time to experiment with the position and attitude of each element—that's what montage is all about!*

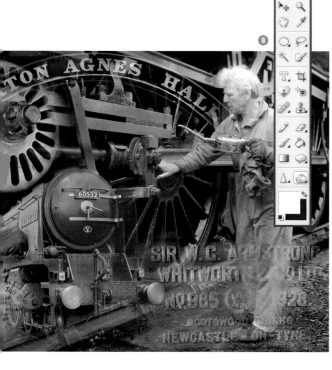

8 You now need to deal with all the unwanted highlights in the image. You can use the *Burn* tool for this process. Go to the *Option Bar* and select a very low *Exposure* of around 5%. Choose a soft-edged brush and set your range to *Highlights* before working your way around the image, darkening down all the unwanted and distracting light parts.

TIP

You can go back to each layer at any time and adjust the size of each image. This is important as you will often find the need to make changes as the montage develops into a finished image.

9 You can now try a few experiments with color balance. Open the *Hue and Saturation* palette from the *Menu Bar* via *Enhance > Adjust Color > Adjust Hue/Saturation* and tick the *Colorize* box. Adjust the sliders for a pleasing sepia tone or perhaps a blue tone. Try using a new adjustment layer to add an all-over tone with just a hint of the original color coming through.

Making Panoramas

Panoramic pictures, which use two or more images displayed together, have always been a popular way to present those pictures that clearly benefit from that treatment. Seascapes and landscapes are among those that immediately spring to mind.

You can display your panoramic pictures in several ways. You can produce each part as a separate image and place them together in an irregular way; these are often called "joiner" pictures.

You can also blend each image together so that the resulting panorama is completely seamless and appears as one long image. These images do not display at their best on computer screens because the restriction of width means the images must be quite small. However, printed out at full size they can be dramatic. If you place six images side by side, for example, the result may be a panoramic image around five feet long.

Photoshop Elements comes complete with the tools you need to produce these panoramic images, but this is one area where you should consider the *Photomerge* process at the time you take your pictures.

Ideally, you should shoot your panoramic images from a steady tripod that is set up as level as possible. You should also allow a 50% overlap between the images you take, so that your software has a better chance of blending the images together seamlessly. It is also good practice to switch the controls of your camera to a manual exposure setting and take all the shots using that one exposure. Select a white balance that fits the scene, such as "cloudy" or "sun" and avoid taking the pictures on an auto setting.

These measures will ensure that the images you produce have a better chance of being blended together perfectly via *Photomerge*. Having given that advice, the example pictures here were all taken hand-held with none of the compensations mentioned above. They were originally taken for use in a joiner-style panorama, but they also demonstrate the power of Elements, in that although the images are not perfect, a superb end result was achieved.

From the *Menu Bar*, select *File > New > **Photomerge**[TM] **Panorama**.This brings up the *Photomerge* palette. The palette gives you advice on what to do next via a text panel in the center. The advice at this stage is to click the *Browse* button to locate your images.

2 Our examples are a series of six images that were shot on the Island of Malta. I allowed some overlap of each picture as I took it, but not the recommended 50%. Highlight the files and click *Open* to begin the procedure.

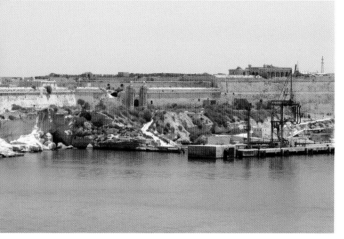

③ Photomerge

Combines images to create a panoramic photograph.
See Help for tips on shooting photos for a panorama.
Click Browse to add images that you want to combine.

Source Files

image6.tif
image1.tif
image2.tif
image3.tif
image4.tif
image5.tif

Browse...

Remove

3 All the files will then
appear in the *Photomerge*
palette. The text panel in the
palette explains what it is going
to do and even tells you where
you can find shooting tips.

4 Click *OK* and wait as it
takes a short while to
perform this procedure. When
the results of the engine room
appear on screen, you may
notice some slight weaknesses
in the blends. As the images
were not shot with this process
in mind this is not surprising.

You can see some banding
on the example panorama, but
nothing that you cannot deal
with. At this stage, the
panorama is likely to be so
long on screen that you may
need to scroll from side to
side to see the whole length.

5 To the right of the
Photomerge palette, you
can see some options, including
an *Advanced Blending* option.
Check the *Advanced Blending*
box and then the *Preview*
button. Click *OK* and Elements
deals with the problem. Within
a few seconds the banding is
almost entirely gone.

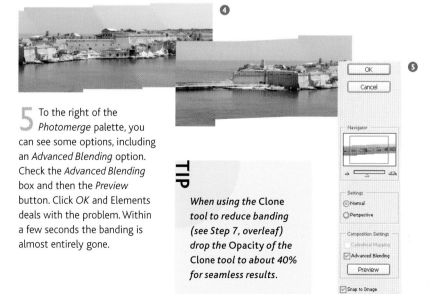

TIP

When using the Clone
*tool to reduce banding
(see Step 7, overleaf)
drop the* Opacity *of the*
Clone *tool to about 40%
for seamless results.*

Making Panoramas continued

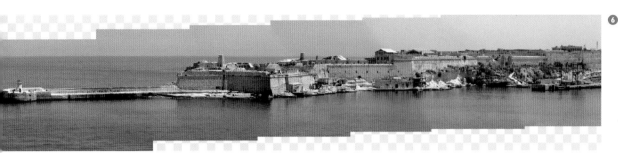

6

6 With Advanced Blending completed, you can review the Photomerge. Select the *Zoom* tool from the *Toolbar* and click the *Fit on Screen* button from the *Options Bar*.

7 You can now select the *Crop* tool and crop the image into the panoramic shape. As you drag out the crop shape over the image, you will notice that to crop effectively you will leave a blank area. This is because the original pictures were not taken on a tripod. However, you can use the *Clone* tool to fill in those areas of sky or water. Any slight banding that shows can also be corrected with a few clicks of the *Clone* tool.

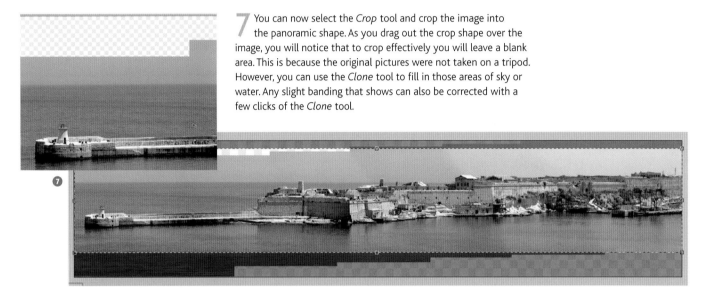

7

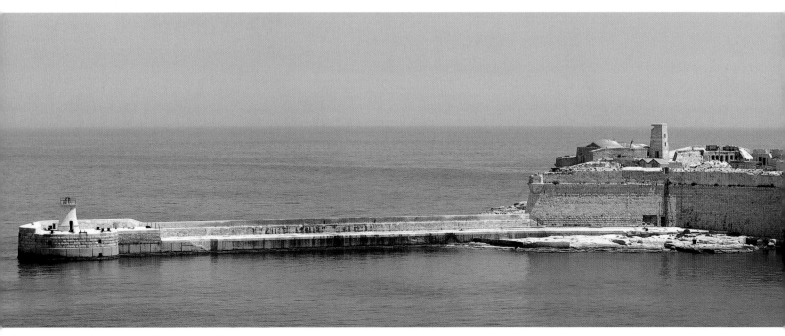

TIP

If your PC struggles with Photomerge, reduce the resolution of your images a little and save the reduced images to a folder on your hard drive. Try Photomerge again with the smaller images and it should work faster.

∨ *This second example was taken with the Photomerge process more in mind, but the images were still taken hand-held. The exposure was set to manual and color balance set to sun.*

An interesting idea would be to create a panorama of a member of your family, but vertically rather than horizontally. You could almost make a life-size image, but it would have to be created in the software in landscape format. The same shooting rules would apply regarding exposure and overlapping of the images.

8 Despite the shortcomings of the original images, which fell well short of what you should provide for Elements to work on, the process worked brilliantly.

For interest, you can now look at the size of the finished montage via the Menu Bar. Select *Image > Resize > **Image Size*** and you will see that the panoramas easily reach five feet in length. It is at this stage that you can apply other routine manipulations such as *Levels* and color corrections, or use *Quick Fix*.

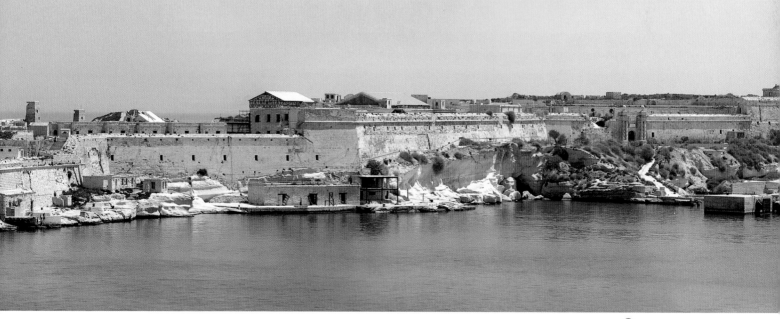

8

Cut-outs

The question of how to do cut-outs arises frequently in digital photography, and the answer depends on a number of variables. The subject is important, but the background probably more so. You need to consider whether the tones between the subject and the background are well separated and therefore suitable for the *Magic Wand* tool. Consider what type of background it is in terms of detail and complexity. What tool to use for cut-outs is not a straightforward question. There are a number of different *Selection* tools at your disposal in Photoshop Elements, but the ones you use most for cutting out detail and objects from one picture to insert into another are:

- **the Magic Wand**
- **the Polygonal Lasso**
- **the Lasso tool**
- **the Selection Brush**

You can also achieve a cut-out without a selection at all using the *Eraser* and a soft-edged brush. You can enlarge the image, change the background into a layer, and erase what you do not want. The soft-edged brush assures that you get the desired soft edge to your subject that you normally apply with the *Feather* tool.

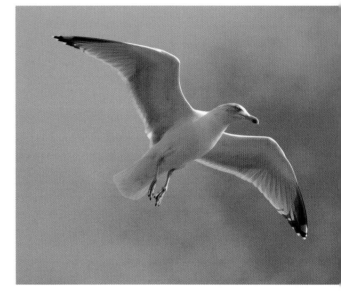

⋀ Magic Wand

The Magic Wand *tool lets you select an area of similar colors. For example, it will select a blue sky around a subject without you having to trace around the outline. You can specify the* Tolerance *for the* Magic Wand *tool in the* Options Bar *at the top of the screen.*

In the first example, the contrast between the blue sky and the frame-filling shot of a seagull is perfect for the Magic Wand *tool.*

TIP

In the course of your digital photography you are likely to want to cut subjects for use in other projects and images. Once you have spent time preparing these objects as a transparency, it is a good idea to save each one in a separate holding area. For example, I have a file called "Odds" that is packed with bits and pieces that I can call on at any time for use in other projects.

⟨ *To cut out an object like the seagull you do not need to make any changes to the* Tolerance *setting. If you click down with the* Magic Wand *tool into the lighter blue area of the sky, a large part of that sky will be automatically selected.*

⋀ *The default* Tolerance *was not high enough to select the entire sky and Elements has recognized the difference between the darker blue and the lighter blue and has not selected it. In some cases, this might be what you want, but not here, where you need all the sky to be selected. You can increase the* Tolerance *value and run the tool again and Elements will select all the blue in one click.*

An easier way to select the seagull is by using the Add To *option from the* Options Bar. *This allows you to add one selection to another. Another method is to hold down the Shift key; it took just three clicks to select the entire sky.*

⋀ *After adding a pixel or two of feather to the selection you can copy the seagull to any other image or remove the sky via the Cut command to make a transparency—i.e. have the subject floating on a transparent background, as shown by the checkerboard effect. Change the background into a layer before cutting out that sky or you will simply cut to the background color.*

⋁ Polygonal Lasso

The Polygonal Lasso *tool is one of the best tools in Photoshop Elements for making effective cut-outs. In this example image, you can see that the* Magic Wand *tool would have great difficulty in selecting the background of this image. Whatever tolerance you chose or how many times you added to the selection with the* Magic Wand, *the job would defeat you because the tone difference between the hawk and the background is just too close. That is where the* Polygonal Lasso *tool comes in.*

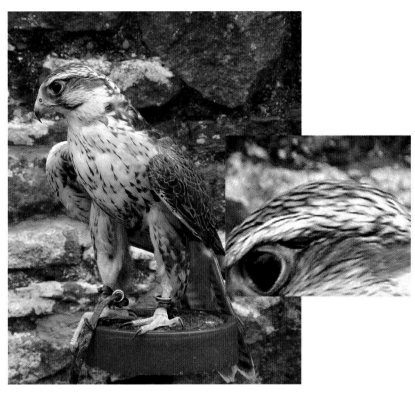

⋀ *In theory, you could use the* Freehand Lasso *tool to draw around the edge of the subject, but in practice it would not be accurate enough. The* Polygonal Lasso *gives you much greater accuracy. Although this tool only works in straight lines, you can cut out any subject, no matter what shape or how intricate it may be. You should use this tool with the image greatly enlarged. This allows you to place the lasso selection right on the edge of the subject and also to select around the most intricate subjects. The degree of enlargement should be as far as you can go before the image gets so large that it becomes difficult to see the edge. In this case the image was enlarged almost 400%.*

Polygonal Lasso tool continued overleaf

Cut-outs continued

Polygonal Lasso tool continued

∧ *Select the* Polygonal Lasso *tool and click down on the edge of our subject. As you move away from that point an elastic line will stretch out with the tool. The secret is to make the selection with this tool in short steps. Every time you touch down, the selection is anchored to that spot.*

These steps can be longer on straighter sections, but much shorter on curved sections.

> ∨ *Using this method of selection, you can select the most difficult of subjects. The effectiveness of the* Polygonal Lasso *tool used in this way can be seen from the completed image. The rusty iron that the hawk is standing on was also cut out using this* Polygonal Lasso *tool method.*

TIP

If you make a mistake, your selection may suddenly join up to the starting point long before you have completed the selection. This is not a problem: simply select the Add to a Selection *icon from the* Options Bar *or* Subtract from a Selection, *whichever is appropriate.*

Magnetic Lasso

This tool works in a very similar way to the Polygonal Lasso. *You should work with the image greatly enlarged and draw around the edge of your subject. It doesn't matter if you stray a little from the edge with this tool as Elements will leave anchor points and the line will snap to the edge of the subject.*

The Magnetic Lasso *tool can be a much quicker option if your selection does not need to be perfectly accurate.*

∨ Selection Brush

The Selection Brush *tool works in a different way for the same end result. This example image is very fussy and the background and different colors would defeat the* Magic Wand *tool. Working with the image greatly enlarged you can choose the* Selection Brush *and from the drop-down menu options choose* Mask *as a mode setting.*

∧ *Select a small brush for use around the edges of the subject and a larger one for the other areas, and you can paint a mask over the parts of the image you wish to cut out. If you make a mistake as you apply the mask, you can switch to the* Selection *mode and repair it. As you switch modes a selection will appear, but you can nudge that selection back into place with the brush. When you switch back to* Mask *mode, the red color returns and we can continue.*

∧ ∨ *Before long, you can have your complicated selection made, your cut-out complete, and a new background added.*

TIP

This task can be made easier if you hold down the Shift key and mask in straight lines using the same technique as you would for the Polygonal Lasso. *Work around the outline of the object in steps. This is probably a better option for those not so skilled at freehand drawing.*

Inserting an Object from One Shot into Another

You might hear it said that a picture is a setting for something. In other words, the image is good, but it needs something extra to bring it to life. With Elements, you can add the interest digitally; by taking objects from one photo and placing them in another, you can create a realistic but more interesting composite shot.

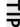

TIP

With the Move tool selected, you can hold down the Ctrl key and click onto any of the birds within the layered stack. Elements will automatically select the layer that the bird or object occupies. This saves you from continually having to open the Layers palette.

1 I shot this old marker light on a boat trip off the coast of Australia. It is interesting and has impact, but it needs something else to improve it. On the same trip I also shot some pictures of gannets in flight, but I could not get them all in the frame together with the old marker.

2 After applying the usual adjustments to the basic image, such as Levels and color corection, you need to prepare the gannets. All the images were shot against a blue sky so you can use the Magic Wand tool to cut them out.

3 If you click into the blue sky, the whole sky is likely to be selected in one go. Here is where we can demonstrate how good the Magic Wand tool is on the right subject. Feather the edge of the selection by about 1-2 pixels and from the Menu Bar choose Select > Inverse to make the selection active on the bird rather than the sky. Alternatively, use the shortcut Ctrl+Shift+I.

4 Use the shortcut Ctrl+C to copy the selection to the Elements clipboard. After clicking back into the original image, you can use Ctrl+V to paste the bird into that image on another layer. You can then close the original seabird image down as it will now appear in the layer stack with the original image.

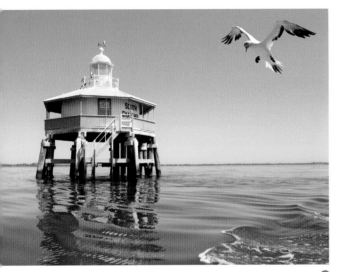

❺

5 Many images where birds are added don't look right because the scale of the bird is wrong. You can use the shortcut Ctrl+T to bring up the *Free Transform* tool from the *Menu Bar* and Photoshop places a bounding box around the subject. While holding down the Shift key, click and drag a corner toggle to resize the bird. The Shift key will keep the image in proportion and you can click the tick on the *Options Bar* when complete.

❹

6 You can repeat the same steps with the other birds and, using the *Move* tool, you can position each one into a good composition. You can also use the *Rotate* > *Flip* > **Layer** command from the *Menu Bar* to flip the birds horizontally.

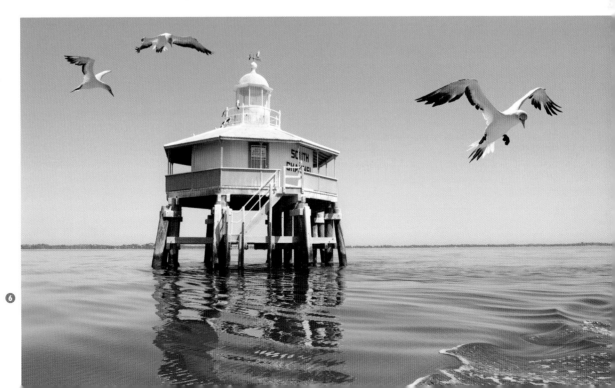

❻

Inserting an Object from One Shot into Another continued

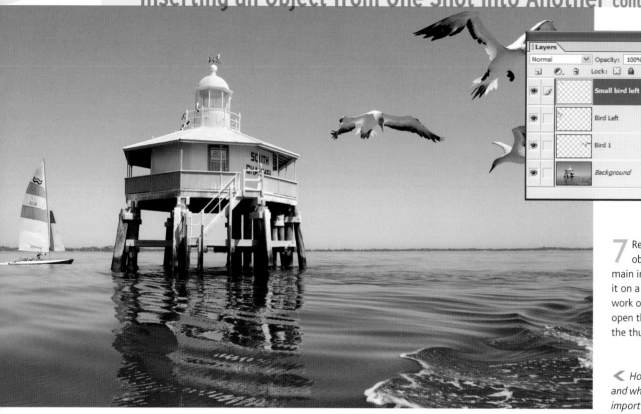

7 Remember that for each object you copy into the main image, Elements will place it on a new layer. So, before you work on any layer you must open the layers and click within the thumbnail to select it.

‹ How you arrange the birds and what other objects you import is up to you.

⌄ The preparation of the images is exactly the same as described in steps 1 to 6 above. On this occasion, I created a border for the image (see page 178-81) and allowed a couple of the objects to break the frame for added interest.

⌃ You can take this technique a stage further to improve your images. The basic image I took of this American bald eagle lacks impact. The bird is far too small to provide an interesting picture, so I used the continuous shooting setting on my digital camera to capture the bird in many different flight poses.

The Halo Effect

When you cut out objects using the *Selection* tools you can introduce an unwanted problem: the halo effect. This is caused where you remove an object from a light background and copy it into an image with a darker one. The few light pixels along the edge of the object can then be seen against the darker background. You sometimes experience the same problem in reverse with dark pixels against a light background.

All of the following techniques remove the halo effect, but your choice of method will depend on the subject.

> *If you look at an enlargement of one of the eagle shots against its new background, the halo can be clearly seen along the bottom of the wing and body of the bird. There are a number of ways to correct this effect.*

Once your original selection is made, before cutting out the subject you can choose Select > Modify > **Expand** *from the Menu Bar. If you expand the selection by just 2-3 pixels before you add a Feather to it, you can prevent some of these pixels from causing the problem. The 2-3 pixels encroach into the subject by a small amount, but it will not be noticed and it may leave those light pixels behind when you make your cut.*

No matter what you do, there will be certain circumstances when the halo still appears. One way to deal with it after the cut process is to select the object layer that has a halo and then select the Eraser *tool. Position the object against the new background so you can see the offending pixels and enlarge the image greatly. Then choose a low* Opacity *from the* Options Bar *along with a small soft-edged brush. You can then simply erase them. By selecting a low opacity our work is gradual, delicate, and seamless.*

∨ *If it is important that you do not erase pixels, you can use another technique. If, for example, you cut out an image of a boat and the mast showed a halo, by the time you removed 3-4 pixels from each side of the mast, there would be little left of the mast. To overcome this, you can select the object layer as before. Click the* Lock *icon within the* Layers *palette. This command will protect the transparent areas of the layer and prevent you from adding pixels where they are not wanted. Using the* Clone *tool, you can clone a few of the pixels on the inside of the halo and transfer them over the halo that is right on the edge. The* Lock *command stops your work from overspilling onto the transparent part, and the halo can be removed within seconds.*

In some circumstances another technique can be employed. To darken a few lighter edge pixels against a darker object like this eagle wing, you can use the Burn *tool. If you set the options to* Highlights *and reduce the* Exposure *to a lower setting, you can darken the halo to match the surroundings.*

Picture in Picture

ADDING TEXTURE

COMPOSITION

TRANSFORM TOOLS

BLEND MODES

PROJECT FOLDER

You can spend some time experimenting with the textures that come within Photoshop Elements, but you can also import and use natural textures in your images. This technique is similar to the one you would use for montage pictures, where you superimpose one or more images over another.

> *This example is a small rockpool. You could also use pictures of a piece of rock or slate. The technique involves taking a number of images and placing them over the stones or sections of the rock or slate.*

I You need to gather the images you want to use for the project and save them to a project folder. With both the rockpool and the first image on screen, select the *Move* tool from the *Toolbar*. If you click into the image you wish to use, you can click and drag that image into the rockpool to start the layered composition.

Using the *Transform* tools, you can reduce the size and rotate the added layer so that the subject fits over the stone in the rockpool. If you then open the *Layers* palette you can reduce the *Opacity* of the layer and use the *Eraser* tool to blend the image into the stone.

2 Repeat this process for all the elements you wish to introduce into the rockpool image, saving the project after each addition. It is good practice to rename all the layers so that you can identify them easily on the *Layers* palette as you work.

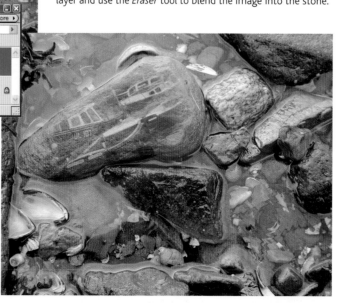

For a stronger composition, try making one of the images more prominent than the others.

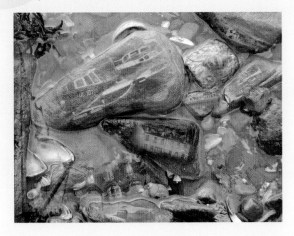

> *In this instance, only one imported image gives all the interest that is needed.*

3 You can use this same technique for other images. This example image of a frost-fringed piece of slate makes a perfect backdrop for the blending-in of a frosty landscape. In some cases, you can also make use of *Blend* modes such as *Hard Light* from within the *Layers* palette.

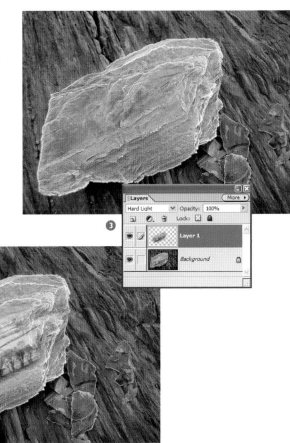

∨ *Picture-in-picture images can be fun to do. Often the images are much stronger together than they would be individually. This example makes use of some border effects for added interest.*

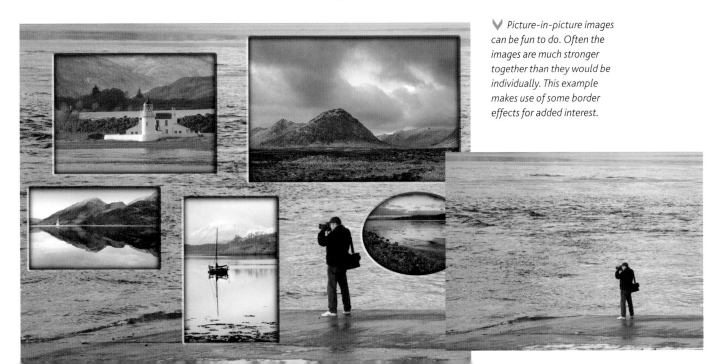

Pattern Pictures

TRANSPARENCIES

CANVAS SIZE

FLIP LAYERS

MIRROR IMAGES

ROTATE LAYERS

Some inventive pattern pictures can be produced from a simple picture taken with your digital camera and the tools of Photoshop Elements. The example featured here uses nothing more than flat shots of some Fall leaves, but using layers and the Rotate commands, we can still create an eye-catching image.

1 Call up the basic leaf shot and remove the background to create a transparency. The *Magic Wand* tool is good enough for this task and will easily select all the black area.

Once you have created the transparent background, you can consider sharpening the image a little and introducing some more saturation.

2 Increase the canvas size to make way for the copying of the leaf. Select *Image > Resize > **Canvas Size*** and increase the canvas, so that it is big enough to accommodate the growing image. You can always add to the canvas size later if you need more room.

You next need to make a copy of the leaf by dragging the thumbnail from within the *Layers* palette up over the left copy icon at the top of the palette.

3 Choose *Image > Rotate > **Flip Layer Vertical*** from the Menu Bar and then *Image > Rotate > **Flip Layer Horizontal.*** Using the *Move* tool, place the copy so that it sits like a mirror image of the original.

TIP

As you go through the tutorial you may need to move more than one leaf layer at a time. You can do this and keep them in their relative positions by clicking the little space just to the right of the Eye *on the layer thumbnail. As you click, a small chain appears to tell you that the layer is linked. This will work for as many layers as you care to join. Move one layer and all those joined to it will move as well.*

4 You can now merge the two visible layers by clicking the small black triangle icon on the tab of the *Layers* palette, which opens up a series of other layer commands. Alternatively, you can use the shortcut Shift+Ctrl+E. Don't get this *Merge Visible* command confused with *Flatten Image*—that will come later when the image is complete.

Copy the merged layer in the same way as you copied the first leaf and then choose *Image > Rotate > **Layer 90° Right***. You can start to see how the image will be gradually built up.

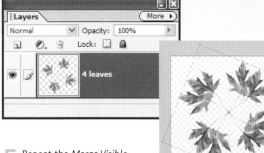

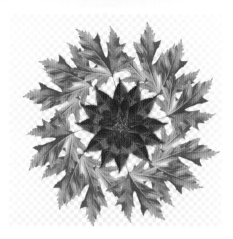

5 Repeat the *Merge Visible* command so that you have four leaves on one layer. You can then copy that layer once again, but this time you need to select *Image > Rotate > **Free Rotate Layer*** and turn the second layer a little to the right by clicking and dragging outside the bounding box. Copy the layer again, which gives you three layers, and rotate the next one a little more to the right to complete the pattern.

6 Where an image like this goes from here depends on you, but I chose to introduce a second leaf and repeat the whole process to provide a centerpiece to the pattern picture. There is also nothing to prevent you from building up your pattern one leaf at a time so that every successive leaf overlaps the previous one. For this tutorial, I took a quicker route by doubling up the leaves using the *Layers* palette.

7 The pattern picture requires a good strong background so create one using the *Gradient* tool from the *Toolbar*. Merge any remaining layers together, create a new blank layer, and drag that to the bottom of the layer stack. Choose a royal blue from the *Color Picker* and hit Alt+Backspace to flood the layer with color. Blue and yellow are complementary colors, so this background will work well against the yellow leaves.

8 Elements will now allow you to draw a line anywhere on the image that defines the start and end of the gradation. Draw a line from the outer edge of the blue background inward a couple of inches and watch the result. A smooth gradation is created. You can add to that from various angles and build a pleasing gradation from royal blue to black.

Using household items
Try the same technique on everyday objects such as cutlery and you can create some very eye-catching images.

9 Choose black as the foreground color and doubleclick the *Gradient* tool from the *Toolbar*. Choose the *Linear Gradient* option from the *Options Bar* along with a gradient type setting of *Foreground to Transparent*.

Jigsaw

Another great effect, which is easier to create than you might imagine, is this jigsaw puzzle. This intriguing project uses nothing more than layers, layer styles, and the *Texturizer* filter, plus a little selection know-how. Elements has many brilliant little tricks that you can find if you spend a little time experimenting.

> *This project needs an image without lots of fussy detail. This sunset shot, taken with a 3-megapixel camera, is perfect. The resolution of the image affects the size of the jigsaw pieces. This one, measuring 10 inches wide at 220ppi will be fine, but an image with a higher resolution may result in the jigsaw pieces being too small.*

1 To apply the jigsaw texture, go to *Textures* from the *Menu Bar*. Select *Filter > Texture > Texturizer* and from the drop-down menu select *Load Texture*. To find some extra textures, go to the *Presets* folder in the folder where Elements has been installed, then go into the *Textures* subfolder and select the *Puzzle* texture from the list.

2 Unlike other textures where a subtle relief setting may be necessary, here you can push the relief setting higher, as you want the relief to show up clearly. You are also likely to need the *Scaling* increased to 200% or thereabouts, before clicking *OK*.

3 If you need to increase the size of the jigsaw pieces, you need to hit the *Step Backwards* command from the *Edit* menu to remove the jigsaw texture. Go to *Image > Resize > Image Size* and check the *Resample Image* box, then reduce the *Resolution* to 150ppi and click *OK*.

3

4 The same texture settings give you slightly bigger jigsaw pieces.

2

TIP

As soon as the texture filter has run, you can check the size of the jigsaw pieces by viewing the image at the print size. Select the Zoom *tool from the* Toolbar *and click* Print Size *from the* Options Bar.

4

5 To start the process of removing some jigsaw pieces, go to the *Layers* palette via the *Palette Bin* and change the background into a layer. Just doubleclick the layer and rename it.

6 Using the *Zoom* tool, you need to enlarge the jigsaw pieces considerably to assist you in the selection process. To make the selection of the piece(s) you can use the *Polygonal Lasso*, the *Freehand Lasso* tool, or the *Selection* brush from the *Toolbar*.

7 From the *Menu Bar* choose *Select > Feather* and add a 1 pixel *Feather* to the selection You can then cut out the jigsaw piece via *Edit > Cut* (Ctrl+X). Paste it to a new layer via *Edit > Paste* (Ctrl+V).

8 Using the *Move* tool from the *Toolbar*, you can move the piece you have cut out anywhere on the image and then repeat the cut-out steps for as many pieces as you wish to remove. If you look at the *Layers* palette, you will see each piece on a different layer.

9 You can also give your jigsaw pieces a drop shadow. This makes them appear as if they are laying on top of the image. Click the *Styles and Effects* palette from the *Palette Bin* and select *Layer Styles* and *Drop Shadows* from the drop-down menus. Select one that you feel is appropriate and doubleclick it. The best option is probably the low shadow. However, once a drop shadow is applied you can open the *Layers* palette and doubleclick the *Layer Styles* icon to the right of the thumbnail. Another dialog will then appear where you can vary the settings.
 Apply the same drop shadow to each jigsaw piece and the main jigsaw layer too.

10 Use the *Transform* tools (Ctrl+T) to add a little rotation to each piece so that they do not look too regular. Position the pieces for effect, and then flatten the image. This produces a white background in the space where you removed the pieces.

Borders and Frames

Borders and frames are important to the presentation of your pictures. You wouldn't put a picture on the wall in your home without a frame, because a frame presents a picture so well.

There are many ways to create borders and frames. You can use the automatic tools contained within Photoshop Elements; you can use the normal Elements tools and manually create borders and frames; or you can use some third-party border effects that you can add to Photoshop Elements. You can also use the basic border techniques to ensure that your pictures fit into a standard frame without distorting the width or the height of your picture.

1

I From the *Layers* menu, change the background into a layer by renaming it. From the *Menu Bar*, choose *Select > All* or use the shortcut Ctrl+A. Elements will place a selection around the entire outside edge of the image.

2 With white chosen as the foreground color you can select *Edit > Stroke (Outline) Selection* from the *Menu Bar*. The *Stroke* palette allows you to add pixels of color to your selection line, either inside, in the center, or outside the line. The ideal *Width* setting will vary according to different image resolutions.

2

⋀ Adding a Basic Border

One of the best frames to introduce to a color image is a black one, as it works well with many images where the color is dynamic and bold. Black borders also work more effectively if you add a thin white line around the outside edge of the picture before adding the frame.

3 Add about 3 pixels to the inside of the line and click *OK* and Elements will apply a thin line. If you evaluate the image at the print size, you will be sure of getting the line thickness right. If the line is too thick, you can use the *Undo History* palette and apply it again with fewer pixels.

Go to the *Menu Bar* and select *Image > Resize > Canvas Size* and stipulate the width that you require your border to be. It is at this stage that you can add the size you need to fit a standard frame.

3

If you are creating a white border for a particular frame size, add a thin stroked line to the outer edge of the border so that you have a guide to where to cut after printing.

4 From within the *Layers* palette create a new blank layer and drag that layer to the bottom of the layered stack. Flood the layer with black for a simple yet powerful result. Use a new blank layer so that you can, if you wish, experiment with other background colors by flooding the background layer with color.

Matte Effect

With an image that requires a white border you can also create a matte effect, i.e. the appearance that the image is below the frame. After renaming the background and increasing the canvas size, you need to select the *Magic Wand* tool from the *Toolbar*.

◄ *You can reverse the colors and use this process for an image that could benefit from a white border along with a thin black line.*

1 Click down in the transparent border area and Elements will select the area for you.
Create a new blank layer above the image and flood the selection shape with black. Create another blank layer above that and flood that with white, and then remove the selection via Ctrl+D.

2 Select the black layer and from the *Filter* menu add a degree of *Gaussian Blur* and the border will then appear as though it is above the image.

❶

Borders and Frames continued

Color Frames

Your image will often benefit from a color frame. If you select sample tones from within the image for the border color, the result can be very pleasing to the eye. While a contrasting hue can work well in some contexts, using colors that match those of the image makes a more complementary frame for your photo.

Borders and Frames

Elements supplies some edge effects and frames for your use in the *Styles and Effects* palette found in the *Palette Bin*. Click the tab and doubleclick the border or effect of your choice. Some of the designs verge on the tacky, and in nearly every case subtlety pays off, so try to avoid frames that might overpower your image.

◄ *You need to change the background into a layer, add your chosen canvas size, create a new blank layer, and drag that layer to the bottom of the layer stack as before. If you select the Eye Dropper tool from the Toolbar, you can sample one of the tones from within the picture and apply it to the frame.*

⋀ *You can sample two tones of blue from the picture and apply those to the blank layer via the* Gradient *tool. You can also add a few pixels of monochrome* Noise, *which will give an attractive subtle texture to your borders.*

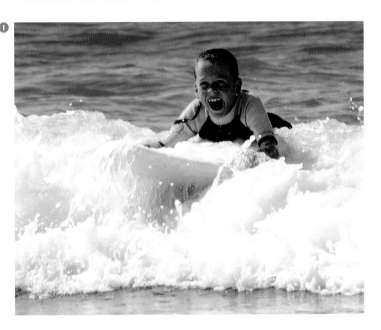

The Cookie Cutter Tool

New to Elements 3, the *Cookie Cutter* tool allows you to make a shaped selection from an image with just one click of the button. There are a staggering number of shapes to choose from, including animals, frames, awards, and even faces. And of course, once you've selected and cut your shape, you can use the *Styles and Effects* palette to create some really interesting results.

1 We're going to use this image of a boy surfing to create a surfer's certificate.

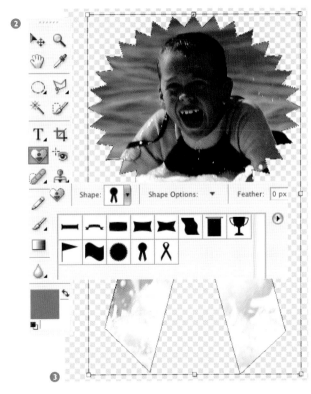

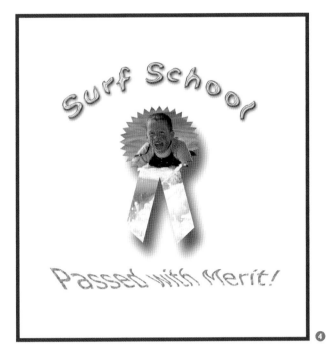

2 Select the *Cookie Cutter* tool from the *Toolbar*, and then go to the *Options Bar* to select the shape you want. Here we've chosen a rosette style shape from the *Banners and Awards* collection. To see what's on offer, click on the small black triangle, and you'll be confronted with the complete list of options.

3 Next, simply click and drag over the image to make the selection that you think works best. Once you think you're nearly there, release the mouse, and you'll see that Elements has drawn a bounding box around your shape. You can now adjust the height, width, and size of the shape until you're happy with it.

4 Now that you've got your rosette shape, you can complete the surfing certificate by adding some text using the *Styles and Effects* palette to give it a bit of a lift.

Frame Spilling Effects

OVERSPILLING

MASKS

DISTORTION

MOVEMENT BLUR

TRANSFORM TOOLS

With Photoshop Elements and a little time you can create some pretty experimental images. With this picture of the London Eye, I wanted to produce an eye-catching picture that was different from the thousands of other images already taken of this subject.

I decided to transform a London Eye capsule into a time "spacecraft" using Photoshop Elements and to make it look as if it were bursting from out of the picture frame.

TIP

If you make a mistake and overspill the edge of the mask, don't despair. Switch to Selection *mode from the* Options Bar *and a selection will replace the mask. Using a small brush you can now nudge the overspill selection back into shape. Click back into the* Mask *option and the opaque red reappears to continue the masking.*

2 You need the image enlarged considerably to start this process. From the *Layers* palette, rename the background thumbnail, changing it into a layer. Then choose the *Selection* brush from the *Toolbar*. From the *Options Bar* at the top of the screen, select *Mask* as the *Mode* option with an *Overlay Opacity* of 50%.

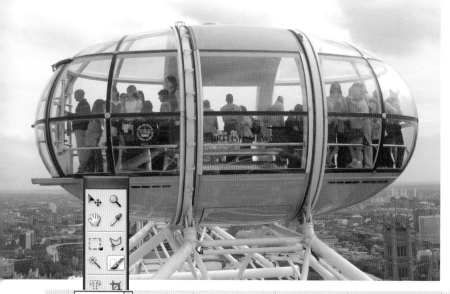

1 The first task is to remove the capsule from its background. You could use the *Polygonal Lasso* tool for this job, but on this occasion let's use another of Elements *Selection* tools, the *Selection* brush from the *Toolbar*.

3 Touch down on the inside edge of the capsule with a brush size of around 20 pixels or less. Elements will create the start of your mask and show it as an opaque red. Hold down the Shift key and move along the inside edge of the capsule and touch down again to create a mask around the entire edge of the capsule. Working in small stages may help the masking process. However, if you are adept at using a freehand brush, the mask can be made this way too.

4 Once you are happy with the mask, you can switch to *Selection* mode. At present the selection contains the capsule. You need to inverse the selection in order to remove the sky. Use the shortcut Ctrl+Shft+I for the inverse command, then add a 1-2 pixel *Feather* to the selection.

Hit the Ctrl+X keys and the capsule will be free of all the background clutter and floating on a transparent background.

5 You can also cut out some of the windows in the capsule, so that when you introduce it to a new background, it will show through the windows. Use the *Selection* brush or the *Polygonal Lasso* tool to select and remove the appropriate areas so that the checkerboard pattern shows through.

6 You now need to open the image that will form your background clouds and, with the *Move* tool selected, drag and drop the capsule image into the sky. As you will see, the capsule is too big for the new background and needs resizing, turning, and repositioning. Before you do that, you will need to create some extra space around the edge of the sky.

FRAME SPILLING EFFECTS

Frame Spilling Effects continued

7 From within the *Layers* palette doubleclick the cloud thumbnail and rename it. Then go to *Image > Resize > **Canvas Size*** from the *Menu Bar* and add a few inches to the width and height—you can always crop back later if you add too much.

You can then select the capsule layer from the *Layers* palette and the *Transform* tools via the shortcut Ctrl+T. With this one tool you can click inside the bounding box and move the capsule around the picture space. You can click and drag outside the box to rotate the capsule and click and drag a corner toggle to size the capsule. This one tool allows you to adjust the capsule size, give it a tilt and position it.

8 You can create a feeling of movement by first making a duplicate layer of the capsule from the *Layer* menu. If you then select *Image > Transform > **Distort***, you can create a tapering shape by dragging the toggles at the edges of the bounding box.

9 Apply *Movement Blur* from the *Filter* menu to create the streaking effect. Use the *Eraser* tool to remove some of the blurred layer so that it blends with the capsule.

10 For the border, you need to create a new layer from the *Layers* menu, then drag that layer down to the bottom of the layered stack and flood it with black.

To create the cloud spilling out of the smashed frame you need yet another new blank layer. Select the *Clone* tool and clone some clouds to it using the *Use all Layers* option from the *Clone* options. Turn off the other layers first, leaving only the sky and the new layer, or they will be cloned as well.

▼ *Take the basic idea and techniques used to make this image and add your own touches to the final result. Have fun and don't show your picture to anyone about to take a ride on the London Eye, as you might make them nervous!*

real world
projects

Working and experimenting with your images is always fun, but the real satisfaction of mastering Photoshop Elements comes when you share your finished efforts with others. While photography might be going digital, there is nothing to beat a high-quality print when it comes to showing off your latest masterpiece. Getting the best from a standard home printer isn't as simple as you might hope, but the tutorials on the following pages will show you how. We also won't forget the Internet or e-mail as a way of making your pictures available to others, either. Get your pictures off your computer, and out into the real world.

Printing

Printing can cause a lot of frustrations for digital photographers, but it can be our impatience that causes most of the problems in the first place.

For example, have you ever printed a landscape image in a portrait format and not realized it until a sheet of paper and a fair amount of ink have been wasted?

Once you have completed an image and are ready to print, your first thought should be, what size do I want to print the image and do I need to add a border first?

TIP

Try not to get bogged down in the resolution issue when printing. Print at the highest resolution you can. A shot from a 3-megapixel camera will have a resolution of about 200ppi at 10 x 8 inches, and that will be adequate for a good-quality letter-sized print. You could even stretch the image to tabloid size as long as the print wasn't going to be viewed up close. Equally, printing an image at 400ppi won't improve it.

◄ *The most common size for printing will be 10 inches by 8 inches, which is a perfect size to fit on a sheet of letter paper. The modern print utility software that comes with printers can now do much of this for us, but let's deal with it manually using an example picture taken by a 6-megapixel camera.*

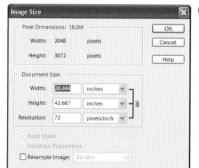

With the image on screen, open the *Image Size* palette from the *Menu Bar*. You will see from the palette that the image from the camera is 42 by 28 inches at 72ppi. Obviously, the size is too big and the resolution too small for a letter-sized print.

You need to resize the image so that its *Height* goes down from 42 to 10 inches. If you tick the *Constrain Proportions* box you can adjust the *Height* and the *Width* will remain in proportion. Most importantly, do not tick the *Resample Image* box. If you do the printer software throws away pixels during the size reduction, which loses you some of the quality needed for printing.

2 Untick the *Resample Image* box and adjust the *Height* to 10 inches. As you click OK, nothing will seem to happen. You have to open the *Image Size* palette again to see the results of the operation.

You now have your 10-inch size and the resolution is a healthy 307ppi. From that resolution you will get an extremely good, high-quality image from the printer.

If you were printing the image for a 10 by 8-inch frame you can see that the 10 by 6.6 inch image is not going to fit that well—there will be a gap down the sides. One solution is to crop the image to 10 by 8 inches if there is room to do so and if cropping would not affect the appeal of the image.

Alternatively, you can reduce the print size a little more and give the image a 10 by 8 border (see pages 178-80).

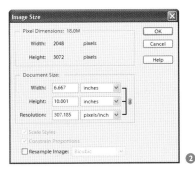

3 You need to consider your paper choice at this stage as high-quality color photographic images need to be printed on the correct paper. This paper will generally be heavyweight glossy paper, although some filtered images often look better on matte paper. Whatever paper you choose, it must be photo-quality paper or the resulting image will not display anywhere near the quality that your printer is capable of.

More prints are spoiled by rushing through your printer software options than for any other reason, so it pays to take some care here.

You will also need to specify landscape or portrait format. It is quite common to receive a warning from your printer software that the image is larger than the paper's printable area. This is due to the fact that you are printing in landscape or portrait format but you have not yet changed the format in the printer options. The software tells you that you cannot get a portrait image on landscape format paper, but you can click past this warning. Just load your paper and print your image.

It is in the properties of the printer software that you can select your format and paper size—for example, standard letter.

It is also in the properties that you are likely to be able to select paper type, such as Premium Glossy Photo Paper.

Multiple Images per Page

PHOTO BROWSER

PICTURE PACKAGE

MULTIPLE PHOTOS

LAYOUT

BORDERS

FRAMES

One of the most common questions I am asked is how to print more than one picture on a page. It's easy to understand why, as printing a batch of prints on a single sheet of paper makes economic sense. Four pictures placed on an 8 x 10 sheet can be cut out into handy-sized prints to carry around in your pocket. Alternatively, it makes a great way to display a small panel of images, perhaps in a frame on the wall. Whatever the reasons, Photoshop Elements makes the task very simple.

From the *Photo Browser* module, select the first image you want to print, then go to *File > **Print***. In *Standard Edit* mode, open up the image then go up to the *Menu Bar* and select *File > **Print Multiple Photos***. In either case, when the print dialog opens go to section 2—*Select Type of Print*—and choose *Picture Package* from the menu. By default, Elements decides you want one large photo and 2 smaller photos, but if you go to the drop-down menu titled *Layout*, you can click the *(4) 4 x 5* option. Ticking the *One Photo Per Page* checkbox sets up four identical prints, which has its uses if your whole family wants a picture of a new baby, but what if you want four different photos on the same page?

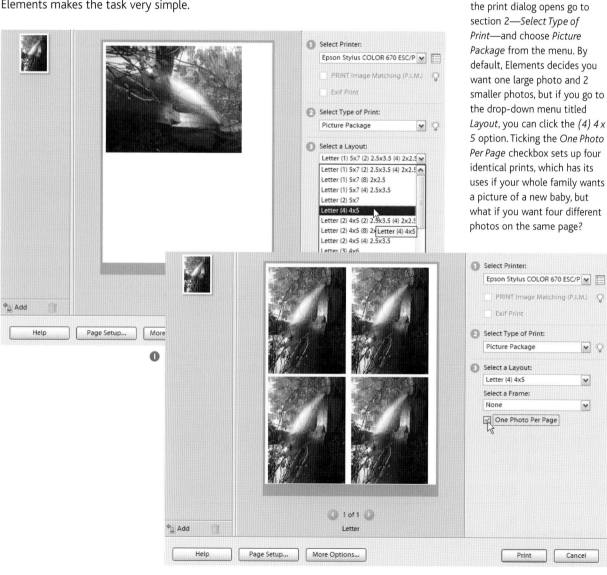

k photos from any set and click Add Selected Photos. After all desired photos have been added, click OK.
cel throws away all additions made within the dialog.

FOR MAC USERS

In the *Menu Bar* go to *File* > ***Picture Package*** and Elements will bring up a dialog box from which you can begin to assemble the multiple image page you want .

2 Uncheck the *One Photo Per Page* checkbox, then click the *Add* button at the bottom of the column of thumbnails on the left. The *Add Photos* dialog appears, enabling you to add photos from the *Photo Browser*, your photo collection, or using any catalogs or tags that you have previously set up. To choose an image, simply click on it, then click the *Add Selected Photos* button. You can, of course, choose more than one image at a time. Click *OK*, and the selected photos will be added to your sheet.

3 If you want to add or change an image, click on the *Add* button once more, then select more photos from the *Add Photos* dialog. Click *OK*, and the thumbnails for the new images will appear in the column on the left. To replace the photo on the sheet, simply drag the new thumbnail over the existing shot and drop it on top. The shots will be switched immediately. Clicking on the unwanted photo's thumbnail in the column, then clicking the trashcan icon below will get rid of it. It only takes seconds to have four separate pictures ready for printing. You can also add a frame to each shot at this stage, picking from the wealth of options—some great, some fairly ugly—in the *Select a Frame* drop-down menu.

The *Layout* menu gives you several different options, but the basic process remains the same for each one.

2 From the drop-down menu titled *Layout*, you'll be offered many choices of print layout. Here we've chosen *(4)4x5*. Having decided on the print layout, it's simply a matter of clicking the *Choose* button and selecting the images that you want. To begin with, Elements places the first picture you select four times. To select other images, simply click on one of the duplicates you want to replace and a browser appears prompting you to select another image. Within seconds you can choose four separate pictures. Once you're happy with the layout click *OK* and Elements automatically makes up a page with your selected images ready to print.

Contact Sheets

A contact sheet is a term used in film photography where negatives, usually in strips of six, are placed directly onto photographic paper and exposed to light. The developed 8 by 10-inch print is used to evaluate and aid selection of any of the 36 negatives from a roll of film.

You can create contact sheets using Photoshop Elements, but why should you wish to? You have the ability to scroll through your images using the Photo Browser, so why bother making a print too? The reason is that, after a very short while, you will not be able to store all the images you shoot on your computer—there is just not enough hard drive space. In any case, it is safer to have your images saved to CD as well as stored on your hard disk. It is not until you begin searching for that one special image that is buried somewhere on one of your CDs that you will wish you had created a contact sheet for each one. It is much easier to flick through a few pages of thumbnail pictures to find what you are looking for than to shuffle loads of CDs in and out of the CD-ROM drive.

Of course, Elements makes the task much simpler and faster than it ever was in the developer's darkroom.

∨ *It's best to create contact sheets from the* Photo Browser *in* Organizer *mode, though you can also use the* File > **Print Multiple Prints** *command if you're in* Standard Edit *mode. Select an image or choose a previously organized collection, then go to* File > **Print**. *Go to the* Select Type of Print *section but this time choose* Contact Sheet *from the drop-down menu.*

> *Click on* Page Settings *if you need to change the paper size or the format (from portrait to landscape). Otherwise, you'll find the rest of the options in the* Select a Layout *section of the* Print Photos *dialog. Change the number of columns to determine how many images you can fit on each page, and then check the relevant boxes to add labels for* Date, Caption, *or* Filename *to each thumbnail, or* Page Numbers *to the bottom of each printed page.*

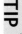 As with printing multiple images, you can always add images to the contact sheet by clicking on the Add button beneath the thumbnails column then selecting new images from the Photo Browser. *You can also delete images by clicking on the thumbnail for the photo, and then on the trashcan icon.*

TIP

If you carry out this task for all of your images, you will be sure to find it useful at some stage. Electronic catalogs have their place, but nothing beats flicking through a contact sheet.

FOR MAC USERS

In the *Menu Bar* go to *File* > **Contact Sheet II** and Elements will bring up the contact sheet palette, which is divided into four sections. The top section is where you locate the folder of images to be included on the contact print. Click the *Choose* button to locate the folder.

2 You can choose the page size from the *Document* section. The default 8 x 10 is probably the most useful size. In this section you can also select the resolution. As an aid to finding a particular image 72ppi is adequate, although you can increase this if you wish.

3 In the *Thumbnail* section you can choose how many images you want to appear on a page. Again the default setting of 5 columns by 6 rows is about right. Fitting more images on a page makes them difficult to identify, but if you need to differentiate images up close you can easily select fewer images per page.

4 In the final section, you can tick the box to choose whether or not to include the images' final names. Once you've made all your selections, click *OK* and Elements goes to work. If there are a large number of images in the folder, then making up the contact sheets will take a few minutes.

CD Covers and Inserts

There is dedicated software available for creating CD covers and inserts, but it gives you much more sense of accomplishment if you create your own using Elements. There are two types of jewel cases used for CDs: the standard type, and the slimline cases that seem to be standard for cheap CD-Rs.

1 To create a slimline jewel case insert, the first task is to create a template. You can create a single-page insert or a double-page insert that will need to be folded after printing. After selecting *File > **New***, create a square template with a width and height of 4.75in (12cm). This is the exact size of a slimline jewel case and will be perfect for a single-sheet insert.

2 From the *Menu Bar*, choose *Select > **All*** and then apply a thin black or gray line via the *Stroke (Outline) Selection* command from the *Menu Bar* to form your cut line. When you print your cover onto white paper, these lines will show you where to cut.

If you want a double-page insert so that you have information on the outside and inside of the cover, you need to double the size of the template. You will still need to know where the edge lines are, but also the center line of the cover. After printing you will need to know where to cut and also where to fold the cover. It is probably easier to duplicate the square with the lined edge that you have already created than create a new template.

3 To create the other side of the jewel-case insert, you need to ensure that white is selected as the background color. From the *Menu Bar*, select *Canvas Size* and double the width while anchoring the template to the left.

4 Choose the *Select All* command once again, apply the stroke line around both sides of the cover, and you will have a perfect template for the jewel case.

Save this template somewhere safe on your computer for future use.

The design of your cover is a personal one, but you might find it interesting to use your own images. This can be purely for decoration or to indicate what the CD contains.

5 Open an image and with the *Move* tool selected, drag the image onto the cover template. You can use the *Transform* tools to size and rotate the images to fit in with the design and shapes. Each part of the cover can be dragged and dropped onto the layered stack and you can gradually build it up. Design both sides separately and leave room to add a title, text, and any contact details that you might need.

6 Add text and then use the various text options and layer styles to give it impact. Drop shadows and bevels seem to work particularly well.

Digital Audio Visual

Images gently fading from one to the other set to beautiful music

Want to put Audio Visual slide shows together ?

The CD contains all you need to know including samples of the software, where to get it and how much it costs. Install the slide show software from the CD and buy your licence over the internet for just a few dollars. The CD contains all you need to know in a step by step form from the basics to the more advanced AV.

Sample images are already prepared to guide you through the process and royalty free music in MP3 format is included. As a super bonus the Photoshop 7 toolbar is included for almost every tool.

This CD should auto run when put into your CD drive. If it fails to do so you can access the tutorials and other information via your Windows Explorer and double click the Start.htm icon. If your browser tries to take you on line, click cancel and the CD will open. Alternatively copy the entire file structure to your hard drive for ease of use. These files can be deleted at any time and nothing is written to your computer.

To run the video tutorials you will need to install a small Codec file called tscc found in the goodies/software folder on the CD.

For a logical approach to following this CD click the Introduction button from the main menu and follow the next buttons on each page. Alternatively you can move through the CD by clicking buttons on the main menu from left to right .

Digital Audio Visual

All the words and images on this CD are copyright and your use of the images contained on the CD is limited to following these tutorials. The words, pictures or parts of the pictures may not be reproduced without the permission of the author.

◄ *Your CD covers can be an extension of your creativity or they may need to be simpler in design and more instructional, especially if the CD cover is designed for a tutorial CD. In this case most of the area is taken up with text explaining how to run and use the CD.*

▶ *Use Elements' ability to create a contact sheet, and you can transfer your finished contact sheet onto your CD covers. This cataloging method works especially well when you back up your collection to CD.*

Slide shows

One of the nicest ways to show your pictures to family and friends is with a slide show; a preselected sequence of your best images put together like an automated book. With the help of Photoshop Elements, you can have a slide show up and running within a couple of minutes, and you don't need any additional software.

Before you start, there are a few things to consider. While not essential, it looks better if you arrange all of your images in either landscape or portrait format. Images that constantly change from one format to another reduce the slide show's appeal. Arranging images in thematic groups, such as vacation shots or photos from an airshow, will also make a better show. Finally, consider the length of the slide show. What you discard is just as important as what you include, and if you edit your images robustly and keep your slide shows to between three and five minutes, your viewers will always be happier for it.

2 The Photoshop Elements *Slide Show Editor* dialog opens. Click in the bottom panel to load some images, ready for your slide show. You can select or deselect images from the entire catalog, clicking once on the image or the checkbox to select, then once on the checkbox to deselect, or you can make things easier by narrowing your selection down to a particular collection or set of tags. When you've made your selection, click *Add Selected Photos* then *OK*.

3 By default, the slide show holds each image for 5 seconds before switching to the next. To change the timing, click the small arrow below the slide and choose a new timing from the pop-out menu. Add transitions by clicking on the tiny arrow in between each slide and selecting the transition, then click on the arrow below the transition icon to set the timing. Remember—short is sweet, and tempting as it is to use every transition in the box, it's actually more effective to keep things consistent.

To create a slide show from either the *Standard Edit* or *Photo Browser* modules, click on the *Create* button in the main *Toolbar*, and the main *Create with Your Photos* dialog will appear. Choose *Slide show* from the *Select a Creation Type* menu, then click *OK*. You now have two options: to create a simple PDF slide show, ready to e-mail to friends and family, or create a *Custom Slide Show*, which can contain music, transitions, text, and audio captions. Let's take the *Custom Slide Show* option.

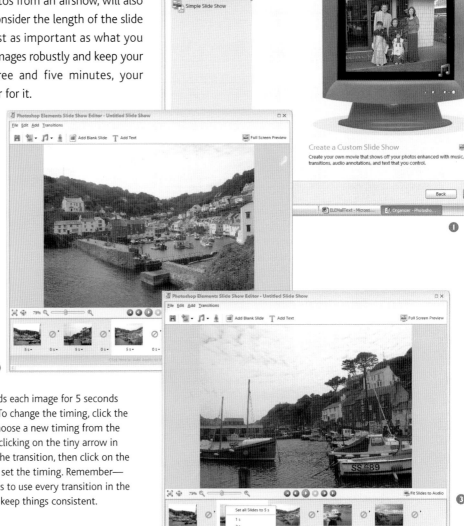

4 That's the basics, but you can do more. To add a title or caption, click on the *Add Text* icon in the toolbar and type it into the space provided. Change the font, color, and alignment using the relevant buttons and menus, then click *OK*. Don't worry if the text is placed slap bang in the middle of the slide; just click on it and drag it to a new position.

5 You can also add background music to your slide, by clicking the *Add Audio* button, then browsing for a suitable MP3 or WMA audio file. If you want your slide show to fit the length of your soundtrack, it's easy. Clicking the *Fit Slides to Audio* button will do exactly that. Sadly, the *Slide Show Editor* isn't smart enough to match your slide show to the tempo of the music. If you want that, you'll need to adjust the timings by hand. Click the *Full Screen Preview* button in the top right corner to check out your work in progress.

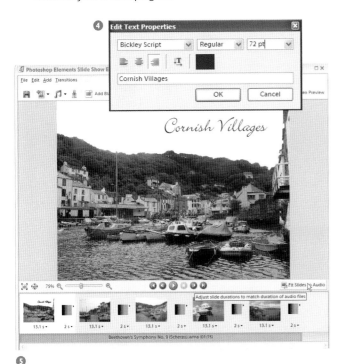

6 When your slide show is finished, save it, then go to *File* > **Output as WMV** to create a Windows Media file that you can burn to CD and share with friends. The WMV file will be an 800 x 600 high-quality video file by default, but you can choose different settings by clicking the *Change WMV output quality* button.

Alternatively, choose *File* > **Burn a Video CD** to create a Video CD of your slide show that will play on most computers and in some (though not all) DVD players.

FOR MAC USERS

1 From the *Menu Bar* select *File* > *Automation Tools* > **PDF Slide Show**. Elements will bring up the *PDF Slide Show* palette. Hit the *Browse* button and browse through your folders for the images you want to select for the slide show.

2 Highlight all the images in your folder, click the Open button and the files will be transferred into the *PDF Slide Show* palette window.

3 You can choose a transition effect from the drop-down menu and also how many seconds each slide is shown. Once you've made your selections hit the *Choose* button and select where you want the PDF file saved. Click *OK* and Elements goes to work. A dialog window will pop up when the operation is complete. Click *OK* again, locate your PDF file, and sit back and enjoy your slide show.

E-mailing Pictures

FILE SIZE

ATTACHMENTS

DOWNLOADING

AUTO CONVERT

JPEGS

This is an area that often causes confusion and frustration, mostly because images being sent over the Internet are far too large. This might be fine if you have a broadband connection, but it is particularly annoying to those who still connect to the Internet using a slower 56K modem, as downloading anything over 1Mb can take a serious amount of time.

But help is here in the form of Photoshop Elements. Before attaching an image to an e-mail, your images need to be reduced in size so that they are small enough to send quickly, but large enough to be viewed by the recipient at a good size and at a reasonable quality.

3 You have three options in the *Choose Format* section. *Photo Mail* creates an HTML format photo mail, complete with a nice frame and a simple layout, if you desire. *Simple slide show* puts one or more photos into a basic PDF package, ready for e-mail. *Individual Attachments* sends one photo, or more, as attachments to an e-mail, with no fuss. Click the *Convert Photos to JPEG* option to minimize the file size.

TIP

An image sent by e-mail need be no larger than 10 inches on the long side or more than 72ppi in resolution for the quality to be good enough for viewing on a computer screen.

5 Add in a message if you want and click *OK*. Elements will open up your e-mail package, with the addresses and the message already added in. All you need to do is click *Send*.

Automatic e-mail

1 The example image is saved as a Photoshop file and is 18 megabytes in size. You would not be thanked for sending that image via e-mail to a friend.

2 Whether you're in the *Photo Browser* or in *Standard Edit* mode, select *File* > **Attach to E-mail**. In *Standard Edit* mode, you can also click the shortcut icon in the main *Toolbar*.

Elements will open up its new *Attach Selected Items to E-Mail* dialog box. In the left panel you'll see your image, in the middle panel, any recipients you have entered into your *Elements Contact Book*, and on the right hand side you can see format and layout options. If the right name isn't in your contact book, just click the *Add Recipient* button and enter their name and e-mail address into the spaces provided.

4 We'll take the last option. Go down to the *Select Size and Quality* settings and Elements gives you four options, *Big*, *Medium*, or *Small*, or *Leave As Is*. If we pick the latter, our image will be 431KB in its new JPEG format—that is still a sizable download for our impatient friend. Change the setting to *Big* however, and they will still get a good looking photo, but at a dramatically reduced size.

FOR MAC USERS

I Open the image you want to send as an e-mail attachment. From the *Menu Bar* select *File* > **Attach to Email** or use the shortcut icon in the *Shortcut Bar*.

2 If the image you're trying to send is not a JPEG (the best compression option for image files), Elements will ask you if you want to convert it. Clicking *Auto Convert* will convert the file into a JPEG and reduce the file size to a size that will be convenient for e-mailing.

3 If the file is already saved as a JPEG, but is too large for some recipients, particularly those with a 56K modem, then Elements throws up a warning panel telling you that the file you are about to send may be too large and offers to reduce it for you. Elements also allows you to override the warning, as on some occasions you may need to send larger images.

4 If you click *Auto Convert*, Elements not only adjusts the picture size for you, but opens your e-mail software and attaches the image to a blank e-mail. All you have to do is address the e-mail, type a message, and send it. Elements doesn't reduce the size of your original saved image so you don't have to worry about having two copies of the image on your computer.

⋀ Manual e-mail

If you wish to prepare your image manually for attaching to an e-mail, you will need the image on screen. From the Menu Bar, *select* Image > Resize > **Image Size** *and Elements will open the* Image Size *palette.*

I If you look at the example image size, you can see that the image is 18 megabytes, which is far too big to send as an e-mail attachment. The physical size of 42 x 28 inches is also too large.

The solution is to reduce the size of the image to no more than 10 inches on its long side. Make sure that the *Resample Image* box is ticked or the size in inches will reduce but the resolution will increase, leaving the file size at 18 megabytes. With the image reduced to 10 inches on the long side, the *Resample Image* box ticked and a resolution value at 72ppi, you can hit *OK*.

The image will then become only 1013KB. You have removed some of the pixels that made it so big, but not so many that you affect the image quality on screen at its 10-inch size. Click the *Zoom* tool and the *Print Size* button from the *Menu* bar and you will see that the image can still be viewed fine.

However, even at 1013KB the image is still too large to send as an e-mail attachment.

2 If you save the image as a Jpeg file compressed to level 6, the 1,013k file will reduce as the format compresses the file. Choose File > *Save As* from the *Menu Bar* and select *Jpeg* from the drop-down *Format* box. Select a *Quality* of 6 and hit *OK*. The image has now been saved and is a mere 48KB, which is no problem to attach to an e-mail. It is still a 10 x 6-inch image and the recipient will be able to view it comfortably.

TIP

Make sure that you do not accidentally save the reduced resolution image over the top of your original. Always rename the file or locate it in another folder for attaching to an e-mail.

Preparing Photos for the Web

Preparing photos for use on a website means ensuring the picture is big enough for the viewer to be able to see and appreciate the image, but that the resolution and size of the image is small enough for a quick download. If your image takes ages to appear on screen, viewers may get bored of waiting and move on.

You need to strike a balance between image size, quality, and speed. This is where Photoshop Elements offers some help with its *Save for Web* option. Before you go ahead and save your image, you need to decide on the size at which you wish to display it.

TIP

As a rule of thumb, images for display on a website should be no larger than 72ppi and no wider that 700 pixels, which is just under 10 inches. This ensures that they will display on most computers without the need for scrolling. There is nothing worse than an image on screen that you need to scroll around in order to view everything—the appeal will be immediately lost.

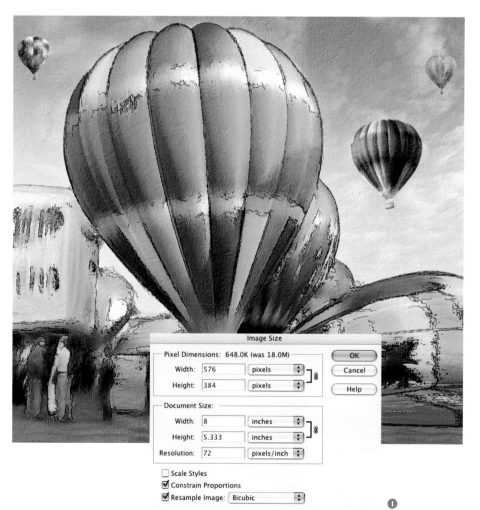

From the *Menu Bar* select *Image > Resize > **Image Size*** and reduce the size of the image for Web use.

Choose an image size of no more than 8 inches on the long side unless the image is in a letterbox format, in which case you can extend the width to 9 inches. Make sure that the *Resample Image* box is ticked.

As a final test of your image size, select the *Zoom* tool and click the *Print Size* button from the options. This is the actual size that your image will appear when viewed on screen.

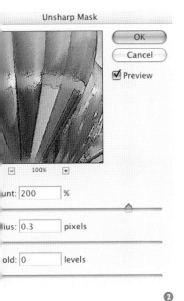

Unsharp Mask

OK
Cancel
☑ Preview

100%

unt: 200 %

lius: 0.3 pixels

old: 0 levels

2 The first step involves reducing the size of the image, but also taking out pixels or resolution to make the image suitable for Web use. This can sometimes affect the sharpness of the image.

The smaller-sized image may look OK, but if it appears to have lost sharpness you may need to replace it. Select *Filter > Sharpen > **Unsharp Mask*** from the *Menu Bar*. Add the smallest amount of sharpness until you see an improvement. Click the *Preview* button on and off to compare the before and after effects. This will help you to evaluate your settings.

❷

3 You also need to consider what sort of background your image will be placed against. It could be a plain or textured background, light or dark in color. You may also want to add a thin line around the outside edge of the image so that it is presented well.

To do this, use the shortcut keys of Ctrl+A for *Select All* and a selection will appear around the outer edge of the image. From the *Menu Bar*, we can select *Edit > Stroke (Outline) Selection* and add a 2-pixel white line to the image.

The image looks very strong presented against the dark, textured background.

Balloons

❸

Save For Web

❹

OK
Cancel
Help

Preset: JPEG Medium

JPEG
Medium Quality: 30
☐ Progressive
☐ ICC Profile Matte:

Image Size
Original Size
Width: 576 pixels
Height: 481 pixels

New Size
Width: 576 pixels
Height: 481 pixels
Percent: 100
☑ Constrain Proportions
Apply

Animation
☑ Loop Frame Delay: 0.2
1 of 1

JPEG
57.96K
22 sec @ 28.8 Kbps 30 quality

Preview In:

4 To save the file, choose *File > **Save for Web*** and the *Save for Web* palette will appear. From the options on the right-hand side you can set up the palette to save the file in JPEG format. If you click the *Quality* slider you can adjust the amount of compression you give your JPEG image.

Using the before and after previews on screen, reduce the *Quality* slider as far as you can before it affects the image quality to an unacceptable level. You can see that the original 812KB image will save at quality 30 to a JPEG file size of 64KB, which will take 12 seconds to download on a 56k modem.

The *Save For Web* option allows you to keep your images as small as possible, but with the advantage of being able to see how much you are affecting the image quality. The lower the jpeg compression setting, the lower the quality.

Click *OK* from the *Save For Web* palette and save the image to the place of your choice.

Web Galleries

Photoshop Elements spoils you for choice when it comes to putting your images on display via your own website. You can use the Adobe Web Photo Gallery feature to automatically generate a Web photo gallery from your images. A Web photo gallery contains a home page with thumbnails of your images and also gallery pages containing larger images. Each page contains links that allow viewers to find their way around your site. For example, when a visitor clicks a thumbnail image on the home page, a gallery page with the associated larger image will load automatically.

1 It's wisest to create galleries from the *Photo Browser* module, using a collection that you've already prepared, but you can do it in *Standard Edit* mode when you have an image open. In either case, simple click on the *Create* button in the main *Toolbar*, then choose the *Web Photo Gallery* option from the *Creation Setup* dialog.

2 The *Web Photo Gallery* dialog is divided into four main sections. On the left is a thumbnail column containing the images for your gallery. Click on the *Add* button to browse through the catalog and any collections, and add new photos to the gallery. You can always remove them from the thumbnail column later by highlighting the shot and clicking the *Remove* button.

3 The top section of the palette is where you can decide on the style you want for your Web gallery. As you select each style from the drop-down menu, Elements displays a thumbnail of what the chosen style will look like.

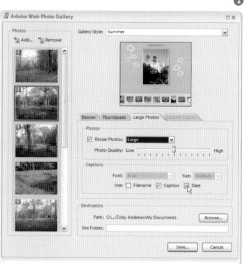

4 The section below has four tabbed pages. With the *Banner* tab selected, enter the title of your gallery and a contact e-mail address. Elements uses this to provide a contact link to that address on the main thumbnail page when the gallery is created, enabling your website's visitors to contact you easily. You can also add a subtitle and change the *Font* and *Size* if desired.

Click the *Thumbnail* tab to set the size of the thumbnails and select the text—File name, caption and/or date—that will appear beneath them.

The *Large Photos* tab is the most crucial. Elements

automatically resizes the images in your Web gallery to a size suitable for browsing. You can control the size and the quality level, depending on your site and on who you expect to browse it. You want the images to be large enough to view, and the quality needs to be high enough to do them justice, but at the same time huge, high-quality photos could make visiting your gallery a fairly slow experience. Here we're using large photos at a medium quality setting as a compromise.

5 The fourth tab may be grayed-out depending on your choice of style. If you can select it, the *Custom Colors* tab enables you to set colors for your background, banner, and any links.

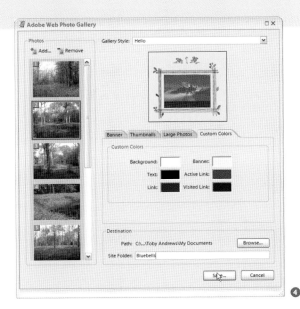

④

From the *Menu Bar* select *File* > **Create Web Photo Gallery**
and the *Web Photo Gallery* palette will appear. It is split into
three main sections.

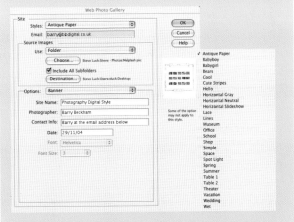

6 In the final *Destination*
section you can inform
Elements where you want your
new gallery saved, and what
you want the folder called.
Click *OK*, and Elements goes
to work. Your original images
will not be changed, as copies
will be produced automatically
by Elements at the same time
as it reduces the size of the
images. When the process has
run, Elements will present your
fully functional gallery on
screen. Click on a thumbnail
and the larger image should
jump into view. The page is

working just as your viewers
will see it on their computers.
Click your e-mail contact and
your e-mail program will
open with an e-mail already
addressed to you.

If you look at the folder
where you stored your
webpages you will see that
Elements has put everything
in the right place. All you need
to do is upload it to your Web
server. This will differ depending
on your Internet Service
Provider, so check with
their help files and other
documentation for details.

2 The top section of the palette is where you can decide on
the style you want for your Web gallery. As you select
each style from the drop-down menu, Elements displays a
thumbnail of what that chosen style will look like. If you enter
your e-mail address in the *Email* section Elements provides a
contact link to that address on the main thumbnail page when
the gallery is created. The second section of the palette is
where you select the images and where you want the
webpages to be created. In the third section you can select
your banners and enter the contact details that will appear on
your main page. From the drop-down menu you can control
your large image sizes and the quality. There are similar options
for the smaller thumbnails, as well as some color options to
choose from. Make your preferences and click *OK*, then
Elements does the rest.

3 When the process
has run, Elements
will present your fully
functioning gallery on
the screen. Click on the
thumbnail and a larger
image will appear, with
navigation buttons
linking to the next or
previous image.

*If you're using Windows then Elements features a powerful tool
called Photo Album. This features numerous suggestions on how to
make the most of your photographs, from Slide Shows, through
Postcards, even to creating your own Photo Album or Calendar.*

Web Animations

Having your pictures displayed on your own website is far more fun than it may first sound. Once you have used the tools of Photoshop Elements to create your web pages, you can then add some movement to them by creating some simple animated GIF images.

The GIF format uses 8-bit color and efficiently compresses solid areas of color while preserving sharp details in images like line art, logos, or type. It is this format that you will use to create your animated image as it is supported by most browsers.

The GIF format uses LZW compression, which is a lossless compression method. GIF files are limited to 256 colors, so saving an original 24-bit image such as our photographs as an 8-bit GIF can subtract colors from an image and reduce the quality.

Your animations must be fairly simple so that they are small in size and do not take a long time to download. You can create them in the *Layers* palette: each layer from the bottom of the *Layers* stack to the top will form a frame in your animation. These animations will be viewable in your Web browser.

Follow these steps to find out how to create and optimize a simple web animation from a layered Photoshop Elements .PSD file.

1 Your animated GIF example will be based on text. From the *Menu Bar* select *File* > **New** and create a small panel to begin your work. Something 2-3 inches in length will be big enough at 72ppi.

Select the *Text* tool from the *Toolbar* and type the word "Photoshop." From the *Text Options Bar* at the top of the screen, select the *Warped Text* icon and introduce some shape to the text.

2 From within the *Layers* palette you need to make enough layer copies so that you have one for each letter of the word "Photoshop." Do that by dragging a thumbnail up over the left copy icon at the top of the *Layers* palette.

Starting from the bottom of the layers stack, you need to remove letters so that the word "Photoshop" builds up letter by letter from the bottom of the layer stack toward the top.

Create three other copy layers for the full word "Photoshop" that is at the top of the stack. This will provide a slight pause in your animation.

Elements

3 Create a new text layer by selecting the *Text* tool and clicking into the image. Type the word "Elements" and add some warped text effects to that word as well. Repeat the one-letter-per-layer technique that you applied to the word "Photoshop."

You should now have quite a large layer stack, which is not as complex as it might appear.

4 To complete the animation, select *File > Save for Web*. From the options select *GIF* from the *Settings* and tick the *Animate* box. In the *Animation* panel at the bottom of the *Options* palette, tick the *Loop* box so that your animation runs continuously, and adjust the frame delay. Here I set a frame delay of 0.2 seconds.

Click *OK* and save the GIF to a convenient place on your computer. Using Windows XP, locate the file and right-click the *Animated GIF* icon. From the options choose *Open With Internet Explorer*. Your browser will open and your animation will run. This animated GIF can now be imported into any of your web pages. This example was just 18KB.

If you are good at drawing, you have the option to enhance your website with some more exciting animations. Even a quick surf around the Internet will show you plenty of inspiring examples.

reference

Image Size and Resolution

The relationship between image-size and resolution is often misunderstood. If you're having trouble, this step-by-step tutorial should help clarify things. Above all else, it helps if you keep these two basic rules in mind:

1 For the best quality prints, retain all the pixels in your image up to 300ppi.

2 To send a picture as an e-mail attachment, get rid of some pixels from the image to make it smaller—not necessarily smaller in inches, but smaller in megabytes.

Open up a full-resolution image from your digital camera onto your screen and then select *Image > Resize > **Image Size*** from the *Menu Bar*.

If you look at the size of the image in the *Image Size* palette you will see that it is 43 by 28 inches at 72ppi. This is an image straight from a 6-megapixel camera; the file size of 18 megabytes is shown at the top of the *Image Size* palette.

72ppi gives you 5,184 pixels in every square inch (72 x 72 = 5,184). The 43 by 28 inch picture has 1,204 square inches (43 by 28 = 1,204). Therefore 5,184 pixels per inch by 1,204 inches gives you a 6-million-pixel image, give or take a few pixels.

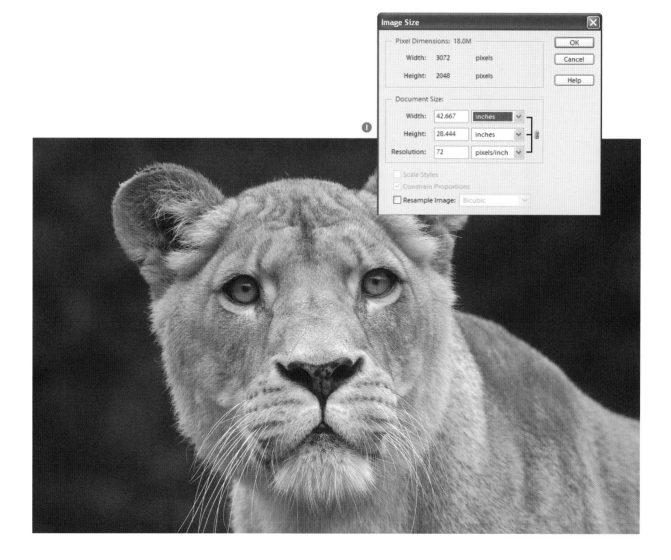

②

② Obviously, you cannot print a 43 by 28 inch image at home. Let's assume that you wish to print your image 10 inches on the long side to fit a letter-sized sheet. This requires you to resize it. Open the *Image Size* palette and remove the tick from the *Resample Box*. Note the file size at the top of the *Image Size* palette—18 megabytes—and the PPI resolution (currently 72). Adjust the picture length from 43 inches to 10 inches, and the width will change automatically to just under 7 inches. Click *OK*. Nothing will appear to have happened, but open the *Image Size* palette and look again at the file size in megabytes. Although you have reduced the image dramatically, it is still 18 megabytes.

How can that be? The answer lies in the pixels per inch (ppi). In the first example, the ppi was 72. After the adjustment, it increased to 307ppi. The 6 million pixels that made up the quality in the original 43 by 28-inch image have now been compressed into 10 by 7 inches. The image won't look different on screen, but you now have a 10 by 7-inch image at 307ppi, which will give you an excellent print because every bit of detail has been retained.

④

∧ *If you select the Zoom tool and enlarge the image until the lioness' eye fills the screen, you see quite a different result.*

➤ *Resolution is simply how many dots you have to make up your image. The more dots, the better the image, but the more dots, the bigger the image.*

③ If you now select the *Zoom* tool and enlarge the image one click at a time until the lioness's eye fills the screen, you can still see a good quality image, given the magnification.

③

④ Follow the same process again right from the start using the same image, but this time tick the *Resample* box. If you then compare the sizes you see a different result. The 10 by 7-inch image is now 72ppi and only 1 megabyte in size. In this example, you have discarded pixels, but as screen resolution runs at 72ppi it doesn't look much different on screen, especially at the print size.

File Formats

JPEG

TIFF

GIF

EPS

BMP

file formats

Photoshop Elements can save pictures in a variety of ways, but often those varieties can cause some confusion. When you see just how many formats there are, you may well ask, what do you use for the best, when do you use it, and how?

While you are working on an image, it is always a good idea to save the file as a Photoshop file with a .PSD extension. This way, you can always be sure that all the image data is saved including any layers, adjustment layers, or text layers. If you save using other formats you can lose these, along with the ability to retrieve your image later and make changes easily.

It is not until we have completed our image that the thought of saving it in another format needs to be considered. Many of the formats available are designed to enable the image to be recognized in different software packages, including web-design programs and desktop-publishing software. This means many of them can be safely ignored until you find a need to save in those formats.

If you are going to save images for your own use, the three main contenders are: A Photoshop file (.PSD), a TIFF file, or a JPEG file.

The JPEG format (Joint Photographic Experts Group)

This is the format you use to send an e-mail and to prepare images for web use. To save in JPEG format select *File* > **Save As** from the *Menu Bar* and choose *JPEG* from the drop-down format choices.

With the JPEG format, your file will be compressed and saved smaller than it would as a Photoshop or TIFF file. You are also given the choice of what level of compression to select. For e-mail and web use, a good guide is level 6, but other levels may be better with some images. You need to consider this format alongside your *Save For Web* option in Photoshop Elements.

When an image saved as a JPEG is opened it will return to its original size.

The TIFF format (Tagged-Image Format)

The TIFF format is used when you want to exchange files between different computers, as the format is supported by most paint and image-editing software. TIFF format is also what magazine editors and publishers will expect you to send them because they can be read on practically any computer, including Macs.

To save an image format as a TIFF file, select *File* > **Save As** from the *Menu Bar* and choose *TIFF* from the drop-down menu. You can compress them, but most TIFF files are saved without any compression.

Photoshop format

If you are storing images for your own use, the Photoshop format is fine. With this format, all the image data will be saved. The disadvantage is that file sizes can be slightly larger than some other formats, but given that modern hard drives are so big and CDs cheap, this is not generally an issue. Your images will need to be saved onto CDs at some stage anyway, no matter what file type you use.

GIF format (Graphics Interchange Format)

The GIF format reduces the colors in an image to 256, efficiently compressing solid areas of color while preserving sharp details in images like line art, logos, or type. It is this format that you use to create any animated GIFs for use on your websites. The GIF format is supported by most browsers.

EPS Format (Encapsulated PostScript)

This is used to share Photoshop files with many graphics and page layout programs.

BMP Format

This is a standard Windows image format, but it is rarely used in digital imaging circles.

ORIGINAL

TIFF

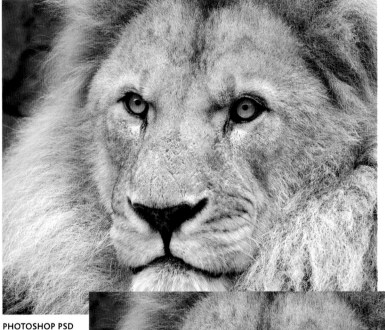

PHOTOSHOP PSD

∧ ⟨ *I saved one layer example image as a PSD, TIFF, and JPEG and then compared the resulting file sizes. There is little difference between the saved TIFF and PSD files, which remained at the original 18 megabyte size. The JPEG image saved at 2 megabytes—a considerable saving, but there may be a tiny loss of quality with this compression process.*

JPEG

Color Calibration

Your monitors will display color more accurately if you make the effort to use color management and accurate ICC (International Color Consortium) profiles. Using an ICC monitor profile helps you to eliminate any color casts in your monitor. It also makes your monitor grays as neutral as possible, and standardizes image display across different monitors.

With Microsoft Windows, you can use the Adobe Gamma software that was installed with Photoshop Elements to create a monitor profile. On Mac OS, you can use the Apple calibration utility to create a monitor profile.

| To run Adobe Gamma, go to the *Start* button and select *Settings* > **Control Panel**.

2 Doubleclick the icon and the Gamma wizard will take you through the process. As each panel appears, the wizard will give you clear and simple instructions to follow.

3 At the end of the process Elements will allow you to check your before and after settings before saving.

Further Reading

Magazines

The following US and UK magazines offer an excellent mix of equipment reviews, general advice on photography, and useful software tutorials:

Computer Arts
Digital Camera
Digital Photographer
Digit
PC Photo
Photoshop User
Photo Techniques
Popular Photography and Imaging

Websites

www.bbdigital.co.uk
The author's own site, with around 50 galleries of images and many extra tutorials available online. Regularly updated.

www.davrodigital.co.uk
This popular site contains some great images, ideas, and tutorials.

www.photoshopuser.com
The site of the NAPP (National Association of Photoshop Professionals). The leading resource for Photoshop news and training, it operates for anyone—not just professional users—who is serious about image manipulation using Photoshop, though it does operate as a "trade body" for users.

www.creativepro.com
News, information, and resources designed for the creative professional.

www.ephotozine.com
Everything to do with photography, digital imaging, and image editing.

www.dcpreview.com
News and reviews and general help/information.

www.photoeducation.net
Education and training in photography and imaging.

www.photo.net
Major photographic resource site with advice, tutorials, and galleries.

Other useful links for Photography and Photoshop Elements

Adobe
www.adobe.com

Alien Skin (Plug-ins)
www.alienskin.com

Andromeda (Plug-ins)
www.andromeda.com

Apple Computer
www.apple.com

British Journal of Photography
www.bjphoto.co.uk

Extensis
www.extensis.com

Microsoft
www.microsoft.com

Xaos Tools
www.xaostools.com

Glossary

8-bit: A color mode in a digital image, where eight data bits are allocated to each pixel, producing an image of 256 grays or colors.

24-bit color: A color mode in a digital image, where 24 bits of color date are allocated to each pixel, giving a possible screen display of 16.7 million colors (a row of 24 bits can be written in 16.7 million different combinations of 0s and 1s). Eight bits is allocated to each of the three RGB color channels.

antialias/antialiasing: A technique of optically eliminating the jagged edges that appear when bitmapped images or text are reproduced on low-resolution devices such as monitors. Achieved by blending the color at the edges of the object with the background color by averaging the values of the pixels involved.

artifact: A visible flaw in an electronically prepared image, usually occurring as a result of imaging techniques. JPEG compression, for example, reduces image data through operating on square blocks of pixels, and these can become clearly visible, particularly when high contrast or color effects are applied.

aspect ratio: The ratio of the width of an image to its height, expressed as x:y. For example, the aspect ratio of an image measuring 200 x 100 pixels is 2:1.

bas-relief: An image that is embossed, so that it stands out in shallow relief from a flat background and gives an illusion of further depth.

bevel: A chamfered edge applied to an element in an image (usually type or a button) to give it a simple three-dimensional effect.

bit depth: The number of bits assigned to each pixel in an image file. Today's computer systems can handle 24-bit, or up to 16.7 million, colors. In contrast, the GIF file format can support only eight-bit color, or 256 different hues.

bitmap: A bitmap is a "map" describing the location and binary state of "bits" that define a complete collection of pixels or dots in an image. The term is also used to refer to pictures that have only black and white pixels.

blend mode: A feature used in Photoshop Elements and other image-editing applications to control how the pixels in one layer interact with the pixels in the layers below. This interaction could be limited to one layer covering another, but other blend modes cause more complex changes to color or brightness values.

brightness: The strength of luminescence in a pixel, going from light to dark.

burn: A method used in the conventional darkroom to darken areas of an image. Often simulated in digital image-editing packages.

calibration: The process of adjusting a machine or piece of hardware to conform to a known scale or standard so that it performs more accurately. In graphic reproduction it is important that the various devices and materials used in the production chain—such as scanners, monitors, and printers—conform to a consistent set of measures in order to achieve true fidelity, particularly where color is concerned. Calibration is generally carried out in software.

capture: The action of "getting" an image, by taking a photograph or scanning an image into a computer.

CCD (Charge Coupled Device): A component used in digital imaging hardware—including digital cameras—to turn beams of light into an electrical signal that can then be converted to digital form.

clipping: Limiting an image or piece of art to within the bounds of a particular area.

CMYK: Color model describing the primary colors of reflective light: cyan (C), magenta (M), and yellow (Y). Together with black (K), they are used in most forms of printing. The letter K is used rather than B to avoid confusion with blue.

clone: In image-editing applications, a retouching operation where pixels from one area of an image are copied to another area using a brush tool.

color cast: A strong color overtone that affects all or part of an image. Usually an unwanted effect, and one that can be removed by most image-editing programs.

color picker: An onscreen palette of colors in an application, from which the user can select colors to paint, draw, or otherwise manipulate an image with.

composition: The effective arrangement of elements in the scene captured in the photographic frame.

compression: The technique of rearranging data so that it occupies less space on disk or transfers faster between devices or on communication lines. Different kinds of compression techniques are employed for different kinds of data—applications, for example, must not lose any data when compressed, whereas photographic images and films can tolerate a certain amount of data loss. Compression methods are described as either "lossless" or "lossy" accordingly.

constrain: In digital imaging, to ensure that an image maintains a particular aspect ratio or proportions during resizing or resampling.

continuous tone: An image that contains infinite continuous shades between the lightest and darkest tones, as distinct from a line illustration, which has only one shade. A photographic print or slide would be an example of continuous tone, but a photo printed in a magazine would not, as its colors would have been broken down into patterns of tiny CMYK dots for the mass printing process.

contrast: The degree of difference between adjacent tones in an image from the lightest to the darkest. "High contrast" describes an image with light highlights and dark shadows, but few shades in between, while "low contrast" images have even tones and few dark areas or highlights.

crop: To trim or mask an image so that it fits a given area, or so that unwanted portions of the image are discarded.

cut-out: An element of an image that has been selected and separated from the rest of the picture for purposes of composition or manipulation.

definition: The overall quality—or clarity—of an image. In a photo this is determined by the combined effects of graininess and sharpness. In a digital image resolution also has a part to play in the mix.

density: The darkness of tone or color in any image. In a transparency this refers to

the amount of light which can pass through it, thus determining the darkness of shadows and the saturation of color. A printed highlight cannot be any lighter in color than the color of the paper it is printed on, while the shadows cannot be any darker than the quality and volume of ink in the printing process will allow.

density range: The maximum range of tones in an image, measured as the difference between the maximum and minimum densities (the darkest and lightest tones).

depth of field: A photographic function that defines the extent to which the area in front of the lens will appear in sharp focus. The effects of depth of field are often used for creative purposes.

desaturate: To reduce the purity of a color, thus making it grayer.

diffuser: Any material that scatters transmitted light, thus increasing the area of the light source.

digital: Anything operated by or created from information represented by binary digits. Distinct from analog, in which information is a physical variable.

digital data: Information stored or transmitted as a series of 1s and 0s ("bits"). Because values are fixed (so-called discrete values), digital

data is more reliable than analog data, as the latter is susceptible to uncontrollable physical variations.

digital image: Image converted to (or created in) the digital domain. Elements of the image are represented by groups of pixels, each with their own discrete color and brightness values.

dithering: A technique of "interpolation" that calculates the average value of adjacent pixels. This technique is most often used to add extra pixels to an image—to smooth an edge, for example, or to simulate a large range of hues from a smaller selection.

dodge: A method of lightening areas in a photographic print by selective masking. Many image-editing applications can simulate the effect through digital means.

dots per inch (dpi): A unit of measurement used to represent the resolution of output devices, including printers. Also applied, erroneously, to monitors and digital images, where the resolution should be more properly be expressed in pixels per inch (ppi). The closer the dots or pixels (the more there are to each inch), the better the quality.

duotone: A monochromatic image combining two halftones with different tonal ranges made from the same

original. When printed in different tones of the same original, a wider tonal range is reproduced than would be possible with a single color. Special effects can be achieved by using the same technique and printing with different colored inks.

exposure: The amount of light allowed to reach a photosensitive material, such as photographic film or a CCD imaging sensor, to enable the recording of an image. The amount of exposure has a dramatic effect on the tonal and color values of the shot. Overexposure leads to bleached colors and poor contrast. Underexposure results in dark, gloomy, and badly defined pictures.

feathering: A similar process to antialiasing, this blurs the edge pixels of a selection to give a soft border.

fill: An image-editing operation that covers a defined area with a particular color or texture.

filter: Strictly speaking, a filter can be any component in a software program that provides the basic building blocks for processing data. In image-editing and drawing applications, the term usually refers to the advanced features used to apply special effects to an image.

GIF: Graphics Interchange Format. A file format designed to produce very small,

optimized image files for the Web. GIFs also provide basic built-in animation features. The format allows for simple transparency but can only contain up to 256 colors.

graduation / gradation: The smooth transition from one color or tone to another.

gradient: An effect or fill that uses graduation to control the color or brightness values of the affected pixels.

grain: The density of light-sensitive crystals in a photographic emulsion. Fine grain allows more detail, but the film is less light-sensitive. Coarse grain is sometimes used for a graphic effect, and this can also be simulated using digital means.

graphic: A general term describing any illustration or drawn design. Can also refer, more specifically, to "graphic" images where the emphasis is on high-impact visuals with strong lines and dramatic tones at the expense of realism or fine detail.

grayscale: The rendering of an image in a range of grays from white to black. In a digital image and on a monitor, this usually means that an image is rendered with eight bits assigned to each pixel, giving a maximum of 256 levels of gray.

halo effect: An artifact created when a cut-out is copied to a new image or a different area of the same image. The pixels around the cut-out show up against the new background, creating the effect of a halo surrounding it.

highlight: To mark an item, such as a section of text, icon, or menu command, to indicate that it is either selected or active.

HSL: A color model based on the variables of Hue, Saturation, and Lightness.

hue: A color as found in its pure state in the spectrum.

image size: A description of the dimensions of an image. Depending on the type of image being measured, this can be in terms of linear dimensions, resolution, or digital file size.

import: To bring text, pictures, or any other form of data into a document.

interface: A term most often used to describe the screen design that links the user with the computer program or website. The quality of the user interface often determines how well users will be able to access and use all the features in the program, or navigate their way around the pages within the website.

interpolation: A calculation used to estimate unknown values that fall between known values. This process is used to redefine pixels in bitmap images after they have been modified in some way, such as when an image is resized or rotated, or if color corrections have been made.

JPEG (Joint Photographic Expert Group): A digital image file format used for continuous tone images such as photographs. It uses a lossy compression algorithm to squeeze large images into compact files. The Joint Photographic Expert Group first created the format.

Kelvin temperature scale (K): A unit of measurement that describes the color of a light source, beginning with absolute darkness and rising to incandescence.

landscape format: An image or page format in which the width is greater than the height. Also known as "horizontal format."

layer: In Photoshop Elements, a level to which you can consign an element of the design you are working on, so that you can separate it and work on it independently. Selected layers may be active (meaning you can work on them) or inactive, and can be copied, deleted, or made transparent and even invisible.

lasso: A freehand tool used in image-editing applications to select a portion of an image. In Photoshop Elements this also comes in a magnetic variety, which identifies the edges of a particular element, and a polygonal version, which creates straight-edged selections around an object.

levels: The range of tones in an image going from the darkest to the lightest. Photoshop Elements has a Levels tool designed to give complete control over the tonal range of a digital photograph.

light table: A table or box with a translucent glass top lit from below, giving a color-balanced light suitable for viewing transparencies and, if necessary, color-matching them to proofs.

lightness: The tonal measure of a color relative to a scale running from black to white. Also called "brightness."

line art: Diagrams and graphics comprising (normally) black lines on a white background.

lossless / lossy: Refers to data-losing qualities of different compression methods: lossless means that no image information is lost; lossy means that some (or much) of the image data is lost in the compression process.

magic wand: In image-editing applications, a tool used to select those areas of an image that possess similar brightness or color values in order to operate on them.

marquee: An image-editing tool used to make selections based on simple rectangular or elliptical shapes.

Glossary continued

mask: Originally a material used to protect all or part of an image during photographic reproduction. In image-editing applications, a mask is used to prevent alterations from affecting the masked portion of an image.

master: An original item from which all copies are made, or upon which any changes are marked or made.

megapixel: One million pixels. A term used to describe the CCD and capture capabilities of a digital camera. A 4-megapixel camera takes shots of twice the resolution of a 2-megapixel model.

menu bar: In most applications, the bar at the top of the screen that hosts the various drop-down menus used to access and control program features.

midtones / middletones: The range of tonal values in an image anywhere between the darkest and lightest—usually those approximately halfway.

moiré: An unintended pattern that frequently occurs when a photograph or page from a book or magazine is scanned. Scanner software and some image-editing applications contain filters to counter it.

monochrome: An image of varying tones reproduced using inks of a single color. While this is usually black ink on white paper, this isn't necessarily the case.

montage: A photographic technique, simulated in Photoshop Elements, where parts from two or more images are composited to create a new picture.

multimedia: A generic term used to describe any combination of sound, video, animation, graphics, and text incorporated into a software product or presentation.

opacity: In image editing, the extent to which one layer is transparent or opaque, allowing the pixels in layers below to show through.

options bar: In Photoshop Elements, the bar at the top of the screen that displays the options for the tool that is in current use.

palette (1): The subset of colors needed to display an image. For instance, a GIF image has a palette containing a maximum of 256 distinct colors.

palette (2): A part of the interface in many image-editing and visual-design applications, a palette is a window that contains features such as tools, measurements, options, or other functions. In most applications, palettes can be moved, hidden, and even docked together if desired.

palette well: In Photoshop Elements, an area of the screen interface where frequently used palettes are

docked. These palettes can be viewed, dragged from, or dropped onto the Palette Well as needed.

panorama: An image created from several shots of the same scene that simulates a large, wide-angle shot in a panoramic format.

perspective: A technique of rendering 3D objects on a 2D plane, duplicating the "real world" view by creating an impression of the object's relative position and size when seen from a certain point of view. The perspective narrows as distance increases.

picture skew: The distortion of an image by slanting the two opposite sides of the image rectangle away from the horizontal or vertical.

pixel: Acronym for picture element. The smallest component of a digital image—a single block in the bitmap grid, with its own specific color and brightness.

plug-in: Subsidiary software for a browser or other package that enables it to perform additional functions, e.g., play sound, films, or video.

PNG (portable network graphic): A digital image format that uses a highly sophisticated compression technique, which is said to result in file sizes typically 30 percent smaller than those for comparable GIFs. The PNG format can also support the

full 24-bit color palette, and, as a lossless format, it is less likely to cause artifacts than using JPEG.

polarizing filter: A popular photographic filter used to remove polarized light, including reflected light, resulting in brighter colors and richer skies.

portrait format: An image or page in a vertical format. Also called "upright format."

posterize/posterization: To divide, by photographic or digital means, a continuous-tone image into either a predefined or arbitrary number of flat tones. Also known as tone separation.

proprietary: A design, product, or format developed, marketed, and owned by a single company or person. While some proprietary formats become standard formats, most standards are defined by some form of cross-industry organization.

quick fix: A tool, specific to Photoshop Elements, which allows users to correct the most common faults seen in photographs.

RAM: (Random Access Memory) The memory "space" used by the computer, into which some or all of an application's code is loaded while you work with it. Generally, the more memory, the better. Imaging software, such as Photoshop Elements, might

need up to five times the amount of available RAM that an image file would normally occupy in order to process the image.

red eye: A common problem in portrait shots where the camera's flash is reflected in the blood cells at the back of the eye, giving the pupils a fiendish red cast.

rescale: Amending the size of an image by proportionally reducing or increasing its height and width.

resolution: The degree of quality, definition, or clarity with which an image is reproduced or displayed. In a photograph this would be the result of focus, clarity, and grain structure. In a digital image, resolution refers directly to the numbers of pixels contined within a finite area of the image.

restore: To restore something to its original state or, in the case of a document, to its last "saved" version. Also called "revert."

reticulation: An effect of photographic processing where the film emulsion adopts a distuted or crazed pattern. Usually undesirable, the effect is simulated in some image-editing programs as a quick means of aging an image artificially.

retouching: Altering an image, artwork, or film to modify or remove imperfections. Can be done using mechanical methods (knives, inks, and dyes) or digitally, using Photoshop or a similar image-editing program.

RGB (Red Green Blue): The primary colors of the "additive" color model, used in video technology, computer monitors, and for graphics such as for the Web and multimedia that will not ultimately be printed by the four-color (CMYK) process.

saturation: A variation in color, affecting hues of the same brightness, ranging from none (gray) through pastel shades (low saturation), to pure (fully saturated) color.

scanning: An electronic process that converts a hard copy of an image into digital form. The scanned image can then be manipulated.

selection: A portion of an image that has been selected for manipulation. Any adjustment will only affect this chosen area.

sepia: A shade of brown, which lends its name to the sepia tone, a rich monochrome print in which shades of gray appear as shades of brown.

shadow areas: The parts of an image that are darker or denser than the majority.

soft-focus: An effect that softens or diffuses the lines of an image without altering the actual focus. Soft-focus has been used traditionally to confer a romantic feel to portraits, and can now be simulated in software.

thumbnail: A small representation of an image used mainly for identification purposes in an image listing or, within Photoshop, for illustrating layers.

tonal compression: The effects on an image, usually caused by scanning or printing, where the range of tones, from light to dark, is reduced to the detriment of the picture.

toolbar: In applications, a standard palette which ensures that the most-commonly used tools are always available at a click.

unsharp masking (USM): A traditional film-compositing technique used to "sharpen" an image. This effect can also be achieved digitally. Most image-editing applications contain a USM filter that can enhance the details in a scanned or digital photo, and give an impression of improved clarity.

USB (Universal Serial Bus): A port (socket) for connecting peripheral devices to your computer which can be daisy-chained together. These can include devices such as scanners, printers, keyboards, and hard drives.

vector: A mathematical description of a line that is defined in terms of physical dimensions and direction. Vectors are used in drawing and image-editing packages to define shapes (vector graphics) that are position- and size-independent.

vignetting: A noticeable fading at the edges of an image caused by a reduction in light levels at the edges of the frame. While a problem if caused by deficiencies in a camera, vignetting can also be used to positive effect and simulated via digital means.

virtual: Any thing that, while it doesn't exist physically, can be made to appear as if it does. For example, virtual memory is a simulation of RAM on the hard disk, which the computer uses as if it were physical RAM.

Index

Index continued

the author

Acknowledgments

First of all, thanks to Adobe, who have produced such superb software. Before Elements, many of the projects in this book would have been possible, but a lot more difficult to create and follow.

Thanks, too, to Barry Colquhoun who encouraged me to begin writing tutorials on Photoshop in the early days of Digital Photography. Without him I may never have written anything at all, so he has a lot to answer for. I would also like to thank Barry for the use of a painterly technique that he developed and freely passed on to me for my use in part four of this book.

Most of all, a big thank you to my wife, who tolerates the hours I spend working on images on the computer and the many hours when I had my head down creating the work for this book. Also, thanks to her, in advance, for the time I will spend on the next one.

About the author

Barry Beckham is 53 years old and has been involved in photography most of his adult life. His early involvement in photography came when he joined a Photographic Society and he quickly became involved in all the activities such as development and printing of both black and white and color images. Barry found a creative outlet for his photography via slideshows, and toured clubs in the UK lecturing on the subject.

Barry was introduced to a very early version of Adobe Photoshop some years ago when PCs were almost steam driven and every task took ages to complete. He saw the potential of the digital revolution and stuck with it, learning the techniques and skills required.

In fact, the author now realizes that he was a digital photographer all his life, just waiting for the equipment to be invented. Barry works 100% digitally using a Nikon Coolpix 990 digital camera and a Canon EOS D60 digital SLR. He writes regularly for leading UK digital-imaging magazines, and lectures to amateur and professional photographers on Photoshop and Photoshop Elements.